# Myths of
# VENICE

BETTIE ALLISON RAND

*Lectures in Art History*

# Myths of VENICE

## The Figuration of a State

### DAVID ROSAND

The University of North Carolina Press  Chapel Hill & London

The publication of books in this series is made
possible through the generous support of William G. Rand
in memory of Bettie Allison Rand.

Designed by Richard Hendel
Set in Centaur and Mantinia types by Eric M. Brooks
Manufactured in the United States of America

The paper in this book meets the guidelines for permanence
and durability of the Committee on Production Guidelines for
Book Longevity of the Council on Library Resources.

Library of Congress Cataloging-in-Publication Data
Rosand, David.
Myths of Venice: the figuration of a state / David Rosand.
p. cm.—(Bettie Allison Rand lectures in art history)
Includes bibliographical references and index.
ISBN 0-8078-2641-3 (cloth: alk. paper)
1. Art, Italian—Italy—Venice.   2. Venice (Italy)—In art.
3. Art—Political aspects—Italy—Venice.   4. Art and state—
Italy—Venice.   I. Title.   II. Series.
N6921.V5 R6919   2001
701'.03'0945310902—dc21      2001027041

05  04  03  02  01   5  4  3  2  1

*Dedicated to the Memory of*

MICHELANGELO MURARO $\left(1913-1991\right)$

*maestro veneziano e amicissimo*

# CONTENTS

# PREFACE

The Bettie Allison Rand Lectures in Art History were conceived as a means of making accessible to a broader public scholarship that more often restricts itself to a collegially professional audience. It was, therefore, with enthusiasm that I accepted the invitation to deliver these lectures at the University of North Carolina at Chapel Hill in 1999, for the Rand Lectures seemed to offer an opportunity to share with that larger audience the particular, passionate interests that a teacher allows himself to exhibit and explore in the relative intimacy of the classroom, the hypotheses and intuitions that may yet be beyond absolute documentation, not yet ready for the validation of the bibliographically certifying footnote. In that spirit of sharing my own enthusiasm for the art and history of Venice, I came to Chapel Hill.

For the opportunity to indulge my Venetian passion, as well as for his welcoming southern hospitality, I am especially grateful to William Rand, who established these lectures in honor and memory of his wife. For encouraging that indulgence I thank Mary D. Sheriff, then acting chair of the art department. Two admired colleagues, themselves passionate *venezianisti*, made my visit to Chapel Hill a particular pleasure, intellectually and socially: Mary Pardo and Stanley Chojnacki, whose intelligent probing, at once critical and sympathetic, helped me to clarify my own vision of our shared world.

My thoughts on Venice and its self-imaging have developed over many years and in continuing dialogue with my students at Columbia and with colleagues in the field, whose names appear frequently in the following

pages (for I confess to having obeyed the scholar's call to the footnote). Note citation alone, however, seems hardly sufficient acknowledgment of the kind of personal collegial exchange, going beyond publications, that joins us in a common enterprise of seeking to understand the rich cultural traditions of Venice. Staale Sinding-Larsen and Wolfgang Wolters in particular have been especially crucial companions in my own exploration of those traditions of the lagunar republic. On this side of the Atlantic I have been joined in the exploration of Venetian imagery by Rona Goffen and Patricia Fortini Brown, who have significantly expanded our vision and deepened our knowledge of that imagery. My sense of the built environment of Venice and its architectural traditions owes much to Juergen Schulz and Deborah Howard. In Venice itself, Lionello Puppi and the late Manfredo Tafuri led a new generation of art historians in a more complex appreciation of the art of the Serenissima and gave renewed intellectual impetus and purpose to Venetian studies.

Above all, however, I must recall Michelangelo Muraro, who first introduced me—and a generation before me—to the many dimensions of meaning in the art of Venice. For all of us, Mic opened new prospects on that art, from the material and social aspects of its production to its political and religious resonance. First as inspiring mentor to a novice exploring a wondrous world and then as dear friend and collaborator, he was my surest guide through the canals, and it is to his memory that I dedicate these lectures.

# Myths of
# VENICE

# INTRODUCTION

For these chapters on the myths of Venice, I might well have borrowed the title that Jacob Burckhardt gave to the first part of his classic *Civilization of the Renaissance in Italy*: "The State as a Work of Art." For, in a quite literal sense, that is my subject: that is, the imagery developed by la Serenissima Repubblica, the Most Serene Republic of Venice, to represent itself. I am concerned with what has become fashionably known as Renaissance self-fashioning, but here on a monumental scale.

More than any other political entity of the early modern period, the Republic of Venice shaped the visual imagination of political thought; just as she instructed Europe—and, ultimately, the independent colonies of America—in the idea of statehood, so she taught how to give that idea eloquent pictorial form, especially through the figuration of the state. It is that imaging, the visualization of political ideal and the reciprocal effect of such imagery on that ideal, that is my theme. I am concerned not only with the official iconography of state per se, but with the ways in which such imagery resonates within a culture, the ways in which visual motifs acquire an aura of association and allusion dependent upon a network of shared values and habits of interpretation—what Aby Warburg called "the maintenance of the 'social mneme.'"[1]

Over the course of several centuries, Venice had refined a portrait of itself that responded to and exploited historical circumstance and vicissitude—including its despoliation of Constantinople during the Fourth Crusade in 1204, its final victory over its maritime rival Genoa in 1380, and, in the early sixteenth century, its survival of the war with the League of

Cambrai, an alliance of the major powers of Europe and Italy determined to humble the expanding Republic, and its determined resistance to papal interdict, especially in 1508 and again in 1606.[2] The character of this self-portrait, calm and confident, derived from the celebrated internal political stability of the Venetian republic, founded upon its well-ordered constitution and rule of law. That collective image—of the self-proclaimed Most Serene Republic as an ideal political entity whose ruling patriciate were selflessly devoted to the commonweal—has come to be known as the "myth of Venice."[3]

The relevant dictionary definition of myth here is "the fictions or half-truths forming part of the ideology of a society." The myth of Venice represents a composite of a number of related such "fictions or half-truths" that the Republic invented of and for itself—its origins and legitimacy, its divine favor and holy purpose—and those myths came to be figured in a corresponding number of icons. The first of these was the image of the city itself, miraculously rising out of the waters of the lagoon. The others were figures symbolic of the Republic: its patron saint, the evangelist Mark, and the winged lion that stood for him, and then the regal personification of Venetia herself, Queen of the Adriatic.

The personified Venetia in particular came to epitomize in a single figure the virtues of the Republic, embodying the special qualities claimed for the state itself. An anatomy of this concentrated manifestation of the iconography of the myth of Venice reveals some of its many dimensions, the complexity of its genesis, and the referential range inherent in the forms of her self-presentation. Yielding a clearer understanding of the myth, such an exploration will also elucidate the nature and operations of such imagery. In isolating the individual elements that collectively constitute this image of Venice, we will want to consider the degree to which they continue to resonate separately, necessarily recalling their origins even as they participate in the formulation of a new visual and ideological construct. We will want to test the subsequent reception of such figuration and consider to what extent such later response and commentary offer a legitimate reflection of original or intended meaning. And this takes us to the heart of the matter: the ways in which an image signifies, the dimensions and reach of its meaning.

Several individual elements contribute to the Renaissance compound of

*Venetia figurata.* Each of them draws upon an independent tradition of its own; each contributes a particular aspect to the new construct, a set of values as well as of visual possibilities. The main constituents of the figure of Venice that will interest us include a rather interesting range of models: from the figure of the Virgin Mary and the personification of the cardinal virtue of Justice to the pagan figures of the goddess Roma and of Venus, the goddess of love.[4] The very possibility of figuring Venice depended upon the special nature of that polity. Personification was possible only on the basis of an essential precondition: the abstract concept of the state.

Out of the facts and fictions of its history, the Republic of Venice wove the fabric of propaganda that represents the essence of the myth of itself: an ideally formed state, miraculously uniting in its exemplary structure the best of all governmental types—that is, monarchy, oligarchy, and democracy—and, most significantly, institutionalizing this harmonic structure in a constitution that was to inspire other nations for centuries.[5] True, political activity was restricted to a small ruling class definitively circumscribed by the end of the thirteenth century, a patriciate comprising those families whose previous governmental participation and service to the state had qualified them for such "nobility." These families—that is, their males over the age of twenty-five—constituted the Maggior Consiglio, the Great Council that represented the democratic base of the government. From the Great Council were elected the members of the Senate, the oligarchic component. At the top of this pyramidal organization was the doge, the monarchic element. Elected for life (and usually late in life) through a balloting process of truly Byzantine complexity, the doge was the symbolic embodiment of the Venetian state; his power, however, was severely restricted as Venice zealously guarded its republican virtue against potential tyranny or dynastic aspiration.

With its governmental structure and operations fixed in its celebrated constitution, Venice came to stand for the very idea of the state, an ideal abstraction reified and functioning on earth. It was the rule of law that maintained the serenity of this polity. The very survival of the Republic for well over a millenium seemed proof of its privileged status among nations. A sovereign state, unconquered—until 1797, when it finally surrendered its independence to Napoleon—Venice celebrated its own immutability, remaining secure in its lagoon fortress and in the righteousness of its

institutions, the guaranteed and absolute rule of law that made it the paragon of justice in the eyes of the world.

Venice was a maritime republic of merchants. Its wealth and power, and its cosmopolitanism, derived from its commercially strategic position between East and West. Essential to the successful conduct of commerce was the guarantee of law and order, as Shakespeare's Antonio testified from the London stage:

> The duke cannot deny the course of law;
> For the commodity that strangers have
> With us in Venice, if it be denied,
> Will much impeach the justice of the state;
> Since that the trade and profit of the city
> Consisteth of all nations.
>
> *The Merchant of Venice,* III.iii

As we shall see, after the Venetians themselves, the English played a special role in broadcasting the myth of Venice; they spread the pollen of Venetian propaganda throughout the seventeenth century, when they—like the Dutch—were in active search of laudable and practical political models.[6] And it was the English who gave most poetic voice (Wordsworth's) to the lamentation over the demise of the Most Serene Republic and who supplied the enthusiastic pen (Ruskin's) that would do so much to resurrect the memory of that ancient grandeur and actively urge its restoration.[7]

Historians have long recognized the gap between the myth and the reality of Venice. They have been anxious to reveal the contradictions and hypocrisies and to use such exposures to undermine the myth, to deconstruct it and indict it as deliberately misleading fabrication.[8] But it is precisely as a set of "fictions or half-truths" that myth presents itself as reality, "forming part of the ideology of a society." What for the skeptical political or social historian may seem collective self-deception can be viewed more positively and creatively as deliberately conceived self-representation. And it is that self-imaging, the formal visualization of political ideal, that becomes the legitimate object of study for the art historian. The images themselves come to represent the reality of the myth itself, an artistic incarnation of a political ideal.

Images, especially those developed as communal expressions, carry with them an aura—not exactly in Walter Benjamin's sense of the term, which relates to the uniqueness of a work of art, but rather aura as that emanation of potential meanings sensed by a public defined by shared values: in this case, the Venetian public that naturally read the figural equations of Justice = Venice or Virgin = Venice or lion = St. Mark = Venice, or the interpretive complex of Solomon, Justice, and Wisdom as embodying the highest virtues of their Republic. These are some of the motifs and themes that give form to the myth of Venice and, in their collective complexity and fluidity—what we may call their iconographic slippage—constitute the subject of this book.

# I

## MIRACULOUS BIRTH

Unique in its site, built upon the mud flats of a lagoon, rising above the waters, Venice rhetorically exploited every aspect of its singularity (plate 1, fig. 1). Unwalled, its defense lay in its surrounding waters: the delicate defenselessness of the Ducal Palace (fig. 2) contrasts tellingly with, for example, the heavily fortified Palazzo Vecchio of Florence (fig. 3). Unlike so many cities on the Italian peninsula, Venice was not of ancient Roman foundation, and it made much of that distinction. Emerging after the collapse of the Roman Empire, Venice claimed to be the first republic of the new era, born in Christian liberty, hence a true historical successor to pagan Rome. Originally subject to the authority of Byzantium, Venice gradually asserted its independence of and, eventually, superiority to Constantinople. On the western front, central to the historico-political elements constituting the myth of Venice, were events of 1177, when Doge Sebastiano Ziani (1172–78) mediated peace between Pope Alexander III and Emperor Frederick Barbarossa: from that moment on, according to the local historical vision, Venice stood on the political stage of Europe as a third sword, an equal to the Roman Catholic Church and the Holy Roman Empire. Beginning in the fourteenth century, those events were depicted in a series of pictorial cycles in the Ducal Palace, recorded in manuscript illuminations, repainted in the fifteenth century, and preserved for us now in the canvases painted after the disastrous fire of 1577. However dubious the historical facts and their interpretation, the paintings themselves became in turn the verifying documents, pictorial scripture: as it is painted so it was.[1]

In the mid-fourteenth century, the myth of Venice refined itself rhetorically; its public self-assertion acquired a new, humanistic resonance, enunciated by the most eloquent cultural voice of Italy, Petrarch himself. The great Tuscan poet was prepared to trade his precious library for the intellectual liberty offered by the Serenissima. In 1364 he celebrated his host's swift conquest of Crete with an epideictic vocabulary that was to condition Venetian oratory for centuries. Rejoicing with "the most august city of Venice," Petrarch hailed it as

> today the one home of liberty, peace, and justice, the one refuge of honorable men, haven for those who, battered on all sides by the storms of tyranny and war, seek to live in tranquility. Rich in gold but richer in fame, built on solid marble but standing more solid on a foundation of civic concord, surrounded by salt waters but more secure with the salt of good council . . . , Venice rejoices at the outcome, which is as it should be: the victory not of arms but of justice (*Epistolae seniles*, IV.3).

The rhetoric of revived Latin has been reharnessed to the celebration of state. Exalting the uniqueness of the city, its marvelous site and even more marvelous liberty, acclaiming its identity with divine justice, Petrarch's letter further established basic tenets of the myth and quite naturally became a scriptural text in Venetian apologetic literature of the Renaissance. "Even in our age," Petrarch continued, "fraud yields . . . readily to fortitude, vice succumbs to virtue, and God still watches over and fosters the affairs of man."[2]

God's intervention in the affairs of man was manifest in the spectacular city that He caused to rise from the waters; in the words of Gasparo Contarini, the most influential Venetian apologist of the sixteenth century, the city seemed "framed rather by the hands of the immortal gods, than in any way by the art, industry, or invention of men," a miracle left on earth to be discovered by mortals.[3] It seemed impossible—indeed, was deliberately made to seem impossible—to separate the uniqueness of its legal constitution from the singularity of its physical site, a miracle on earth. The very vision of its wondrous self was an integral part of the powerful image of Venice: *Venetia, Venetia, chi non ti vede non ti pretia.* By the middle of the sixteenth century, this traditional proverb was being Englished as "Venice, he that doth not see thee doth not esteeme thee." And the commonplace was

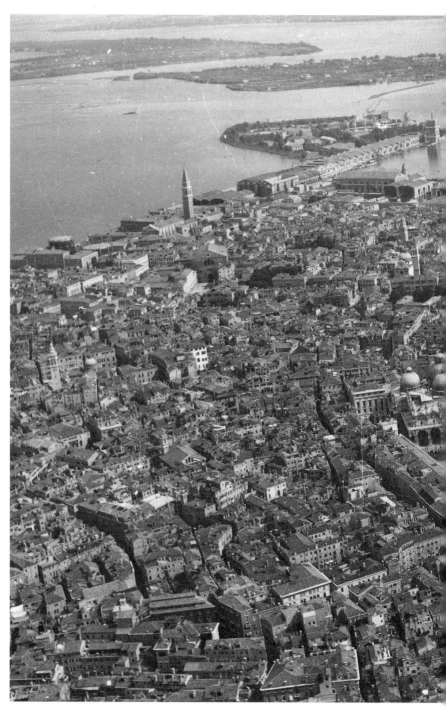

FIGURE 1: Aerial view of Venice (Photo: Böhm).

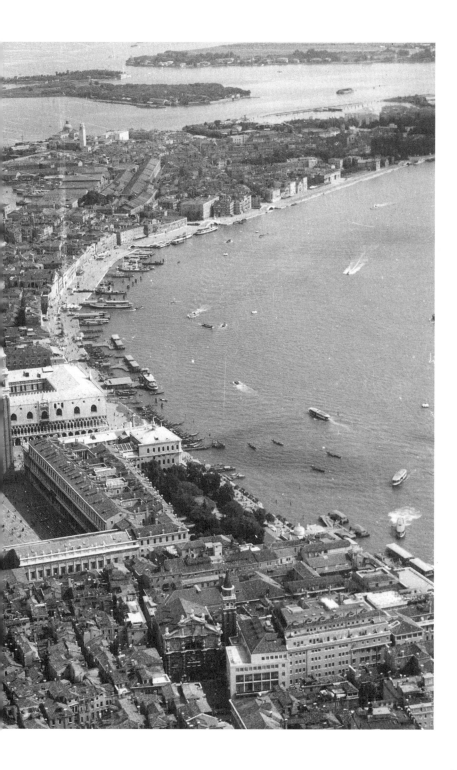

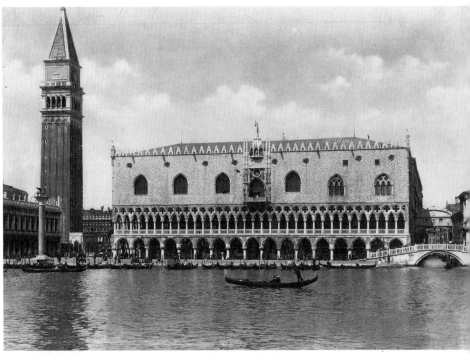

FIGURE 2: Ducal Palace, south facade (Photo: Böhm).

even broadcast from the Elizabethan stage, as Shakespeare's schoolmaster
Holofernes in *Love's Labour's Lost* (IV.ii) proclaims, "as the traveller doth of
Venice: — *Vinegia, Vinegia, chi non te vede, ei non te pregia.*" Some version of the
proverb had reached England already by 1542, the date of Andrew Borde's
*The First Boke of the Introduction of Knowledge*: "Whosoever that hath not seene
the noble citie of Venis hath not seene the beewtye and ryches of thys
worlde."[4] A century later, another Englishman, James Howell, summarizes
this sentiment in his *Survay of the Signorie of Venice*: "the Eye is the best Judg
of Venice."[5]

Such an anthology of English response testifies to the success of the Ve-
netian self-advertising campaign, which took full advantage of new tech-
nology in the second half of the fifteenth century as Venice very quickly
appropriated the recently invented printing press and astutely turned itself
into the printing capital of Europe. She did so in part by creating the copy-
right privilege, attracting publishers by guaranteeing protection of their in-
vestment and thereby encouraging some of the most remarkable graphic

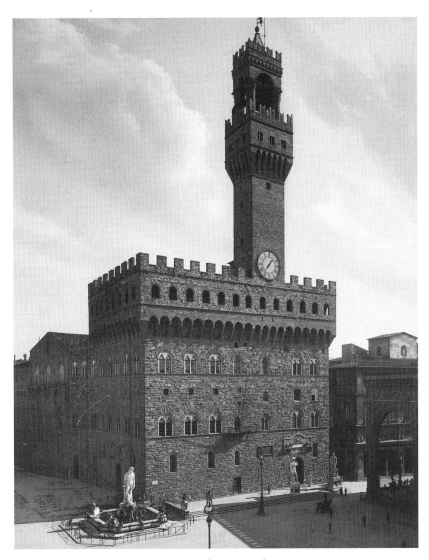

FIGURE 3: Palazzo Vecchio, Florence (Photo: Brogi).

initiatives.[6] On October 30, 1500, Anton Kolb, a German merchant resident in the city, was granted a four-year privilege for a monumental woodcut view of Venice (fig. 4). Designed by Jacopo de' Barbari and realized with the aid of a team of surveyors, the full image, printed from six blocks, measures some nine feet across.[7] In addition to copyright protection, the publisher requested exemption from all duties and license to sell the print, at a price of three ducats, throughout the Venetian domain—which by

1500 had attained its maximum extension into the terra firma. In his petition Kolb declared that he had undertaken this difficult project "principally to the fame of this sublime city."[8] Private enterprise served public policy in disseminating the image of the miraculous city, a center of commerce based upon its maritime power. Part view, part plan, Jacopo de' Barbari's bird's-eye rendering appropriately emphasizes along its vertical axis the main operational centers of Venice: the religious and governmental core around the piazza, centered in the ducal basilica of San Marco and the contiguous Ducal Palace, and, proceeding north along the Merceria, the commercial hub at the Rialto.[9] The figures marking that axis, and their inscriptions, further declare Venice a city favored by the gods: by Mercury (fig. 5), who "shines favorably on this above all other emporia" (as proclaimed by his inscription: MERCVRIVS PRECETERIS HVIC FAVSTE EMPORIIS ILLVSTRO), and by Neptune (fig. 6), who, "smoothing the waters of this port," makes Venice his home (AEQVORA TVENS PORTV RESIDEO HIC NEPTVNVS).

These classical deities represent a Renaissance humanist gloss on a venerable tradition of divine favor, a paganized inflection of a Christian tradition. According to standard legend, Venice was founded on March 25, the date of the Annunciation. On that day in the year 421, with the foundation of the church of San Giacomo di Rialto, the first stone laid in the lagoon, Venice was born. Upon the ruins of the fallen empire of Rome, abandoned by Constantine and destroyed by barbarian invasions, a group of devout refugees from the mainland established on these mud flats the first republic of the new, Christian era. Going back at least to the twelfth century, the identification of March 25 as the birthday of Venice was subsequently elaborated in ways that exploited its fullest resonance. By the end of the fifteenth century, the range of associations extended from the astrological ascendancy of Venus to the day of the creation of Adam and of the crucifixion, as well as conception, of Christ.[10] In his *De origine urbis Venetiarum* (posthumously published in 1493) Bernardo Giustiniani summed up the tradition, giving it further humanistic sanction:

> . . . the sacrosanct day [March 25] was chosen on which the divine message was brought by the Archangel to the most glorious Virgin with the indescribable bending of the celestial highness to the abyss of humility.

It was then that the highest and eternal wisdom, the Word of God, descended into the womb of the most chaste Virgin so that man, lying in the depths of pitiable darkness, might be raised to the most joyful society of celestial spirits. But indeed, there is no measure to the divine wisdom. For He Who, on that day, in choosing the Virgin for the redemption of the whole human race, looked especially towards her humility . . . , wished also that on the same day, in a most humble place and from most humble men, a start should be made toward the raising of this present Empire, a beginning of so great a work.[11]

More than a new Rome or a new Constantinople, Venice was a new Jerusalem, a city beloved of God, who caused her to rise from humble mud, resplendent, above the waters, a beacon of Christian liberty.[12] The Roman Empire had been destroyed by the barbarian tribes; pagan might was fallen, and God in his infinite wisdom saw to a proper, Christian succession. On March 25 began as well the new era of political grace. As the Archangel Gabriel had announced the conception in the womb of the Virgin Mary of a Savior to redeem humanity from Original Sin, so did God assure the political salvation of mankind through the foundation of this Christian republic on the very same date. Thus did the Feast of the Annunciation become an integral part of the state calendar. A celebration (like all such feasts in Venice) at once religious and patriotic, it was an occasion for an official *andata in trionfo*, the triumphal procession of the doge and Signoria, on the feast that came to be known as the Madonna di Marzo. March was a month recognized by all ancient cultures as the beginning of the new year, the season of renewal, spring time, when "the world puts on new colors, refreshing its lost beauty," as Francesco Sansovino sang of "la natività di Venetia."[13]

The referential and allusive range of this discourse introduces us to the kind of expansive resonance that informs the languages of Venetian self-description, languages both visual and verbal. Like so many medieval communes, Venice adopted the Virgin Mary as special patroness. But more than, say, Florence or Siena, Venice subtly but aggressively appropriated the image of the Virgin for its own self-representation. That appropriation begins with the Venetian identification with the Annunciation, that date in March that saw the conception of a divine savior and, four

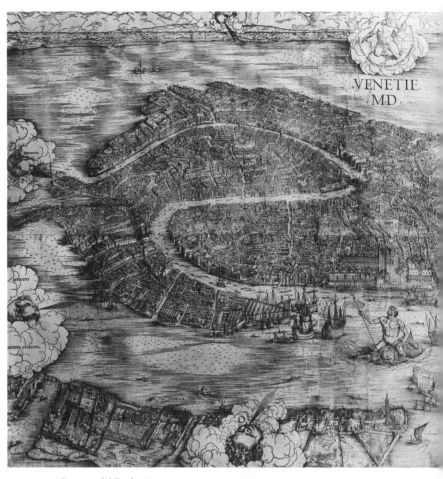

FIGURE 4: Jacopo de' Barbari,
*View of Venice* (woodcut). Museo Civico
Correr, Venice.

FIGURE 5: Jacopo de' Barbari,
*View of Venice*, detail: Mercury.

14

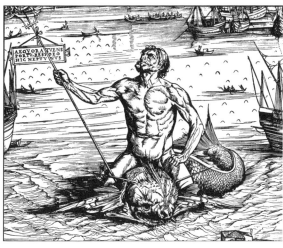

centuries later, the foundation of a political savior. Perhaps no image makes the point as succinctly as the representation of the Annunciation painted in the 1540s by Bonifacio de' Pitati for the Camera degli Imprestidi, the state bond office, in the Ducal Palace (fig. 7).[14] Originally a unified triptych, its central field depicts God the Father and the Holy Spirit soaring above Piazza San Marco: Venice thus participates directly in the theological mechanics of salvation, simultaneously hosting and sharing in the moment of the Incarnation, and thereby receiving its own peculiar divine sanction.

The appropriation of the Annunciation on behalf of Venice found monumental expression long before Bonifacio's painting. In the thirteenth-century sculptural decoration on the facade of San Marco (fig. 8) a mix of trophies, spoils, copies, and original pieces were adapted to create a public display of holy protectors of the Republic. Of the six main reliefs, the two toward the south are of immediate relevance: one represents the figure of the Virgin Orans (fig. 9), that is, standing with both arms raised in an attitude of prayer; the other, an Archangel clearly inscribed as Gabriel (fig. 10). While they were evidently conceived as independent figures, posed frontally and in no way dramatically interactive, their very juxtaposition inevitably invokes the Annunciation. The theme was more deliberately stated in a subsequent sculptural campaign. In the late fourteenth century the Byzantine arches of the facade received a Gothic elaboration of florid ogives, crowning sculpture, and aediculae; early in the fifteenth century the corner aediculae became mansions for the two protagonists of the Annunciation, both appropriately kneeling (figs. 11, 12). Their holy dialogue across the upper reaches of the basilica continues to reverberate in the Piazza.[15] Finally, before it was enclosed in the first years of the sixteenth century to become the funerary chapel of Cardinal Giambattista Zen, the entrance portal on the southern facade of San Marco, that facing the *bacino*, the body of water before the Piazzetta, and therefore gracing the primary public entrance to the city, evidently featured in its lunette a dialogue of the Annunciation—recorded in Jacopo de' Barbari's woodcut of 1500. Nor was monumental display of the Annunciation confined to the governmental and religious center of San Marco; toward the close of the sixteenth century it extended to the very seat of Venetian commerce and international trade, the Rialto (fig. 13): across the graceful arch of the late

FIGURE 7: Bonifacio de' Pitati, *Annunciation*. Gallerie dell'Accademia, Venice (Photo: Soprintendenza ai Beni Artistici e Storici di Venezia).

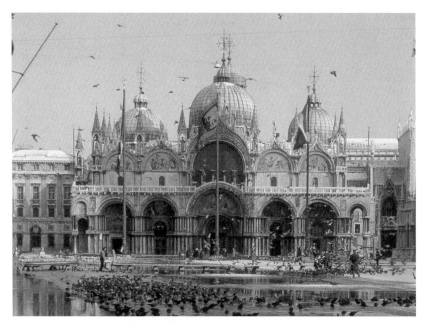

FIGURE 8: San Marco (Photo: Author).

sixteenth-century Rialto Bridge, the Archangel Gabriel hails the Virgin Mary (figs. 14, 15).[16] The Rialto itself was sacred civic ground, the very site on which Venice was born with the foundation of the first Christian church in the lagoon.

Programmatically most deliberate in harnessing the Annunciation to the needs of state is Guariento's fresco of the *Coronation of the Virgin* (fig. 16), which once dominated the tribune wall of the Sala del Maggior Consiglio in the Ducal Palace—and was seriously ruined but not totally destroyed in the fire of 1577. The mural was executed shortly after 1365, that is, in the years immediately following Petrarch's epistolary celebration of the Republic as a manifestation of divine intervention in the affairs of men. Set above the ducal throne in the great council hall, Guariento's depiction of the celestial Paradise quite literally placed the government of Venice under the protection of the Virgin Mary. Such an invocation was hardly unique to Venice; as noted earlier, the special patronage of the Virgin was claimed by most Italian communes, and her image graced many a council hall—most famously, perhaps, the Palazzo Pubblico of Siena, with Simone Martini's *Maestà* (1315). Guariento's fresco assumes a particular complexity,

however, for flanking the architecture of the community of saints in this heavenly Jerusalem were two painted aediculae that housed the Archangel Gabriel and the Virgin Mary (fig. 17). The central theme of the fresco, the regal reception of Mary as Queen of Heaven, is marginally glossed by the origin of that divine favor conferred on the humble maid: the Annunciation. To Venetian eyes, such a representation within the political context of its setting would naturally recall the birth of the Republic.

The architectural definition of Paradise, the Heavenly Jerusalem, standard in medieval visualizations of the celestial city, establishes its direct relevance as a model for the city of man, more particularly, for this city. And the celestial harmony that governs the city of God, sounded by music-making angels, extends itself to the governance of man, more particularly, to the harmony that reigns (ideally) among the ruling patriciate of Venice gathered in this great council hall.

Following the fire of 1577, and after much competition, Guariento's ruined fresco was eventually replaced by the vast canvas designed by Tintoretto (figs. 18, 19). The architecture of Heaven is here transformed into concentric arcs of holy figures, a Renaissance figuration of the celestial spheres—a motif that more clearly structures Tintoretto's earlier modello, now in the Louvre (fig. 20). In essential ways, however, Tintoretto's *Paradise* maintains the traditional iconography, as Christ greets His Mother, Queen of Heaven, she already radiating her Apocalyptic crown of stars (plate 2). His grander radiance proclaims him Sol Iustitiae, the "Sun of Righteousness," He who "shall be inflamed when exercising supreme power, that is to say, when He sits in judgment."[17] Mary's humility before her Son evokes her role as mediator on behalf of humanity on the Day of Judgment, her appeal that His justice be tempered with mercy. To either side of the divine couple, two Archangels inflect the political significance of this heavenly court: accompanying the Virgin is Gabriel, bearing the lilies of her purity, sign of the Annunciation; approaching Christ from the other side is Michael, sergeant at arms at the Last Judgment, with the sword and scales of justice. Along the central axis of the painting, the luminosity of divine grace rains directly upon the doge of Venice enthroned below, a perpetual sign of the heavenly favor of the Republic he represents.[18]

The pairing of the Archangels Michael and Gabriel in Tintoretto's *Paradise* finds a particularly revealing precedent in a triptych painted by Ja-

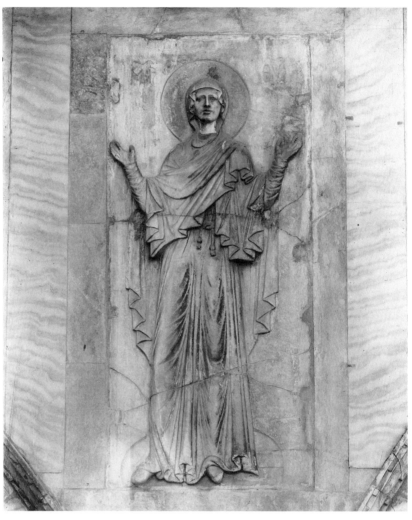

FIGURE 9: *Virgin Orans*. San Marco, west facade (Photo: Böhm).

cobello del Fiore in 1421 for the Magistrato del Proprio, the judges con-
cerned primarily with property disputes (plate 3). Consideration of this
panel leads us further into the associative mechanics of personifying Ven-
ice herself. The crowned figure of Justice is seated upon a leonine throne
of Solomonic implications; she is flanked by the two Archangels: to her
right, on which side she holds the sword of punishment, stands Michael,
triumphant over the dragon of Satan and Evil; on her left, the side of the
scales of judgment, Gabriel approaches, significantly gesturing to the regal

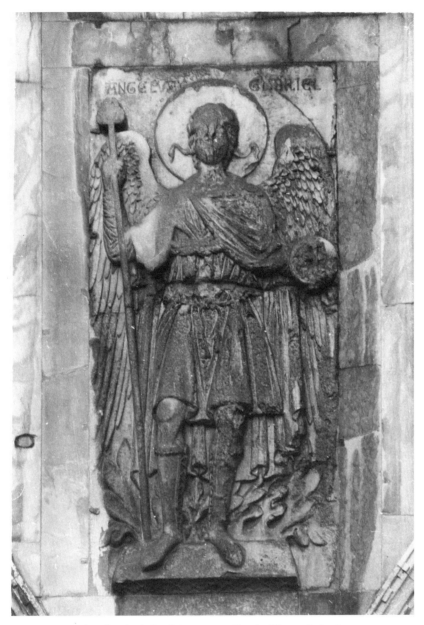

FIGURE 10: *Archangel Gabriel.* San Marco, west facade (Photo: Böhm).

FIGURE 11: *Archangel Gabriel.* San Marco (Photo: Böhm).

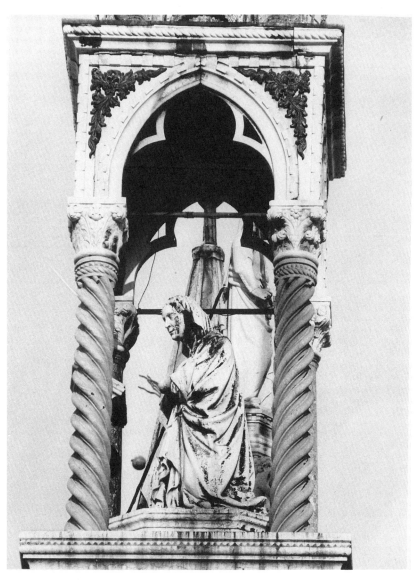

FIGURE 12: *Virgin Annunciate*. San Marco (Photo: Böhm).

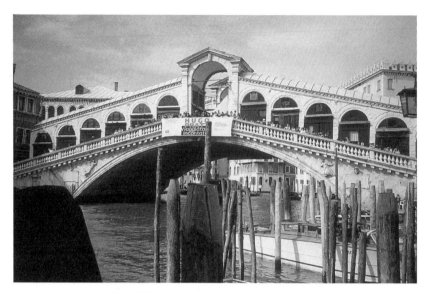

FIGURE 13: Rialto Bridge (Photo: Author).

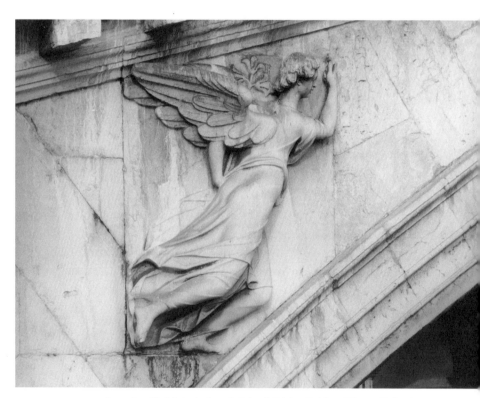

FIGURE 14: Agostino Rubini, *Archangel Gabriel*. Rialto Bridge (Photo: Böhm).

woman. The inscription behind her declares that she "abides by the angels' admonitions and holy words." Michael, traditional guardian of divine (and ultimate) justice, urges her to reward or punish according to merit, to "commend the purged souls to the benign scales." Gabriel, who exhorts her to lead humanity through the darkness, is explicitly identified as the "announcer of the virgin birth of peace among men."[19]

The two lions bracketing the throne of Justice allude to the gilded throne of Solomon the wise judge (1 Kings 10:18–19 [3 Kings in the Vulgate]), the sanctified seat of Justice and of Wisdom. As Sedes Sapientiae, the throne of Divine Wisdom, it came to be identified with the body of the Virgin Mary, the support of the Incarnate Word of God.[20] And, as Jacobello's triptych makes clear, that throne was ultimately inherited—or, better, appropriated—with all its accumulated meanings, by Venice herself. Moreover, the convenient coincidence of the leonine decoration with the beast of St. Mark offered to Venetian iconography a special set of

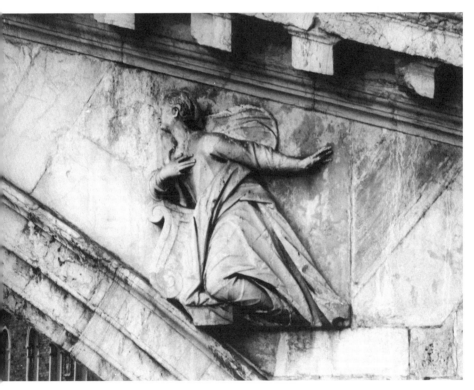

FIGURE 15: Agostino Rubini, *Virgin Annunciate*. Rialto Bridge (Photo: Böhm).

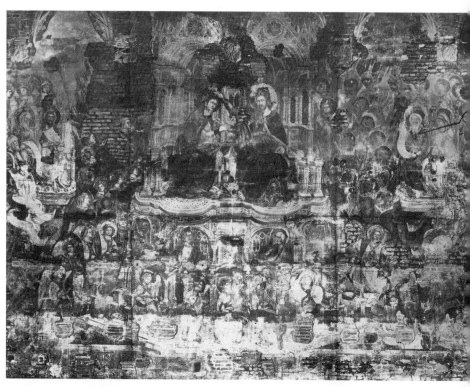

FIGURE 16: Guariento, *The Coronation of the Virgin (Paradise)*. Ducal Palace (Photo: Böhm).

possibilities, of correspondences and cross-references, and a new range of resonance.

In imagining her own figure, the Republic of Venice identified her personified self with the virtue of Justice. The identification of the cardinal virtue with the state was a fairly standard topos in the world of the mediaeval commune—and we need look no further than Ambrogio Lorenzetti's fresco in the Palazzo Pubblico of Siena for monumental testimony of this. However, whereas the Sienese invoked the virtue on behalf of their state, the Venetians effectively fused the two. As the traditional representation of Iustitia became the prime model for the figure of Venetia herself, the two merged into a single identity: Venice *is* Justice.

This identity finds early monumental and official manifestation in a roundel of the Ducal Palace, datable to the mid-fourteenth century (fig. 21).[21] Clearly labeled *Venecia*, she is imagined as a regal matron flanked by

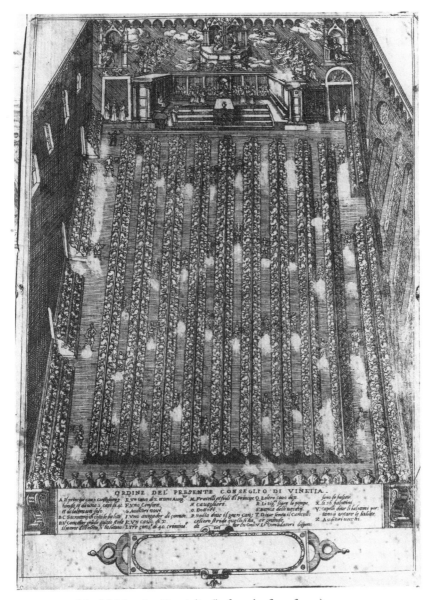

FIGURE 17: Sala del Maggior Consiglio (before the fire of 1577),
anonymous sixteenth-century engraving. Museo Civico Correr, Venice.

FIGURE 18: Sala del Maggior Consiglio, Ducal Palace (Photo: Alinari).

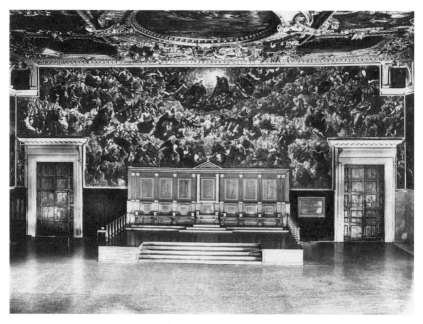

FIGURE 19: Jacopo Tintoretto, *The Coronation of the Virgin (Paradise)*.
Sala del Maggior Consiglio, Ducal Palace (Photo: Böhm).

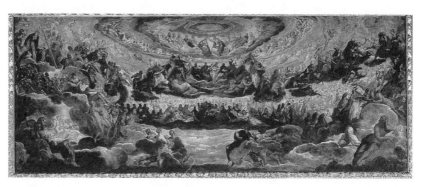

FIGURE 20: Jacopo Tintoretto, *The Coronation of the Virgin (Paradise)*.
Musée du Louvre, Paris.

two lions, seated in triumph above the waves on a Solomonic throne; beneath her feet writhe two vanquished prisoners, whose gestures suggest the vices Ira and Superbia, wrath and pride. In her right hand she holds the sword of Justice, in her left a scroll declares her victorious over the furies, whose costumes in turn suggest civil discord and military threat. The in-

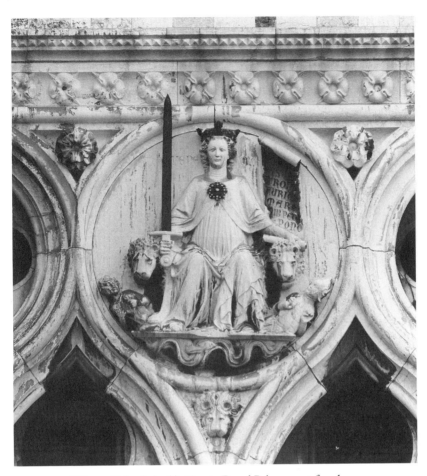

FIGURE 21: Filippo Calendario (?), *Venecia*. Ducal Palace, west facade
(Photo: Böhm).

scription, FORTIS / IUSTA / TRONO / FURIAS / MARE / SUB PEDE / PONO,
translates as "Strong and just, enthroned I put the furies of the sea beneath
my feet." The maritime dimension of this triumphant figure confirms her
identity as Venice herself, ruler of the Adriatic.[22] Given her prominent lo-
cation on the west facade of the Ducal Palace, facing the Piazzetta (fig. 22),
the facade generally referred to as "dalla Giustizia," the label is indeed nec-
essary to distinguish this figure of Venice from her virtuous prototype,
Iustitia—as she is labeled (fig. 23) above the Porta della Carta (plate 4).
Visually, only the absence of scales signals this distinction, and that ab-
sence accords still greater weight to the sword: Justice here is retributive.[23]

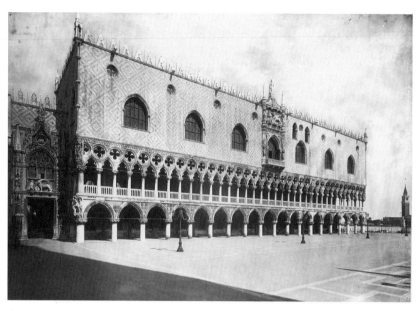

FIGURE 22: Ducal Palace, west facade (Photo: Böhm).

In the Ducal Palace *Venecia*, the basic formal construct and figural type of the personified virtue have been inflected to make a new statement, but the originating construct and type remain very much in evidence, and their continuing felt presence guarantees that their significance inheres in the new image. The transformation is an interesting one, for its visual operation reveals the Venetian political imagination at work, capitalizing upon the possibilities of its own propaganda. Justice was, understandably, the chief virtue claimed by the state, and the iconography of Justice dominates the public facades of the Ducal Palace, making it a new Palace of Solomon.

Once established, the figure of Venetia/Iustitia assumed canonic status. Its individual components, however, always retained something of their original, distinctive significance, never being totally subsumed into the new entity. The image itself remained most usefully ambivalent; it functioned quite deliberately and fluently as a composite. Most often with both sword and scales, the figure was generically recognized as Venice figured as Justice: "una Venetia in forma di Giustizia." The sculptures articulating the surfaces and silhouettes of the Ducal Palace reiterate that theme, which is punctuated by the figures, added by Alessandro Vittoria in 1579, crowning

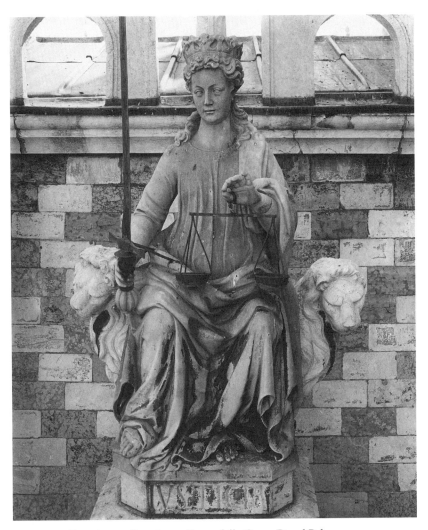

FIGURE 23: Bartolomeo Bon, *Justice*. Porta della Carta, Ducal Palace
(Photo: Böhm).

each of the facades: a personification of Justice over the monumental bal-
cony on the Molo (fig. 24) and, crowning the balcony on the Piazzetta, a
sceptered Venice (fig. 25). Inscriptions and attributions may distinguish
these regal women as Iustitia or Venetia, but the public statement unam-
biguously depends upon their ambivalent resemblance: Venice *is* Justice.

Returning to Jacobello's panel (plate 3), it is in this context of deliber-
ate ambiguity that the Archangel Gabriel's presence becomes resonantly

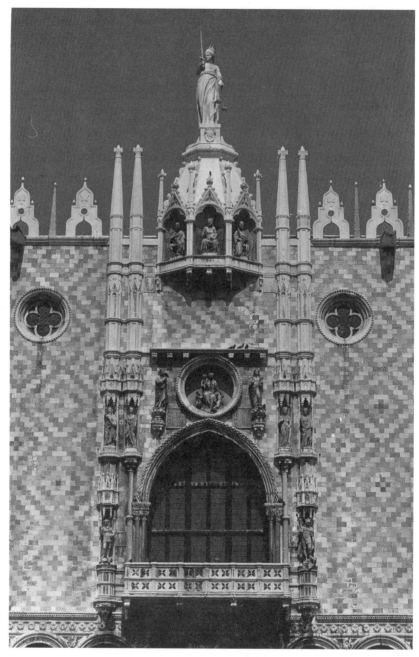

FIGURE 24: Ducal Palace, south facade, detail (Photo: Böhm).

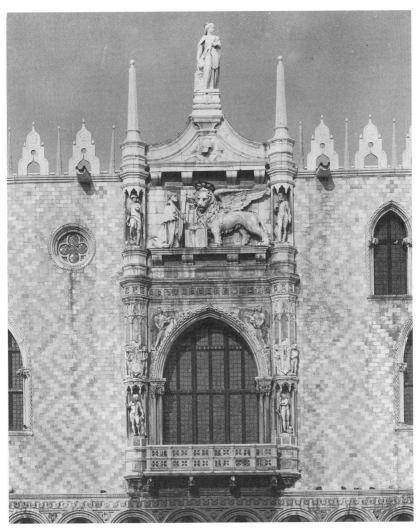

FIGURE 25: Ducal Palace, west facade, detail (Photo: Böhm).

significant. The heavenly messenger, companion of the Holy Spirit and announcer of the Incarnation, is, of course, traditionally associated with the Virgin Mary. And that association is pointedly acknowledged in Jacobello's painting: bearing the lily that is his attribute through his role in the Annunciation, the Archangel assumes a pose of direct address that intentionally evokes that role. His addressee, however, is ostensibly a different virgin, the virgin goddess of Justice. To appreciate the full historical resonance of that figure, we need only recall the Virgo Astraea of Virgil's mes-

sianic fourth Eclogue. The return of Justice to the world signals a new golden age, here being claimed by and for Venice herself. Gabriel's position in the picture and the allusions of his text encourage the kind of associative ambivalence that was central to the Venetian iconographic imagination. The Annunciation scene played out in Jacobello's panel automatically conflates those earlier events of March 25: the theological Incarnation that initiated the new era of Christian grace and that political incarnation of the four-hundredth-and-twenty-first year of that era, the foundation of Venice. The panel, in fact, is dated 1421 and thus commemorates, intentionally or not, the Republic's millennial birthday.

The calendrical parallel quite naturally invited analogies of a vaguer and yet ultimately more effective kind. In its own evolving political litany, Venice increasingly likened itself to the Virgin Mary, and the doctrine of the Immaculate Conception afforded a convenient rhetorical base for this. In a prayer for the doge, dating back to the twelfth century, we find the declaration that God himself had wonderfully arranged the Venetian Republic *ab eterno*: "qui dominium venetum ab eterno mirabilitur disposuit."[24] Such rhetoric, hyperbole bordering on blasphemy, ostentatiously developed on the basis of the Marian liturgy—and on the Old Testament Wisdom texts that underlay that liturgy—was to become standard in Venetian panegyric literature.

The divine origins of the city of Venice were well known. Only divine intervention in the troubled affairs of men could account for the ideal perfection of her constitution, which was itself an imitation on earth of the celestial harmonies. Envoys of the subject cities of the Venetian empire especially embroidered this imagery of the "divine republic" in their formal orations before the Signoria, acknowledging Venice as "a worthy image of divinity that one never invokes in vain, and revered by everyone as a sacred thing on earth to be worshipped, were this permissible."[25] The printing presses of Renaissance Venice assured the broadcast of such texts.

More explicitly historical and with more obvious visual potential was the assertion of the virginity of Venice. "Venetia Vergine" became another common topos, for "with her uncorrupted purity she defends herself against the insolence of others," as Francesco Sansovino explained, recording a commonplace.[26] Indeed, one of the marvels of Venice was her long survival intact, the sheer duration of her independence, her freedom from

foreign domination. An understandable source of pride to the Venetians, that phenomenon did not fail genuinely to impress the rest of Europe. In 1497, for example, the German knight Arnold von Harff was in the city for the Festa della Sensa, the Ascension Day celebration of the marriage of Venice to the sea, and he recorded in his diary the following description of the ceremony and the Bucintoro, the ducal galley:

> Item on Ascension Day the Doge celebrates a festival each year before the haven on the high sea. He then throws a golden finger-ring into the wild sea, as a sign that he takes the sea to wife, as one who intends to be lord over the whole sea. Item the ship in which he celebrates is a small stately galley, very splendidly fitted out. In front of this ship is a gilt maiden: in one hand she holds a naked sword and in the other golden scales, a sign that as the virgin is still a maid, so the government is still virgin and was never taken by force. The sword in the right hand signifies that she will do justice: for the same reason the maiden holds the scales in the left hand.[27]

Here we have clear testimony to the effectiveness of Venetian propaganda, visual as well as literary. The message has been well comprehended by those to whom it was addressed. And it continued to echo in the poetic imagination that lamented the fall of the Republic—Wordsworth "On the Extinction of the Venetian Republic" (1807):

> Once did She hold the gorgeous east in fee;
> And was the safeguard of the west: the worth
> Of Venice, the eldest Child of Liberty.
> She was a maiden City, bright and free;
> No guile seduced, no force could violate;
> And when she took unto herself a Mate,
> She must espouse the everlasting Sea.

Whereas the doge in casting a gold ring into the sea declared, "We espouse thee, O sea, as a sign of true and perpetual dominion," affirming the Republic's (masculine) dominion over the sea, the English Romantic poet, faithful to another aspect of the myth, invokes the maiden city, Venetia Vergine.

Thomas Coryat, an English traveler who published his account in 1611,

begins his extensive commentary on Venice with the following title: "My observations of the most glorious, peerelesse, and mayden city of Venice: I call it mayden because it was never conquered." Returning to the theme later, Coryat writes:

> It is a matter very worthy of consideration to thinke how this noble citie hath like a pure Virgin and incontaminated mayde . . . kept her virginity untouched these thousand two hundred and twelve yeares . . . though Emperours, Kings, Princes and mighty Potentates, being allured with her glorious beauty, have attempted to deflowre her, every one receiving the repulse: a thing most wonderfull and strange. In which respect she hath been ever privileged above all other cities. For there is no principall citie of all Christendome but hath beene . . . at some time or other conquered by the hostile force: onely Venice, thrise-fortunate and thrise-blessed Venice, as if she had been founded by the very Gods themselves, and daily received some divine and sacred influence from heaven for her safer protection, hath euer preserved selfe *intactam, illibatam, sartam tectam*, free from all forraine invasions to this day.

Coryat's concluding lines offer final testimony to the incredible persuasive power of the Venetian propaganda machine of the Renaissance: "and so at length I finish the treatise of this incomparable city, this most beautifull Queene, this untainted virgine, this Paradise, this Tempe, this rich Diademe and most flourishing garland of Christendome." [28]

Throughout the seventeenth century—and on into the nineteenth— the English would carry the banner of St. Mark, especially as they sought to define and defend political positions during their own historical crises. The very title chosen by James Howell in 1651 for his treatise bears witness to the continuing impact of traditional Venetian apologetics: Howell called his book *S.P.Q.V. A Survay of the Signorie of Venice, of Her Admired Policy, and Method of Government, &c.* And his opening lines summarize the basic tenets of the myth of Venice:

> Were it within the reach of humane brain to prescribe Rules for fixing a Society and Succession of people . . . the Republic of Venice were the fittest pattern on Earth both for direction and imitation: This Maiden City . . . had the prerogative to be born a Christian, and Independent

. . . and hath continued above a thousand hot Sommers an intemerat Virgin.[29]

The degree to which Venice herself could exploit such celebratory metaphor in her own political imagery is fully demonstrated in a votive painting by Domenico Tintoretto in the Avogaria of the Ducal Palace (fig. 26). It portrays the Avogadori (the state attorneys) and notary of this magistracy; above them, atop a globe, presented by an angel and accompanied by a figure identifiable as an ecclesiastical virtue and triumphant over figures of strife and envy, a regal Venice receives the blood from Christ's side. Through this direct rapport with the Eucharist, the political figure of Venetia usurps the role traditionally assumed by Ecclesia or Fides, for whom the chalice is a standard attribute. The clearly antipapal connotations of this image suggest that it dates between May 1606 and April 1607, the year of the excommunication of the Venetian government and the papal interdiction of the entire Venetian domain. Without rehearsing the complex background to this most consequential interdict, we need only observe that, despite the papal ban, the government of Venice decreed that all churches remain open and all religious offices continue to be celebrated. The substitution of Venetia for Ecclesia in Domenico Tintoretto's composition becomes, then, a clear pictorial affirmation of the ecclesiastical policy of state.[30]

Venetian defiance of Rome found its most eloquent spokesman in Paolo Sarpi, and the public conflict between church and state excited all Europe—most especially the Protestant centers of the north.[31] It was still a burning issue when Thomas Coryat embarked upon his grand tour in 1608. And we can continue to gauge the effectiveness of Venetian political iconography and propaganda by accompanying this curious Englishman on his visit to the Sala del Maggior Consiglio—which was, he wrote, "the sumptuousest of all, exceeding spacious, and the fairest that euer I saw in my life. . . . Neither do I thinke that any roome of all Christendome doth excel it in beauty." Coryat naturally lavished special praise upon the "wonderfull richly gilt" ceiling and its pictorial fields, making the obligatory comparison with the art of the ancients: "the curiousest painting that ever I saw done with such peerelesse singularity and quintessence of arte, that were *Apelles* allive I thinke it impossible for him to excell it."[32] The specta-

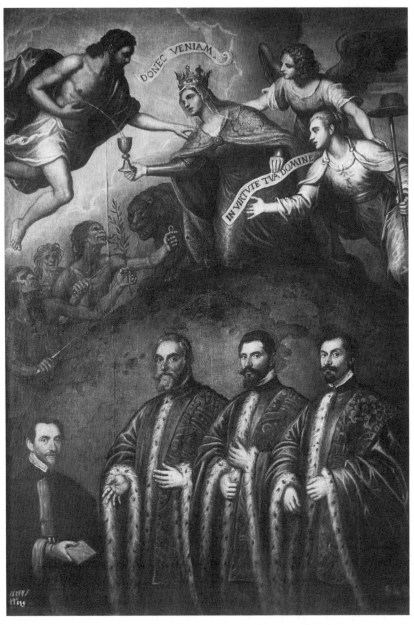

FIGURE 26: Domenico Tintoretto, *Votive Picture of Three Avogadori*. Avogaria,
Ducal Palace (Photo: Fiorentini).

cle of the room was working its intended effect upon the visitor. Venice was showing itself off, and the foreigner was indeed properly impressed.

It was precisely for an audience of *forestieri*, visiting foreigners including Italians, that Venice published a guide to the pictorial decorations in the Ducal Palace, the paintings that replaced and expanded upon those lost in the fire of 1577. The iconographic program was written by Girolamo Bardi, advisor to the patrician inventors; published in 1587, it was reprinted several times into the early seventeenth century.[33] The libretto itself represented a deliberate effort to disseminate the program as such, to offer the scenario of Venetian imperial display to a wider audience of visitors, actual and potential. Although Coryat evidently failed to consult this little guidebook, his misreadings are quite revealing.

Bardi's *Dichiaratione* of the ceiling of the Sala del Maggior Consiglio follows the sequence of the three grand canvases, a central rectangular composition designed by Tintoretto and two ovals by Palma il Giovane and Paolo Veronese. Each of these paintings features a figure of Venetia, and Bardi makes clear that a definite progression is intended, culminating in the canvas over the tribune of the Signoria. The sequence moves from the militant triumph of Palma's Venice victorious, enthroned on earth (fig. 27), through the stately piety of Tintoretto's apparition of Venice descending from heaven to doge and councilors before the church of San Marco (fig. 28), to the joyous celebration of virtue in Veronese's enskied Olympian figure (plate 5). At the base of each composition the progress is from conquered provinces to voluntary allegiance to jubilant thanksgiving for the blessings of Venetian rule.

The visiting Englishman reports that these paintings "especially are passing glorious," and his reading offers an interesting measure of the resonance of such imagery, of the continuing potency of its individual ingredients. Coryat appreciates the secular imperial triumph in Palma's painting of a militant Venice victorious, enthroned above her conquered provinces and crowned by a winged Victory. He recognizes "armed men supporting a Queene on their shoulders, whereby is signified Venice, and the winged Lyon is painted hard by her." And he goes on to describe the "company of naked slaves, with fetters about their legges, and armour and helmets under their feete; whereby are meant the victories and conquests of Venice inthralling her enemies, and bringing them into slavery and captivity." Re-

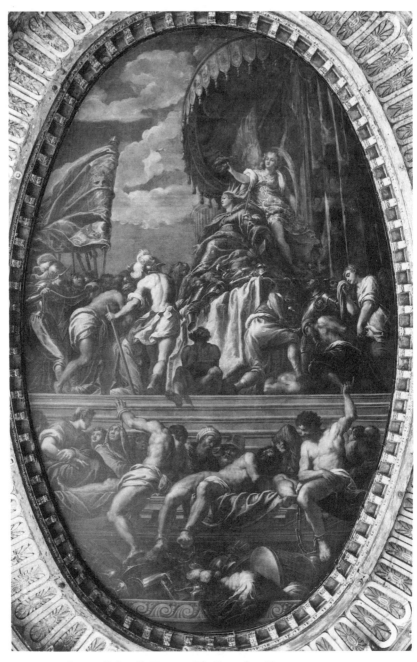

FIGURE 27: Jacopo Palma il Giovane, *The Triumph of Venice.*
Sala del Maggior Consiglio, Ducal Palace (Photo: Böhm).

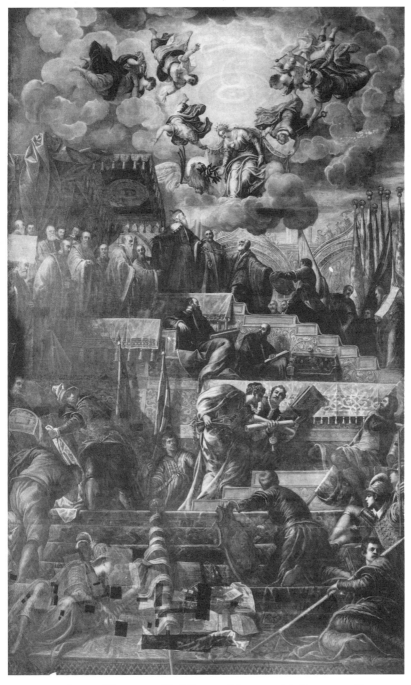

FIGURE 28: Jacopo Tintoretto, *The Voluntary Submission of the Provinces to Venetian Dominion*. Sala del Maggior Consiglio, Ducal Palace (Photo: Böhm).

sponding to the martial tone and detail of Palma's composition, Coryat interprets the triumphant message correctly—however discordant, from a Venetian point of view, the political implications of his final words. Both tone and detail, of course, confirm the acknowledged model for this enthroned warrior queen: the victorious goddess Roma, as she is represented in ancient medals.

In the central canvas, designed by Tintoretto, the figure of Venice, surrounded by pagan deities and nymphs, descends from the empyrean, symbolizing Venetian dominion over land and sea; she and the lion present the doge, Nicolò da Ponte (1578–85), with palm and laurel, signs of victory and honor. Members of the Collegio, the ducal cabinet, accompany the doge, and collectively they represent the Venetian state. Below, subject cities of the *dominio* render spontaneous submission to the Republic. This is the basic outline of Bardi's published program. Coryat's description of the picture is as follows:

> In the next border . . . is represented the Duke in his Ducal maiesty, accompanied with the greatest Senators and Patricians. . . . A little aboue the Duke is painted the Virgin *Mary* . . . with a crowne on her head, attended with two Angels: shee feedes the winged Lyon with a branch of the Olive tree, by which is signified peace.

Coryat assumes, and not inappropriately, that a regal woman in the clouds must be divine. He recognizes the basic structure of the composition: its distinction of heaven and earth and the possibility of mediation between the two realms, the visual semiotics of salvation. The images he surely had in mind are altarpieces and, more immediately at hand in the Ducal Palace itself, votive pictures such as those in the Sala del Collegio and elsewhere in the Ducal Palace.

In Veronese's canvas Venetia achieves her most exalted figuration, the object of spontaneous and joyous adulation of "the peoples ruled by this glorious Republic," to quote Bardi's program. Very much an Olympian Juno, this sceptered queen is crowned with laurel by a winged Victory in full flight. Surrounding her on her cumulus court are allegorical deities described by Bardi as representing peace, abundance, fame, happiness, honor, security, the graces, and liberty.

Coryat's misreading of all this is, again, comprehensible and revealing:

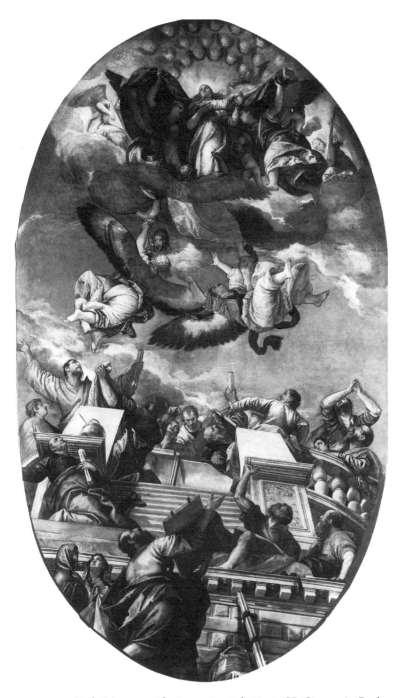

FIGURE 29: Paolo Veronese, *The Assumption of the Virgin*. SS. Giovanni e Paolo,
Cappella del Rosario (from S. Maria dell'Umiltà) (Photo: Böhm).

"In the first of these borders . . . is painted the picture of the Virgin *Mary* in marveilous rich ornaments, with an Angell crowning of her." The system of transference and interpolation that had produced the figure of Venetia personified conditions as well the expectations of the interpreter. Among the individual constituents of the image, the most sacred one emerges as dominant in Coryat's reading. However naive, his interpretation is nonetheless grounded in an essentially accurate, if partial, perception. Without the guidance or context of experience — or Bardi's *Dichiaratione* — and faced with a fundamentally novel kind of image, the visiting Englishman reached out to other, more familiar categories to aid in comprehension. A beautiful woman enthroned in heaven, crowned by a winged creature, and surrounded below by a host of adorers: any Christian might be forgiven for seeing an Assumption and Coronation of the Virgin (fig. 29). And such misprision might not have displeased the patrician authors of this Venetian iconography. By the early seventeenth century much creative effort had gone into demonstrating, by word and picture, the intimate relation between the Queen of Heaven and the Queen of the Adriatic.

# 2

# THE PEACE OF SAINT MARK

*Venetia in forma di Justitia*: The personification of Venice herself was founded on the figure of Justice, sword and scales in hand, seated upon a Solomonic throne flanked by lions. That figural association with the virgin goddess of Justice confirmed the special relationship of virgin Venice with the Virgin Mary herself, a relationship documented by their shared holy day of March 25. But there is one other icon of the Republic even more fundamental to the self-identity of Venice, even more venerable, less allegorical and allusive, more directly symbolic and, significantly, more overtly political: the winged lion of St. Mark (fig. 30). The image of the beast associated with the patron saint of the Republic came to stand for Mark himself: *San Marco in forma di lion.*[1]

The four winged beasts of the Apocalypse (4:7), inspired by the vision of Ezekiel (1:5), had been loosely associated with the four evangelists as early as the second century. Once the associations were finally stabilized, the evangelists and their respective beasts became iconographically interchangeable: the man, or angel, stood for Matthew, the eagle for John, the ox for Luke, and the lion for Mark. The leonine form assumed symbolically by Mark signified the saint himself: the saint *in forma leonis*. Mark, of course, was represented as a man in hagiographic narratives and in his sacred feudal role as *dominus Venetiae*, the sovereign lord of Venice. Himself the delegate of a higher lord, Christ, Mark in turn confers authority on the doge. It was the winged lion, however, that more graphically manifested the presence of the saint and, by extension, of Venice (fig. 31).

As the Republic expanded its empire, eastward along the Adriatic shore

FIGURE 30:

*Lion of St. Mark*
(thirteenth century).
Museo Civico
Correr, Venice
(Photo: Böhm).

and into the Aegean and then westward onto the Italian terra firma, well into Lombardy, the winged lion followed: its presence, in relief or sculpted in the round, declared Venetian dominion. It was the extension of that dominion onto the mainland that provoked the powers of Europe and Italy—including Pope, Emperor, and King of France—to form an alliance to counter such "insatiable cupidity and thirst for dominion."[2] The League of Cambrai declared war on Venice in December 1508. Following the rout of Venetian forces at the battle of Agnadello on May 14, 1509, almost all of the mainland, nearly to the shores of the lagoon, swiftly fell to the League—briefly, however, for the amazing recovery of Venice was to become celebrated in the annals of diplomatic luck. Upon taking Bergamo, the French invaders carried off the large sculpture of the winged lion that had marked Venetian lordship of the town; the loyal Bergamaschi protested this violation of "il nostro paron" (our patron or master). Lamenting the event, the Venetian diarist Marin Sanudo referred to the stone beast as "quel San Marco grande."[3] The winged lion represented the saint who represented the state. The battle cry of the Venetians and the popular pledge of its loyal subjects was "Marco! Marco!"

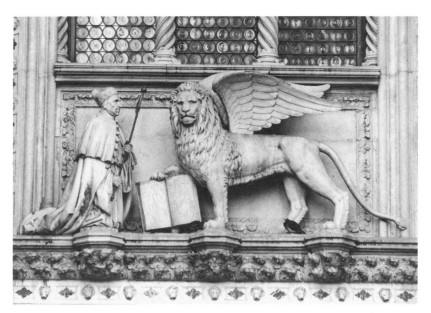

FIGURE 31: *Doge Francesco Foscari before the Lion of St. Mark* (nineteenth-century reconstruction after destroyed original by Bartolomeo Bon). Porta della Carta (Photo: Böhm).

A canvas by Palma il Giovane, a work of the later sixteenth century, takes the leonine protagonist into full battle (fig. 32). In this allegorical representation of the conflict with the League of Cambrai, Doge Leonardo Loredan (1501–21) calmly leads Venice personified, with her sword of justice now in action as she follows her aggressive lion against the invading forces of Europe on her bull. Personifications of Abundance and Peace accompany Venice, and winged Victories above assure the outcome. Part of the redecoration of the Sala del Senato after a fire in 1574, Palma's image of the lion militant was painted in about 1593, when the actual military capability of Venice had long passed its prime.[4] Although most of the terra firma empire was indeed regained by Venice following the war with the League, success was achieved essentially by diplomatic means. After that chastisement, Venice became the public champion of peace. Like Justice, Peace was to be a gift of Venice to an embattled Europe. The lion may have been tamed, but it carried that message with renewed rhetorical purpose as the pacific nature of the Republic was announced in the Peace of St. Mark.

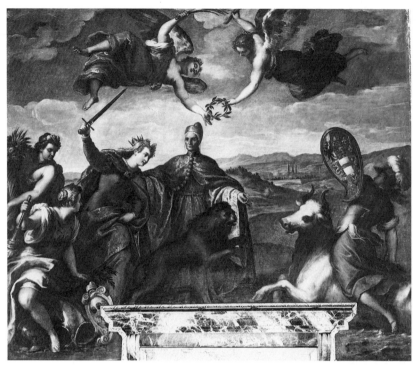

FIGURE 32: Jacopo Palma il Giovane, *Allegory of the League of Cambrai.*
Sala del Senato, Ducal Palace (Photo: Alinari).

Following the surrender of Venice to Napoleon in 1797, many of the
leonine images in the city were destroyed in a Jacobin outburst against the
emblem of ancient patrician authority. But the lion in its several forms is
still to be found throughout Venice and the Veneto and beyond, well into
the eastern Mediterranean, vestigial markers of a once-extensive empire on
land and sea.

Of those several leonine forms, the most heraldic is that *in moleca* (fig. 33),
an allusion in Venetian dialect to its crablike shape. This compact form, an
*imago clipeata* particularly appropriate for coinage (fig. 34), derives directly
from the Apocalyptic formula of the winged beast emerging from one of
the four rivers of Paradise (fig. 35). That aquatic base assumed a special
meaning as Venice appropriated the evangelist's lion. More natural than
this official seal, however, was the lion passant, the full-bodied beast in
monumental stride, dominating a politically charged landscape. Literally
imperious, the type developed along with the territorial expansion of

FIGURE 33:
*Lion of St. Mark*
*"in Moleca"*
(seventeenth
century).
Museo Civico
Correr, Venice
(Photo: Böhm).

Venetian dominion onto the mainland, beginning in the early fifteenth century. Extending his reach from sea to land, this lion enacts the very extension of Venetian empire, staking claim to both the *stato da mar* and the *stato da terra*.

And yet this militant beast, especially as rendered by Carpaccio in 1516 (plate 6), bears the promise of peace. PAX TIBI MARCE EVANGELISTA MEUS, his open book declares: "Peace be with you, Mark, my evangelist."[5] Originally the comforting words of Christ to Mark in prison (fig. 36), these words were appropriated by Venetian legend to become the angelic salutation in a dream Mark had in a boat on the lagoon while returning from his mission to Aquileia (fig. 37). *Hic requiescet corpus tuum*, the divine message continues in the Venetian appropriation, promising that Mark's body will find its final rest here. This *praedestinatio* was a thirteenth-century addition to the standard Marcian hagiography. A particularly Venetian inflection of the legend, it contributed an essential element to the appropriation of the saint by the state. The angelic prophecy lent divinely sanctioned inevitability to Venice's right to the relics, further testimony to the privileged status of this Christian Republic.[6]

Such divine preordination notwithstanding, Mark was not in fact the

FIGURE 34:
Lira of Doge
Nicolò Tron
(reverse).
Museo Civico
Correr, Venice
(Photo:
Museum).

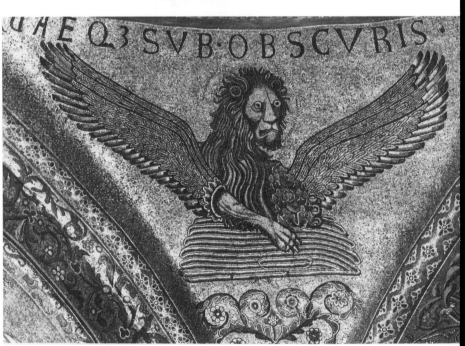

FIGURE 35: *Lion of St. Mark* (mosaic). San Marco, east dome pendentive
(Photo: Böhm).

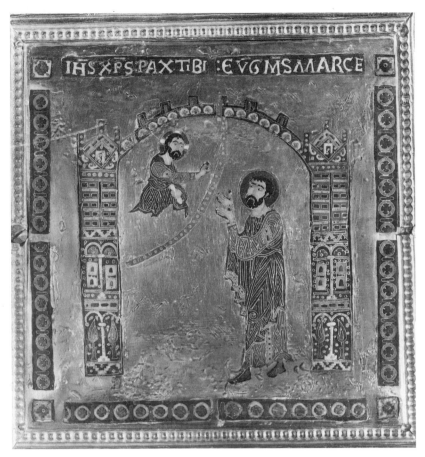

FIGURE 36: *The Apparition of Christ to St. Mark* (enamel), Pala d'Oro. San Marco (Photo: Böhm).

original patron saint of the early Venetians. That distinction went to Theodore, a Greek warrior saint, whose patronage effectively attested Venetian status as a province of the Byzantine empire, under the immediate command of the exarchate of Ravenna. The symbolic turning point in relations between the Italian province and the Greek emperor occurred in 829, when two Venetian merchants, Buono da Malamocco and Rustico da Torcello, brought the body of St. Mark back from Alexandria, where he had been martyred (fig. 38). Sanctioned retroactively by the invented *praedestinatio*, that event brought to Venice the relics of the evangelist who was, significantly, apostle to the Italians. In Venice a new reliquary church

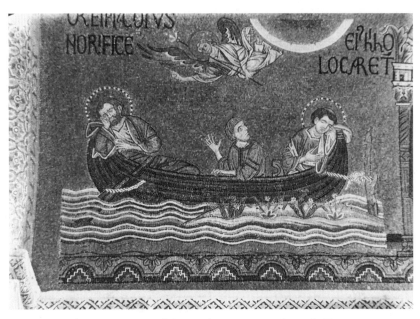

FIGURE 37: *The Dream of St. Mark* (mosaic). San Marco, Cappella Zen
(Photo: Böhm).

was built between the Ducal Palace and the older chapel of St. Theodore,
which was eventually totally absorbed by the competing and dominating
structure.

Mark had been baptized by St. Peter himself and accompanied him to
Rome, and it was Peter who sent Mark on his mission to Aquileia to
spread the word of God into northern Italy. Mark's major convert and dis-
ciple there, Hermagoras, was consecrated as the first bishop of the Roman
province of Venetia and Istria, and Hermagoras was the first Christian
martyr in that province, along with his deacon, Fortunatus. Of Mark's mis-
sion to Aquileia there is no evidence other than the medieval embellish-
ment of the history of Hermagoras and Fortunatus. The evangelist's pres-
ence in northeastern Italy, however, was essential to the Venetian edition
of Mark's legend, and that presence, according to the subsequent Venetian
spin, was divinely verified by his lagunar passage and dream.

Once his relics did indeed come to rest in the lagoon, Mark served as an
Italian alternative to the Greek St. Theodore and then as an explicitly
Venetian alternative to the Roman St. Peter. In its later conflicts with the
papacy—especially in the early sixteenth and early seventeenth centuries,

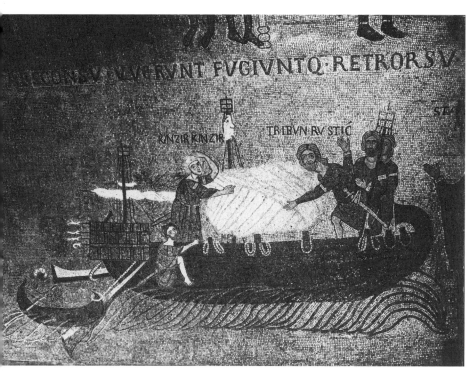

FIGURE 38: *The Abduction of the Body of St. Mark* (mosaic). San Marco, Cappella di S. Clemente (Photo: Böhm).

when it was under papal interdict and excommunication—Venice claimed its intimate relationship with the evangelist Mark as at least equal to Rome's relation to apostolic Peter. More urgent in the ninth century, the translation of the relics to Venice provided a highly symbolic basis for its independence of Constantinople. The patronage of Mark conferred an independent legitimacy upon the emerging maritime state.[7]

Nonetheless, one does not reject saints. At the public entrance to the city, in the Piazzetta facing the *bacino*, two massive granite columns, trophies from the east, were erected in 1172 (fig. 39). Atop one is a bronze lion: a chimera of antique oriental origin, transformed by the addition of wings into a lion of St. Mark—creating the columnar leonine model that was to be replicated in the public squares of many towns of the later empire. Crowning the other column is a composite figure, made up of pieces ancient and modern: a warrior triumphant over a dragon, haloed to represent St. Theodore. Pious Venice did not forget its first protector.

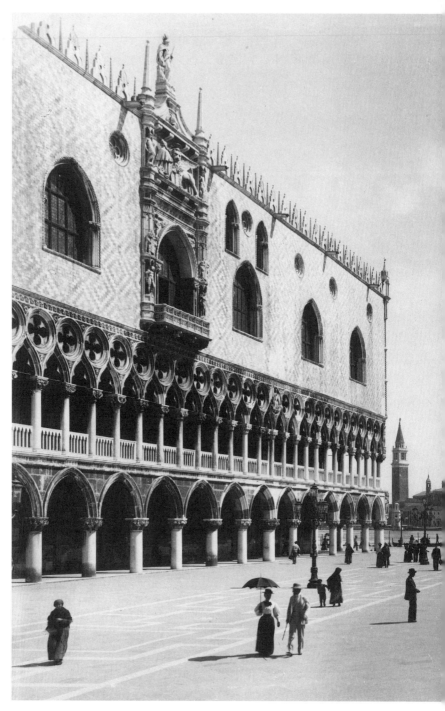

FIGURE 39: Piazzetta San Marco (Photo: Böhm).

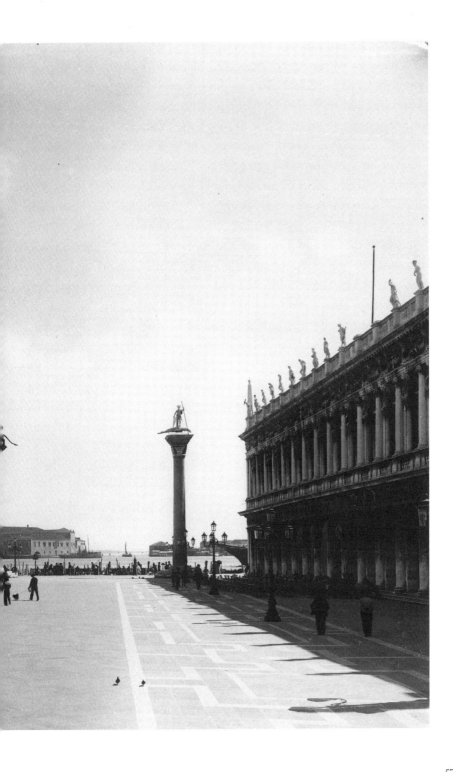

But it was Mark whose relics occasioned and sanctified the ducal church of Venice and whose legend, retrospectively enhanced by the subsequently invented *praedestinatio*, lent glory to the city that claimed him as its own. The image and imagery of St. Mark, his legend as well as his lion, were inextricably woven into the fabric of Venetian self-identity. Mark wrote his Gospel text in Rome, at the instruction of St. Peter, but the geographic reach of his apostolic career extended from Aquileia in northeastern Italy south to Alexandria in Egypt, the site of his miracles and of his martyrdom. The earliest representations of Mark's story feature his preaching in Alexandria, his miraculous healing of the cobbler Anianus (fig. 40), the baptism of the converted Anianus and his family, and his eventual consecration as bishop of Alexandria. Following Mark's capture and martyrdom, his body was rescued from a pyre by faithful Christians and secretly entombed in Alexandria, awaiting—at least according to Venetian account—return to its final, ordained resting place (fig. 41). These events are pictorially recorded in several cycles of the twelfth- and thirteenth-century mosaics of San Marco, as well as in the enamels of the Pala d'Oro, the golden enameled retable assembled first in 1105 and revised several times up through 1345, when Paolo Veneziano and his sons painted the panels for the ferial cover of that bejeweled altarpiece, in which was included yet another Marcian narrative (fig. 42).[8]

Having found rest in the reliquary church built by the Venetians, the remains of St. Mark continue to reaffirm the *praedestinatio*. In the second half of the eleventh century, the church was rebuilt, acquiring the basic form it has today. In the course of this campaign, the relics of the saint were lost; they had been hidden for the sake of security, but all the guardians evidently died before revealing their secret. In 1094, as the new structure neared completion and was being prepared for consecration, there was still no sign of the relics. The doge, Vitale Falier (1084/85–96), accompanied by the Signoria and the clergy, led the people in prayer for their recovery: "Hear, O Lord, all the supplications of thy people," reads their plea in the thirteenth-century mosaics representing the event on the west wall of the south transept (fig. 43). The prayers of the Venetians were, of course, answered, significantly, on the third day: a stone miraculously fell from a pillar to reveal the relics (fig. 44). With this apparition, the saint reavowed his holy allegiance to this chosen city.[9]

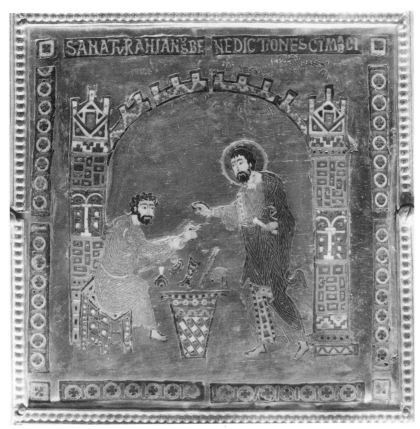

FIGURE 40: *St. Mark Healing Anianus* (enamel), Pala d'Oro. San Marco
(Photo: Böhm).

The *apparitio* belongs to a later phase of hagiographic expansion, the
posthumous miracles performed by the saint on behalf of the faithful.
These became the primary materials of medieval compendia of saints' lives,
such as the *Golden Legend* compiled by Jacobus da Voragine in the thir-
teenth century.[10]

The distinction informs what is effectively the last of the great cycles
devoted to St. Mark in his Venetian church: the two sets of bronze reliefs
by Jacopo Sansovino set into the *pergoli*, or tribunes, of the *coro maggiore*,
that part of the choir of San Marco reserved for the doge and officials of
the state.[11] The first set, completed in 1537, presents two scenes of Mark's
ministry in Alexandria, the baptism of Anianus (fig. 45) and his miraculous
healings (fig. 46), and a third represents his martyrdom (fig. 47). Captured

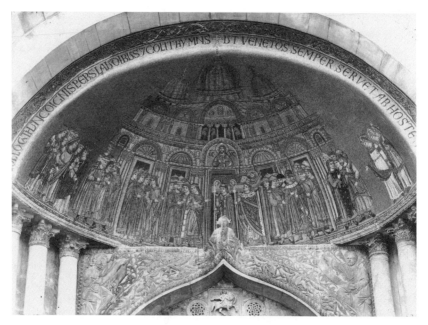

FIGURE 41: *The Reception of the Relics of St. Mark* (mosaic). San Marco, Porta di S. Alipio (Photo: Böhm).

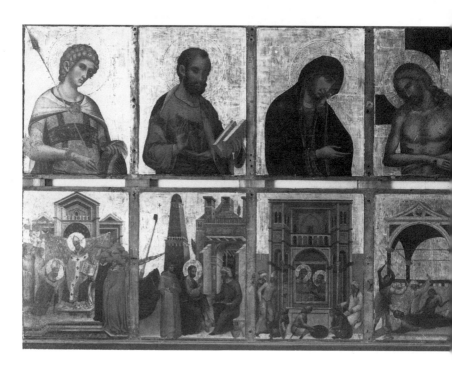

at Easter Sunday mass, Mark is beaten and dragged through the streets of the city. The account in the *Golden Legend* explains the meteorological fury of Sansovino's actively molded relief: "The pagans wanted to burn the martyr's body, but suddenly the air was turbulent, hail drummed down, lightning flashed, and everyone's thought was to find shelter, so they left the holy body untouched, and Christians took it away and buried it with all reverence in the church."

Sansovino's second *pergolo* reliefs, created between 1541 and 1544, are devoted to the afterlife of the saint, to those posthumous miracles that kept the faith alive, "the miracles that God deigned to work through the intercession of St. Mark," in the words of a later, Venetian hagiographer.[12] These are among those recorded in the *Golden Legend*. *The Miracle of Rain in Apulia* (fig. 48) represents the terrible drought that befell Apulia because the Pugliesi neglected to venerate St. Mark: "The people therefore invoked the saint and promised that they would celebrate his feast, so Mark banished the sterility and, by sending salubrious air and needed rain, provided the people with plenty." *The Miraculous Healing of the Knight's Hand* (fig. 49) depicts the tale of a knight of Lombardy whose hand had been nearly sev-

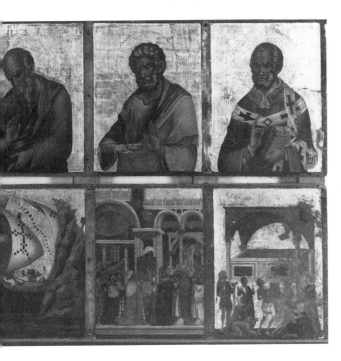

FIGURE 42:
Paolo Veneziano,
Pala Feriale.
Museo Marciano
(Photo: Böhm).

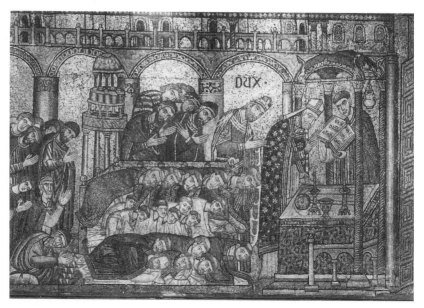

FIGURE 43: *The Prayer for the Recovery of the Relics* (mosaic).
San Marco, right transept (Photo: Böhm).

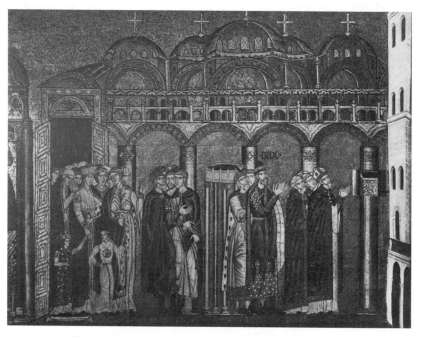

FIGURE 44: *The Miraculous Apparition of the Relics* (mosaic).
San Marco, right transept (Photo: Böhm).

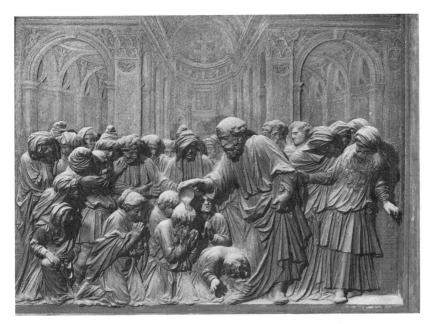

FIGURE 45: Jacopo Sansovino, *The Baptism of Anianus.*
San Marco, choir, south tribune (Photo: Böhm).

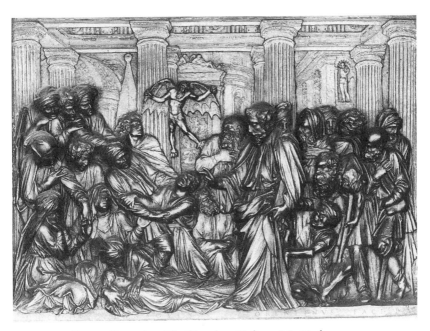

FIGURE 46: Jacopo Sansovino, *The Miraculous Healings of St. Mark.*
San Marco, choir, south tribune (Photo: Böhm).

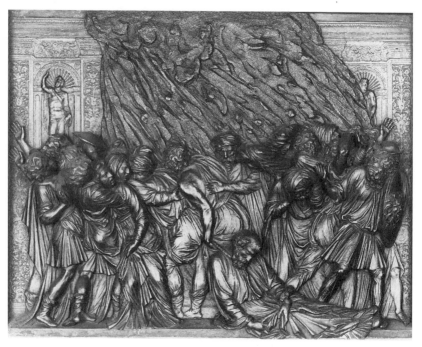

FIGURE 47: Jacopo Sansovino, *The Martyrdom of St. Mark.*
San Marco, choir, south tribune (Photo: Böhm).

ered in battle; refusing the advice of doctors and friends to have it ampu-
tated, he instead invoked the aid of St. Mark, and the injury was immedi-
ately corrected—"All that was left of the wound was the scar, as evidence of
the miracle and a monument to the great blessing granted to the knight."[13]

But it was the miracle of *St. Mark Saving the Slave of Provence* (fig. 50) that
had a particularly Venetian resonance, for this story culminates in the
church of San Marco itself. Having vowed a pilgrimage to the relics of
St. Mark in Venice, the slave, or servant, was refused permission by his
master. Putting "fear of the Lord ahead of fear of his master," as we read
in the *Golden Legend,* he nonetheless proceeded to fulfil his vow. Upon his
return, his master condemned him to be put to various tortures. The slave
invoked the aid of St. Mark, who miraculously appeared and broke the in-
struments of torture—the stakes that were to have blinded him, the axes
that were to have cut off his feet, the hammers that were to have smashed
the mouth that called upon the saint's intercession. "The master, seeing all
this, was taken aback, begged God's pardon, and with his servant visited

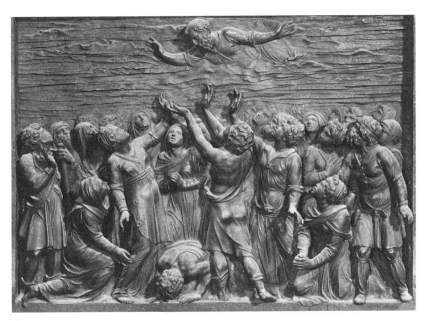

FIGURE 48: Jacopo Sansovino, *The Miracle of Rain in Apulia.*
San Marco, choir, north tribune (Photo: Alinari).

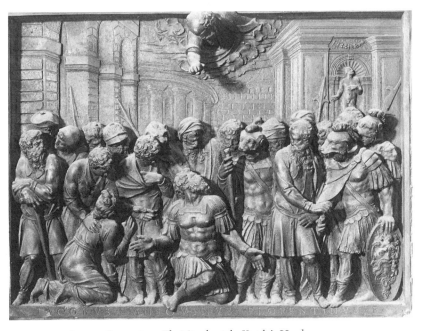

FIGURE 49: Jacopo Sansovino, *The Miracle of the Knight's Hand.*
San Marco, choir, north tribune (Photo: Alinari).

65

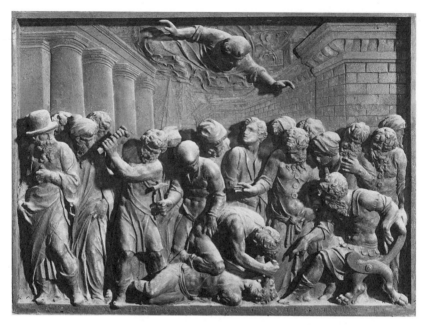

FIGURE 50: Jacopo Sansovino, *The Miracle of the Slave of Provence*. San Marco, choir, north tribune (Photo: Alinari).

the tomb of Saint Mark with earnest devotion." The later Venetian version of the story makes more of its climactic scene in Venice: the church of San Marco becomes the site of confession of sin by the torturers and of the announcement to all the world of the miracle they had witnessed. Through the body of St. Mark, Venice itself becomes the means of such divine intervention.

In every sense, then, St. Mark came to represent Venice: St. Mark *was* Venice. Thus, for example, in Titian's earliest altarpiece (fig. 51), Mark sits enthroned, accompanied by Saints Cosmas and Damian, Roch and Sebastian, the two patrons of physicians and the two saints most frequently invoked in times of plague. Titian's panel was probably painted before 1510 in response to just such a crisis. The protagonist of this *sacra conversazione*, Mark assumes a position generally reserved in such constructs for the Virgin and Child, the intercessor and the ultimate source of redemption. The shadow that falls over him bespeaks the darkness of the moment. Mark here personifies Venice suffering the calamity and, at the same time, represents its prayer for salvation from that pestilence.[14]

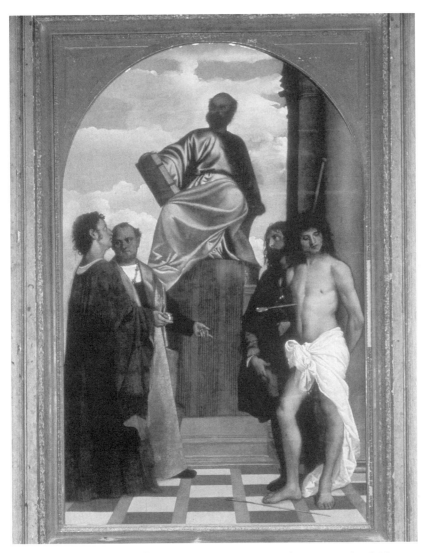

FIGURE 51: Titian, *St. Mark Enthroned with Saints Cosmas and Damian, Roch and Sebastian.*
S. Maria della Salute (Photo: Soprintendenza ai Beni Artistic e Storici e Storici di Venezia).

The saint becomes identified with the people of Venice. The church
that keeps and venerates his relics becomes the public symbol of the piety
of that people. Giovanni Bellini's altarpiece for the church of San Giobbe,
of about 1480, offers eloquent pictorial testimony to the symbolic role of
San Marco (fig. 52). His church, not the saint himself, is evoked here, in
the apsidal enclosure of this *sacra conversazione*, in the golden mosaics of its

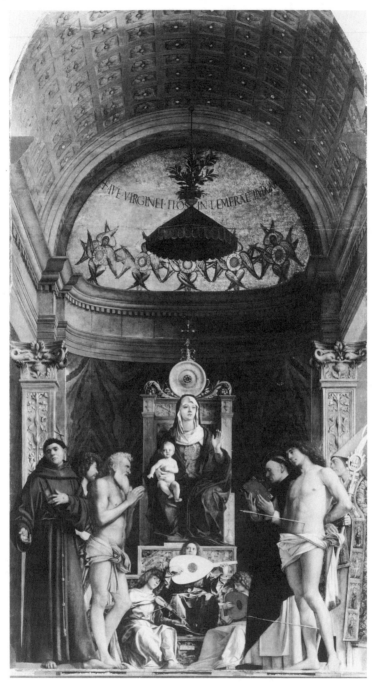

FIGURE 52: Giovanni Bellini, *San Giobbe Altarpiece.*
Gallerie dell'Accademia, Venice (Photo: Böhm).

half-dome and in the veined marble revetment of its walls, a rich combination particularly distinctive of San Marco (fig. 53) and accorded special mention in Renaissance guidebooks. Indeed, the marble itself, its slabs carefully sliced to create symmetries of figural suggestiveness, had been singled out for comment by Albertus Magnus in the thirteenth century—a public recognition of the miraculous image of the church that was cited by Francesco Sansovino in the detailed description of the revetment in his great book on Venice of 1581.[15] Part of a Byzantinizing revival in the late fifteenth century, Bellini's invocation of the basilica of San Marco invests his altarpiece with a particularly Venetian aura of sanctity.[16]

These two altarpieces suggest just how the figure of St. Mark and the image of his church could inform the Venetian religious imagination, how the very idea of the saint could be extended from the center of the state, outward and downward. Anianus, Mark's first convert in Alexandria, was a cobbler, and through that craft association the shoemakers of Venice could lay claim to the patronage of St. Mark himself: The tympanum of their guildhall, the Scuola dei Calegheri, features the healing of Anianus (figs. 54, 55). Mark's patronage descends from the patrician Signoria down to the populace, following the structured organization of Venetian society.[17]

A major means for the extension of such patronage and devotion, as well as iconography, were the confraternities of Venice, great and small: devotional societies, craft and trade guilds, and associations of national groups within Venice that catered to the spiritual as well as economic and social needs of their members. These confraternities constituted a fundamental system of organizing the nonpatrician population of the city. Although the citizens of Venice were barred from the Great Council and thus from government, through the confraternities and guilds, they participated in the Republic's political and social life; membership in such institutions defined their role and position within the fabric of society. The civic function of the confraternities involved various services to the state—caring for the sick and indigent, supplying men for the militia and galleys, providing personnel for public processions. The major institutions in this network of social organization were the so-called great confraternities, the *scuole grandi*. By the middle of the sixteenth century, there were six such *scuole*, one for each of the *sestieri* of Venice. These lay brotherhoods were devoted to acts of piety and charity. The oldest of them originated as

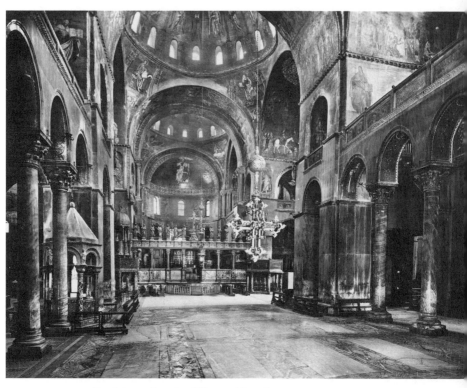

FIGURE 53: San Marco, interior (Photo: Alinari).

*scuole dei battuti* during the flagellant movement of the mid-thirteenth century. In the course of the fifteenth and sixteenth centuries, the *scuole grandi* became as renowned for their architectural magnificence and interior embellishments as for their charitable activities. And that splendor was actively encouraged by the Venetian government as a contribution to the greater glory of Venice itself.[18] The participation of the *scuole* in the public pageantry of Renaissance Venice is most immediately, and famously, documented for us by Gentile Bellini's canvas of 1496 (plate 7), part of the cycle originally decorating the walls of the Scuola Grande di San Giovanni Evangelista. Preceding the ducal procession known as the *andata in trionfo*, this grand spectacle in Piazza San Marco features the display of the *scuole grandi*.[19] Just behind the central group of the brothers of San Giovanni Evangelista bearing their most precious relic of the Holy Cross occurs an event of April 25, 1444: a visiting merchant prays to the relic for the cure of his wounded son in Brescia, and his prayers are answered. April 25,

FIGURE 54: Scuola dei Calegheri (Photo: Author).

the date of the miracle, and of the procession depicted, is the feast day of St. Mark. On that day and in the piazza before the Venetian basilica, the salutary power of the relic of the Cross operates in effect under the protection of the patron saint of Venice.[20]

The most magnificent of the great confraternities was the Scuola Grande di San Marco (fig. 56). Owing to its patronage, it enjoyed a privileged position within the highly competitive world of the *scuole*, and the brothers were proud of their special relationship to the Republic itself established by the patron saint. Bearing the name of "the protector of this most illustrious state," as one *guardian grande* declared, the Scuola di San Marco was obligated to surpass all the others in the magnificence of its building, "out of reverence for the divine cult and to honor this most renowned republic."[21]

Founded in 1261, the Scuola di San Marco moved to its present site in

FIGURE 55: *St. Mark Healing Anianus*. Scuola dei Calegheri (Photo: Author).

1437, next to the Dominican basilica and convent of Santi Giovanni e Paolo. And that site itself, opening onto the *campo*—which was to be punctuated by Verrocchio's equestrian monument of Bartolommeo Colleoni—was the most distinguished of all the *scuole*. The original building was destroyed by fire the night of March 31, 1485. Response to that disaster confirmed the special status of the confraternity. The rebuilding of the Scuola di San Marco was deemed of such importance to the Republic that the Signoria contributed directly to the project through enormous grants and credits.[22] Clearly, any institution dedicated to St. Mark was of the utmost importance to the Serenissima.

The monumental facade of the new building—the work of Pietro Lombardo and Giovanni Buora, followed by Mauro Codussi—proclaims that importance in every way. Setting a new standard, the triple arcade of its profile brings the traditional Gothic forms of *scuola* architecture (as exemplified by the old Scuola Grande della Misericordia) into the Renaissance.[23] Indeed, that profile has been compared to the silhouette of the

FIGURE 56: Scuola Grande di San Marco, facade (Photo: Böhm).

domes of San Marco itself—an allusion not beyond the *cittadino* awareness
of the brothers of the Scuola. Rather little is known about the meeting hall
begun in 1437 and destroyed in 1485. Francesco Sansovino reports that the
lunette over the entrance to the new building (fig. 57), which he attributed
to Bartolomeo Bon, was actually rescued from the fire and reused.[24] This
relief documents the traditional devotion of the *confratelli* to their patron
saint: enthroned, Mark offers his hand and benediction to the hooded
brothers of his confraternity. (An earlier votive tablet, of the late four-
teenth century, depicts the brothers offering the standard of the Scuola to
their patron saint *in forma de lion* [fig. 58].) Crowning the portal of the
Scuola di San Marco stands a figure of Caritas, a personification of the
major theological virtue to which all the *scuole grandi* were dedicated.[25]

Flanking the doorway, set within ambitious Renaissance perspectives,

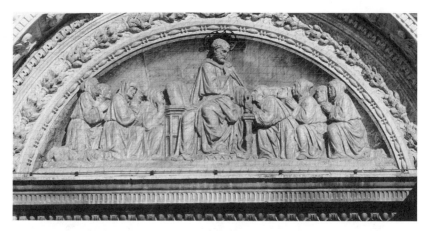

FIGURE 57: Workshop of Giovanni and Bartolomeo Bon, *The Brothers of the Scuola di San Marco Worshipping St. Mark*. Scuola Grande di San Marco, lunette (Photo: Böhm).

two lions guard the entrance to the Scuola (fig. 59). Although there is a venerable tradition of such guardian beasts at the portals to churches as well as secular buildings, in this particular context the lions, although wingless, resonate with a fullness of Venetian meaning. A similar pair of unusually offensive beasts stand vigilant on the pedestals of the columns framing the entrance to the Arsenal, constructed under Doge Pasquale Malipiero (1457–62); in the pediment above, fully winged and haloed, the lion of the evangelist Mark rules over the great enterprise of this true center of Venetian maritime and military power. On the triumphally arched entrance to the Scuola di San Marco, the two lower lions may also be seen as secular creatures in comparison to the evangelist himself, enthroned in the lunette above. Secularity, however, is a very flexible notion in Venice, where the religious and the political are rarely so neatly distinguished. It is true that lions were actually kept in the Ducal Palace, gifts to the Signoria; these presumably are the beasts recorded in drawings by Jacopo Bellini earlier in the fifteenth century. But, unlike the menageries of other courts, these particular animals assumed special value in a Venetian context: as living models for the creatures carved and painted on so many walls of the Republic, and, ultimately, as natural manifestations of the ideal beast of the evangelist.[26]

One document in particular suggests such an inflected reading of the

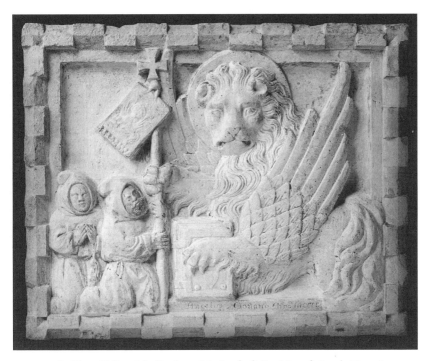

FIGURE 58: *Votive Tablet of the Brothers of the Scuola di San Marco before the Lion of St. Mark.* Museo Civico Correr, Venice (Photo: Böhm).

lions on the facade of the Scuola di San Marco. In 1437 Giovanni Bon designed the portal of the original building; the contract describing its various parts includes on the architrave "two St. Marks or rather lions" (*due S. Marchi ovver lioni*), between whose paws was to be a carved inscription (*lettere scolpite*).[27] In this sense, the two lions conceived by Pietro Lombardo (or his son Tullio) for the new structure may be seen as *restauri*, modernized restorations of a significant motif on the lost building, here adapted to a new monumental setting. Such "restoration" was typical in Venice, most particularly in the Ducal Palace or San Marco itself, where replacement of lost or decaying images always respected precedent; maintaining pictorial tradition was essential for maintaining the myths of Venice.[28] The two lions on the facade of the Scuola di San Marco are thus legible as figuring St. Mark.

Flanking the minor entrance to the Scuola are two narrative reliefs. Within elaborately rendered architectural perspectives are the opening scenes of Mark's mission to Alexandria: the healing and baptism of Ania-

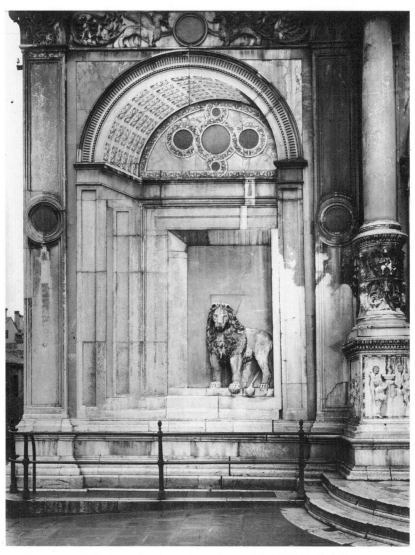

FIGURE 59: Scuola Grande di San Marco, facade, detail (Photo: Böhm).

nus (figs. 60, 61). These events were to be repeated in the pictorial decora-
tion of the *sala dell'albergo* of the Scuola, the administrative seat of the con-
fraternity where the officers of the *banca*, the governing board, met. Among
the officers was the painter Gentile Bellini. With his brother Giovanni, in
1492, he had offered to paint a vast canvas for the main wall of the new
*albergo*; this was to replace decorations lost in the fire, paintings by their
father, Jacopo Bellini. It was not until 1504, however, that the cycle was ac-

tually initiated, with the canvas representing *St. Mark Preaching in Alexandria* (plate 8)—a painting completed by Giovanni after Gentile's death in 1507. The Alexandria imagined by Gentile—punctuated by minarets, towers, columns, and appropriately Egyptian obelisks and palms—is dominated by a structure that clearly recalls—or, rather, anticipates—the essential structure of San Marco before the external mosaics and ogive curves and pinnacles of its later Gothic dressing.[29] The proleptic resonance of this structure operates along two distinct coordinates: historically, as a pagan temple about to cede to Christian truth; geographically, as allusion to the ultimate fate of the saint's relics. Gentile's fantastic building offers a kind of architectural *praedestinatio*. Another prolepsis is suggested by the presence of the officers of the Scuola, including most prominently the artist himself: the governing officers of the *banca* lined up behind the saint further affirm the relationship of ancient Alexandria to contemporary Venice. In this way, the nonpatrician citizens participated pictorially in one of the essential myths of Venice.

Gentile also projected a second grand canvas on the entrance wall opposite the *banca*, "una bela fantaxia" of the martyrdom of St. Mark. Giovanni began the painting itself (fig. 62) only in 1515, the year before his own death; it was subsequently completed and signed by his follower Vittore Belliniano in 1526. It too is replete with contemporary portraits, modern Venetians witnessing the torture of their patron saint. On the side walls of the *albergo*, the major events of Mark's life in Alexandria were depicted in canvases by another Bellini follower, Giovanni Mansueti: *The Healing of Anianus* and *The Baptism*. A third larger canvas represents episodes leading up to the martyrdom, including the condemnation of Mark, his arrest while celebrating mass, and his imprisonment, during which, according to the *Golden Legend*, he was comforted by Christ, who affirms—reaffirms, according to Venetian hagiography—the promise of peace: "Pax tibi, Marce, evangelista meus."[30]

That peace, of course, was realized with the *translatio*, the transfer of the saint's relics to Venice in 829. As promised, Mark came to rest within the lagoon, in the reliquary church built for him by the Venetians. After his missions to Aquileia and Alexandria, his legend continued to expand, now taking on increasingly local coloration. As in the *apparitio* of 1094, Mark continued to manifest his special protection of his faithful devotees and

FIGURE 60: Lombardo workshop, *St. Mark Healing Anianus.*
Scuola Grande di San Marco, facade (Photo: Böhm).

78

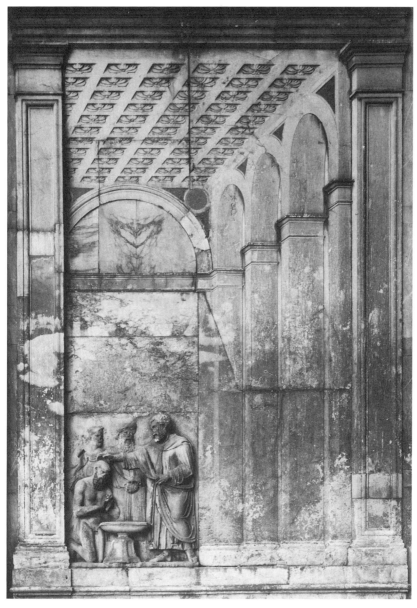

FIGURE 61: Lombardo workshop, *The Baptism of Anianus.*
Scuola Grande di San Marco, facade (Photo: Böhm).

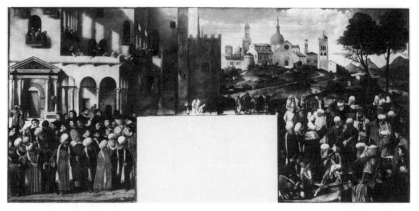

FIGURE 62: Vittore Belliniano, *The Martyrdom of St. Mark.*
Gallerie dell'Accademia, Venice (Photo: Böhm).

their city. Thus, on the night of February 25, 1341, a terrible storm struck
Venice, with strong winds and *acqua alta*. An old fisherman, seeking refuge
under a bridge, was approached by a figure coming from the church of
San Marco who, despite the storm, commanded to be ferried out across
the *bacino* to the island of San Giorgio Maggiore. There another stranger
met them, and the fisherman was asked to take them to San Nicolò al
Lido, where a third *anonimo* joined the group. At that point the three
revealed their identities—St. Mark, St. George, and St. Nicholas—and
directed the fisherman to row them out to sea. There in the turbulent
waters appeared a galley manned by demons intent upon the destruction
of the city. Prayers from the saints and the sign of the cross made by Mark
succeeded in sinking the infernal vessel. By such divine intervention was
Venice saved.

This is the subject of the next canvas commissioned by the *confratelli* of
the Scuola di San Marco for their *albergo*, a painting begun by Palma il Vec-
chio and, after his death in 1528, completed by Paris Bordon (fig. 63).[31]

The miraculous salvation of Venice had become a rather charged theme
following the war of the League of Cambrai. Shortly after the dissolution
of that alliance in 1513, the publisher Bernardino Benalio requested a copy-
right privilege for a monumental woodcut representing the submersion of
pharaoh's host in the Red Sea (fig. 64). The design was by Titian. The in-
scription on a later edition, of 1549, retains the significance of the image:
the punishment of a cruel and oppressive enemy who dared to persecute "a

FIGURE 63: Jacopo Palma il Vecchio and Paris Bordon, *Venice Saved from Demons by Sts. Mark, George, and Nicholas*. Gallerie dell'Accademia, Venice (Photo: Böhm).

people so beloved of God."[32] Venetians, of course, were hardly unique in identifying with the chosen people, but their survival of the great threat posed by the powers of Europe could only be viewed as yet another sign of God's favor. That salvation came from the sea added a particularly Venetian note. (It is interesting to recall that the decorations of the old Scuola di San Marco, destroyed in the fire of 1485, included a "submersion" of pharaoh and his army and a painting of "the people of Moses in the desert," both commissioned of Gentile Bellini in 1466.)[33]

Following the miraculous salvation of the city from the demon crew in 1341, St. Mark gave a ring to the fisherman, to be presented to the doge as testimony of this great event. That presentation is the subject of the final canvas in the cycle decorating the *albergo* of the Scuola di San Marco, commissioned of Paris Bordon in 1534 (plate 9).[34] In its figuration as well as its Serlian architectural background, the painting is the most thoroughly con-

FIGURE 64: Titian (after), *The Drowning of Pharaoh's Army in the Red Sea.*
Metropolitan Museum of Art, New York.

temporary in this cycle. The doge receiving the ring bears the features of
the ruling Andrea Gritti (1523–38); portrait-like individuation character-
izes the flanking members of the Signoria and the members of the *banca* of
the Scuola, who witness the event, appropriately, from the bottom of the
stairs. Through pictorial means, the miraculous intervention of the four-

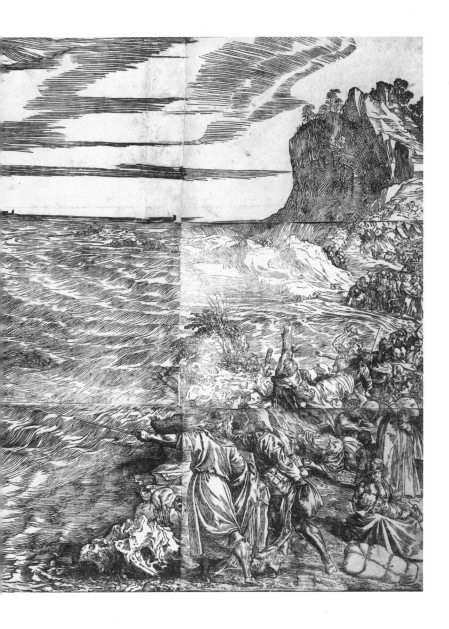

teenth century continues to resound in the sixteenth. St. Mark continues
to protect this chosen people.

On November 30, 1542, the officers of the Scuola di San Marco turned
to the pictorial decoration of their great chapter hall, the *sala del capitolo*;
they voted to commission canvases depicting appropriate "stories of our

protector messer S. Marco," the exact subjects to be chosen in consultation with those expert in such matters.[35] Moving to the posthumous legends of the saint, their initial selection was the *Miracle of St. Mark Saving the Slave of Provence* (plate 10). Early in 1548 Jacopo Tintoretto's canvas of that subject was unveiled, to clamorous reviews both negative and positive. This was the beginning of the painter's rather rocky relationship with the Scuola di San Marco, of which his future father-in-law was an officer. According to one source, the seventeenth-century biographer Carlo Ridolfi, the *confratelli* were divided over whether or not to accept the painting, a canvas that could indeed be viewed as an affront to Venetian tradition, a deliberate challenge to the tableau conventions that had governed mural decoration of the *scuole*.[36] In its dynamic spatial structure and radical foreshortenings, punctuated by figural recollections of Michelangelo, Tintoretto's canvas represented the brash gesture of a relatively young artist making a very public statement. Understandably offended by the debate, Tintoretto is said to have removed the canvas from the Scuola and taken it home. The factions among the brotherhood were eventually reconciled, and the picture was returned to its place in the *sala del capitolo*, between two windows on the wall opposite the altar.[37]

Not until 1562 was the pictorial cycle in the great hall continued. Then, the current *guardian grande* of the Scuola, the learned Tommaso Rangone, physician and philologist, offered to pay for another three canvases representing "the miracles of our most holy protector messer S. Marco." By 1566 the canvases were on view: a representation of the rescuing of the body of St. Mark by the Christians of Alexandria (plate 11), the miraculous salvation of a Saracen at sea who had invoked the aid of St. Mark (fig. 65), and a canvas generally interpreted as the discovery of the body of the saint but including a composite of acts of his miraculous healing (fig. 66).[38] Like the painting of *St. Mark Saving the Slave of Provence*, these too were to suffer critical outrage and rejection. The Tuscan artist and biographer Giorgio Vasari, visiting Venice in 1566, saw the paintings and commented on the speed with which they were executed; Vasari criticized Tintoretto's hasty manner, his wild brushwork and lack of *disegno*, his passing off as finished works canvases that were mere sketches and thus making a mockery of the art of painting.[39] The brothers of the Scuola may well have been offended by the state of finish of a canvas like the *Rescuing of the Body*, but there were other reasons

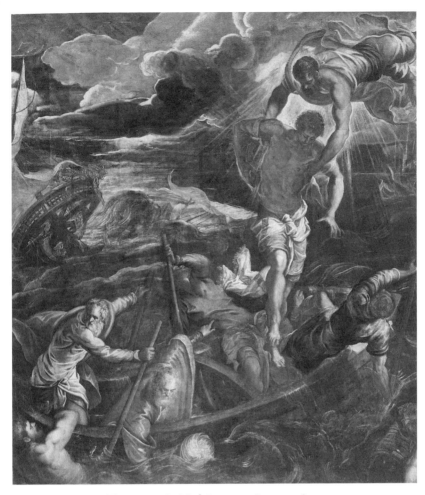

FIGURE 65: Jacopo Tintoretto, *St. Mark Rescuing a Saracen at Sea.*
Gallerie dell'Accademia, Venice (Photo: Soprintendenza ai Beni
Artistici e Storici di Venezia).

as well for their later dissatisfaction. In 1573 they ordered the three canvases
removed and sent back to Rangone, the donor, who refused to accept them.
They were then taken to Tintoretto's house, where the painter offered "to
finish them perfectly, removing the figure of Rangone and replacing him
with another." He also offered to "finish perfectly" a fourth canvas and
donate it to the Scuola gratis, as a courtesy. The brothers evidently had ob-
jected to the prominence of Rangone in these paintings; nonetheless, the
canvases returned to the Scuola without the removal of the portraits.[40]

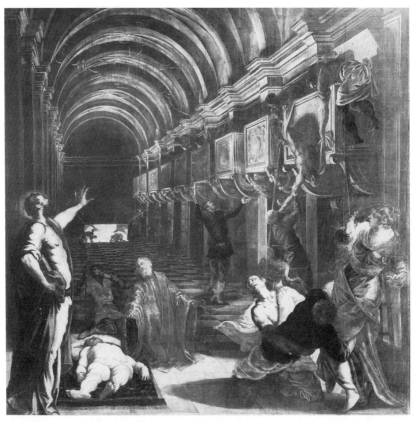

FIGURE 66: Jacopo Tintoretto, *The Miracles and Discovery of the Body of St. Mark.*
Pinacoteca di Brera, Milan (Photo: Soprintendenza ai Beni Artistici e Storici
di Milano).

The figure of Tommaso Rangone does indeed dominate each of Tin-
toretto's compositions—and it may well be his figure that intrudes in the
earlier canvas of the *St. Mark Saving the Slave of Provence.* More assertively
in the *Rescuing of the Body* and the so-called *Discovery of the Body,* Rangone
appears, like Woody Allen's Zelig, in a central position and in privileged
relation to the saint: supporting his head as the body is carried forward,
or witnessing the miracles effected by his apparition—exorcising demons,
curing the blind, resurrecting the dead. This donor's campaign of self-
portrayal is actually of direct relevance to our theme. The wealthy Rangone
was procurator of the church of San Geminiano, which stood opposite the
basilica of San Marco at the far end of the Piazza (fig. 67)—the building

FIGURE 67: Canaletto, *View of Piazza San Marco toward San Geminiano.*
Woburn Abbey Collection, by kind permission of the Duke of Bedford
(Photo: Arts Council of Great Britain).

was demolished by Napoleon to make way for a ballroom. San Geminiano
was begun in 1505 but never quite completed. In 1552 Rangone commis-
sioned Jacopo Sansovino to design a facade for the church, a facade that
was to feature a statue of the donor. The Senate rejected the project: the
glorification of individuals in public places was not generally acceptable in
Venice and most certainly not in the very center of the Republic. Rangone
did get his statue, however, and on a Sansovino facade, but of another
church for which he also served as procurator, San Giuliano, close by San
Marco but tucked away behind the Piazza in a tightly cramped *campo* off
the Merceria.[41]

Nonetheless, Rangone continued to try to associate his effigy with St.
Mark. In 1562 he proposed to have a statue of himself erected on the facade
of the Scuola di San Marco, at his own expense, naturally, and with the
guarantee that it remain there in perpetuity. After some discussion, the
brothers demurred. Eventually, Rangone did manage to get himself repre-
sented in Piazza San Marco, but pictorially.

In Tintoretto's painting of the *Rescue of the Body of St. Mark*, Rangone's
portrait is set directly over the pyre from which the body of the saint has
been rescued (fig. 68). That pyre in turn is set before a towered facade that

closes the space of the action, a space delimited on the left by an arcaded loggia. The space conceived by Tintoretto clearly evokes the experience of Piazza San Marco itself, looking west, away from the basilica and toward the church of San Geminiano; in a rather general way, Tintoretto's two-storied structure along the side reflects Sansovino's new Library, which was to set the architectural model for the modernization of the Piazza, especially the later extension of the Procuratie Nuove by Scamozzi. Although the painting's tall background structure hardly replicates Sansovino's facade for San Geminiano, its location and enclosing function are similar. Tintoretto's space could only bring to mind Piazza San Marco, which was the object of urban replanning throughout Sansovino's career as *protomagister*, the overseeing architect, to the Procuratori di San Marco. Such architectural allusion contributes to, indeed creates, the greater resonance of the image. Unlike his predecessors in the *albergo* of the Scuola, Tintoretto makes little effort to exoticize the Egyptian setting of the saint's martyrdom. Within this thoroughly Venetianized Alexandria, the body of St. Mark is being carried toward its final resting place, the reliquary church of San Marco itself. Tintoretto's narrative begins in Alexandria with the recovery of the body from the pyre but moves, by visual ellision, by the momentum of its figural perspective, to its divinely ordained conclusion, in Venice. This is precisely the kind of iconographic slippage and historical prolepsis that by now we have come to expect in the world of Venetian imagery.

We may assume that a Venetian audience readily responded to such resonance, that the Alexandria-Venice equation would have been for them a natural reading of Tintoretto's picture. The collapsing of far and near, of past and present, was an essential operation in such reading of images, and over many years the Venetian public had effectively been educated in such visual literacy: they knew how to read the allusions to their San Marco in the pictorial reconstructions of the orient, how to locate themselves—through the portraits of their contemporaries—in the great events of the past, how to claim the eternal vigilance of their patron St. Mark on behalf of his favored city. To this civic religious language Tintoretto added a new kind of grammar and syntax of figural inflection, a new corporeal eloquence—as well as a new painterly command that gave visual form to the saint's odor of sanctity, the confirming perfumed emanation that smelled like pork to the infidel.[42]

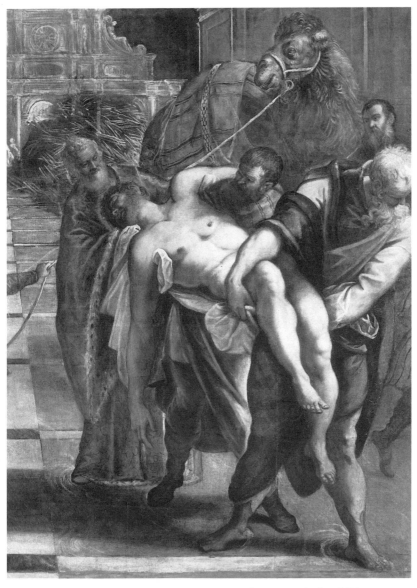

FIGURE 68: Jacopo Tintoretto, *The Rescue of the Body of St. Mark*, detail (Photo:
Soprintendenza ai Beni Artistici e Storici di Venezia).

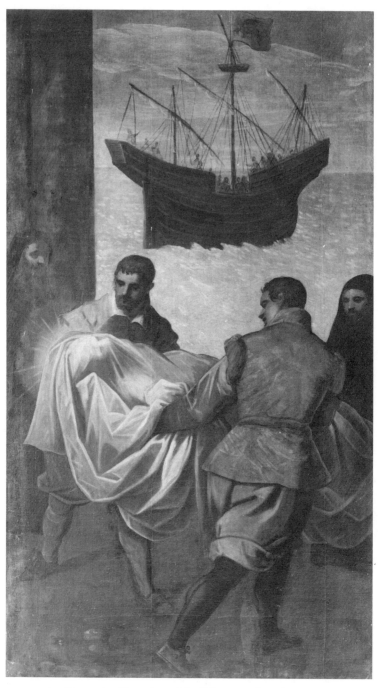

FIGURE 69: Domenico Tintoretto, *The Abduction of the Body of St. Mark.*
Ospedale Civile, Venice (Photo: Böhm).

FIGURE 70: Domenico Tintoretto, *The Reception of the Body of St. Mark.*
Ospedale Civile, Venice (Photo: Böhm).

FIGURE 71: Domenico Tintoretto, *The Miraculous Apparition of the Relics.*
Ospedale Civile, Venice (Photo: Böhm).

The full patriotic resonance of Tintoretto's canvas was made more ex-
plicit as the brothers of the Scuola di San Marco filled out the cycle of
their saint's legend and the details of his special relation to Venice. Twenty
years later, in 1586, they negotiated with the painter to complete the deco-
ration of their hall. The primary responsibility for executing these canvases
fell to the painter's son Domenico.[43] Following the narrative mosaic cycles
of San Marco itself, the major pictorial source of the legend—and almost
despite the implications of Tintoretto's canvas—the *confratelli* wanted a
scene of the Venetian merchants carrying the disguised body of the saint
to their ship, at anchor in the harbor of Alexandria (fig. 69), and then the
reception of the body by doge and Signoria in Venice (fig. 70). Included
in the cycle as well was the *Miraculous Apparition of the Relics in San Marco*
(fig. 71), the self-revelation of the saint's relics in 1094. To either side of the

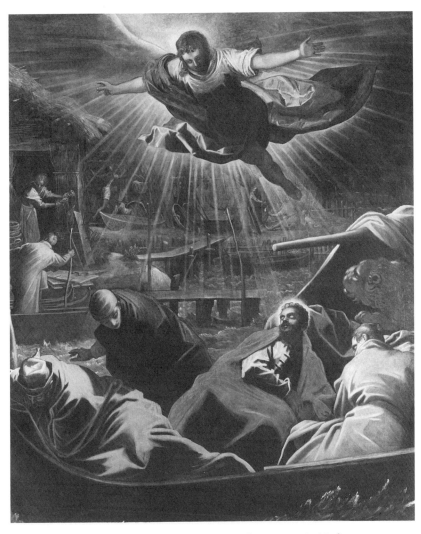

FIGURE 72: Jacopo and Domenico Tintoretto, *The Dream of St. Mark.*
Gallerie dell'Accademia, Venice (Photo: Soprintendenza ai Beni Artistici
e Storici di Venezia).

altar at the head of the *sala del capitolo* were canvases essential to the procla-
mation of the Marcian myth. One, of course, was the *praedestinatio*, the
*Dream of St. Mark* (fig. 72): the angel's appearance to the saint asleep on the
waters of the lagoon and his promise of peace. The other, however, repre-
sents a new subject in the elaboration of the myth (fig. 73): the saint's bene-

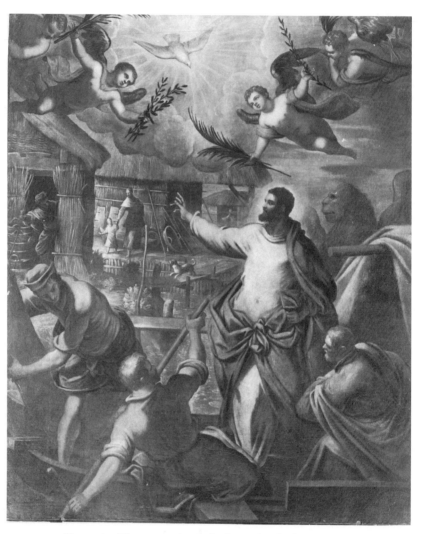

FIGURE 73: Domenico Tintoretto, *St. Mark Blessing the Islands of the Lagoon.*
Ospedale Civile, Venice (Photo: Böhm).

diction of the place of his vision, the rustic islands of the lagoon, with their
primitive fishermen's huts: the future site of Venice itself.

The pictorial decoration of the two main rooms of the Scuola Grande
di San Marco was finally completed after nearly a century. Always con-
scious of the privileged status conferred through sharing a patron saint
with the Republic itself, the brothers of the Scuola, as they commissioned
the canvases that rehearsed the well-known legends, took as their ultimate

iconographic model and inspiration the mosaic and sculptural cycles of the saint's own church. To the standard *exempla*, however, they added one final note, the benediction of the place. Above the figure of the saint in the Tintoretto composition, angels carry palms of martyrdom and victory and olive branches of peace. *Pax tibi Marce.* By the end of the sixteenth century the peace of St. Mark had indeed become a gift that Venice, the militant posture of its lion no longer credible, claimed to offer the world.

# 3

# THE WISDOM OF SOLOMON

The relics of St. Mark sanctify the city of Venice, most pointedly its spiritual and civic heart, marked by the basilica of San Marco and the Ducal Palace. From the outset, the reliquary chapel built to accommodate the relics after their arrival in 829 was attached to the *castello ducale*, and, although each was reconstructed several times in its long history, the architectural intimacy of the two buildings continued to manifest the unity of religion and state in this Republic. That visible relationship lent a particular inflection to the meaning of the Ducal Palace itself. As Francesco Sansovino wrote, the palace and the church were joined because "it seemed appropriate to the Venetians of old that justice should embrace peace and religion, according to the words of the psalm" (85:10).[1]

Founded in the ninth century, the governmental palace of Venice underwent a series of renovations and restorations over the centuries, especially following destructive fires. The Ducal Palace acquired its present Gothic style, its pink and white walls set buoyantly above an open loggia, in the fourteenth century, when major reconstruction led to the creation of an enlarged Sala del Maggior Consiglio—which by 1365 was ready to receive its first fresco by Guariento, the *Coronation of the Virgin*. During the dogate of Sebastiano Ziani (1172–78), extensive remodeling involved three distinct wings of the complex, corresponding to its several functions: facing south, onto the *bacino*, was the communal palace, housing the hall of the Great Council (figs. 2, 18); to the west was the palace of justice (fig. 22), and, to the east, along the canal, there were the residential apartments of the doge. Punctuating the west facade, on the Piazzetta, is the carved roun-

del with the enthroned *Venecia*, "strong and just" (fig. 21). This is located on the part of the palace dedicated to justice (*ad jus reddendum*), a location that serves to inflect the figure of Venice as Justice, even as the figure itself proclaims the function of the building.

Venice, as observed earlier, embodies Justice, and that virtue animates the entire Ducal Palace, dominating the sculptural embellishment of the building and articulating its very meaning. Alessandro Vittoria's crowning figures of Justice and Venice (figs. 24, 25), silhouetted against the sky, together recapitulate the fundamental figural theme initiated in the roundel more than two centuries earlier.

The logic of the equation of state and virtue and the implications of its expanding iconographic potential extends to the elaborate sculptural program of the Ducal Palace. The basic theme is sounded fully at the monumental entrance to the palace, the Porta della Carta (plate 4). Constructed under Doge Francesco Foscari (1423–57)—whose kneeling figure before Venice *in forma de lion* dominates the design (fig. 31: a late nineteenth-century copy, the original having been destroyed in 1797)—the project was commissioned of Giovanni and Bartolomeo Bon in 1438. In 1441 the crowning figure was installed atop the pinnacle, set upon a base inscribed IVSTICIA (fig. 23). Holding her attributes of sword and scales, this regal woman sits upon the Solomonic throne, flanked by lions. Marked as Justice, she is as clearly Venice as the fourteenth-century VENECIA is Justice.[2]

In the tabernacles to either side are the other cardinal virtues: Temperance, Prudence, and Fortitude. The space abandoned by Justice in her elevation to the top has been assigned to Charity, the greatest of the three theological virtues, according to St. Paul (1 Cor. 13). Indeed, along with Justice, Charity was the highest virtue of the benevolent state; the well-being of its citizens, which guaranteed the serenity of the state, depended upon a policy of distributive justice—from the sharing of privilege among the patriciate to the provision of food and shelter to the poor.[3]

At the corner of the palace adjacent to the Porta della Carta, above the capital of the massive column, a sculpted group representing the Judgment of Solomon announces the major theme of the Ducal Palace in a narrative key (fig. 74). On the capital below are represented scenes of justice and law-giving—including the figures of Aristotle, Moses, Solon, Scipio,

FIGURE 74: Bartolomeo Bon, *The Judgment of Solomon*. Ducal Palace
(Photo: Author).

Numa Pompilius, and Trajan; a personification of Justice herself declares its central motif. The public legibility of this imagery is attested by the response of a Florentine visitor in 1442, who described this miraculous city in verse:

> Evvi un palagio tanto suntuoso,
> Fatto di pietre vive e molte storie
> Co[n] molti intagli e tutto grazioso,
> Nei quali si vede la memoria
> Del savio Salamon colla giustizia
> Che fece a quelle donne . . .
>
> There is a palace so sumptuous,
> Made of stone and with many stories
> Carved, and all most graceful,
> In which is seen the memory
> Of wise Solomon with the justice
> He rendered to those women . . .[4]

The meaning of the Ducal Palace was quite clear: as Venice herself was equated with Justice, so the palace of the doge was to be considered a palace of Solomon. Solomon's construction consisted of the house of the Lord and the house of the king. And the temple "was built of stone made ready before it was brought thither" (1 Kings 6:7; 3 Kings in the Vulgate). And the foundation of the house of the king "was of costly stones, even great stones. . . . And above were costly stones, after the measures of hewed stones. . ." (1 Kings 7:10–11). Composed of carefully cut and fitted marble, declaring the wealth of Venice, the brilliant pink and white masonry of the Ducal Palace, might well recall the divinely-inspired glory of Solomon's palace. "Then he made a porch for the throne where he might judge, even the porch of judgment" (1 Kings 7:7). The most famous judgment, of course, involved the two mothers and the living and dead infants (1 Kings 3:16–28): "And all Israel heard of the judgment which the king had judged; and they feared the king: for they saw that the wisdom of God was in him, to do judgment." This is the judgment recalled in the sculpture of the Ducal Palace.

Moreover, the relationship of the Old Testament structures would have

seemed reconstituted in the very proximity of the church of San Marco and the palace of the doge, linked by the figure of Justice and the narrative manifestation of the wisdom of Solomon. Venice could be celebrated as a New Jerusalem and, with respect to divinely inspired purpose and the day of its foundation on earth, even as the most ancient city of the world, having its "most noble origin in the Mind of God . . . defended not by soldiers but by Angels, constructed not by earthly prudence but by Divine wisdom."[5] The very doctrine of the Immaculate Conception, attesting the eternity of the Virgin Mary, could be appropriated by that political virgin, the Queen of the Adriatic. Such was the rhetoric of the orators before the doge, reflecting and amplifying the implications of the imagery that formalized such notions, not least the *Paradise* that transformed the Sala del Maggior Consiglio.

King David could not build a temple to the Lord "for the wars which were about him on every side," but Solomon his son enjoyed a reign of peace allowing him to build the temple and his palace (1 Kings 5:3–5). The embodiment of justice and wisdom, Solomon was celebrated as *rex pacificus*, the king of peace. Above the sculpted group of the Judgment of Solomon on the Ducal Palace stands the Archangel Gabriel (fig. 75), the announcer to the Virgin of the Incarnation of Christ and the new reign of peace on earth. Confirming the pacific significance of the palace, Gabriel cannot but recall as well the earthly incarnation of the Republic. The archangel addresses his message across the palace portal to the church of San Marco, a direction that implicitly adds a further Venetian inflection to his announcement: *Pax tibi Marce.*[6]

Part of the early fifteenth-century reconstruction of the wing of the Ducal Palace *ad jus reddendum*, the Solomonic corner completes a cycle initiated at the most conspicuous corner of the building (southeast), at the angle of the Molo and the Piazzetta. There, above the representation of Adam and Eve, the Archangel Michael rules, sword in one hand and in the other a scroll declaring his purpose to protect the good and to punish the crimes of the wicked: ENSE BONOS TEGO MALORUM CRIMINA PURGO. Original Sin was the reason that God became Man, and that theological necessity had its analogy in the creation of Venice as a means of political salvation of mankind. The Paradise from which our first parents were expelled might be reclaimed through the laws of this Republic, which is the

FIGURE 75: Bartolomeo Bon, *The Archangel Gabriel*. Ducal Palace (Photo: Böhm).

promise implicit in the dominant mural of the Sala del Maggior Consiglio—the hall behind the Archangel of Justice.

At the southeast corner of the palace, toward the Ponte della Paglia, Noah's virtuous sons, Shem and Japheth, piously cover their drunken father's nakedness; separated from them by an arch is Ham, the son who saw and told of the nakedness of his father and was condemned to a state of servitude (Gen. 9:19–27). Above Noah, the Archangel Raphael stands as a guide leading the virtuous; the inscription on his scroll implores him to calm the tempestuous sea: EFICE QUESO FRETUM RAPHAEL REVERENDE QUIETUM. Located at the corner of the Ducal Palace closest to the sea, this appeal acquires a particularly maritime relevance, even as the hope for salvation carries its theological meaning and, of course, its political one.[7]

The promise of salvation held out by the Republic of Venice was embodied in the complex of San Marco and Ducal Palace, which, in their Solomonic conjunction, united peace and religion with justice and wisdom. As an orator proclaimed, in Venice was to be found the "pacific and wise government of Solomon."[8] If justice is the highest virtue of the state, and peace its consequence, the great and necessary virtue of those who govern is wisdom.

The rhetoric of such architectural and sculptural iconography radiated from the building complex at the heart of Venice to the newer constructions of the sixteenth century that transformed the public spaces of the Piazza, especially the Piazzetta directly opposite the Ducal Palace. That transformation was the work of Jacopo Sansovino, the Florentine sculptor and architect who, following the Sack of Rome in 1527, found refuge in Venice and, thanks in large measure to the prescience of Doge Andrea Gritti, a new career. Appointed *protomagister* to the Procuratori di San Marco, the distinguished patrician officials in charge of the church, its treasures, and its piazza, Sansovino served as architect and superintendent of buildings.

Jacopo Sansovino *Florentinus* (as he invariably signed his sculpture) in effect taught the Venetians what a public space ought to be, a public space *all'antica*, to rival the Forum of ancient Rome. Piazza San Marco realized its urbanistic potential through his architectural vision—as well as through his Herculean efforts at cleaning up the Augean mess of rent-paying stalls, shops, taverns, and hostelries, moving them from prime public real estate

to other locations. He introduced a new, monumental classicism to Venice, so that it was said, as Vasari reports, that "with his knowledge and judgment, that city has been almost entirely made anew and has learned the true and good manner of building."[9]

Two structures in particular established a new architectural tone across the Piazzetta from the Ducal Palace: the Loggetta at the foot of the campanile (plate 14) and the Libreria di San Marco (fig. 76), commissioned in 1536 and 1537, respectively. Each elaborates upon the meanings of the seat of government. The allegorical sculptural program of the Loggetta will be considered more fully in Chapter 4, but one of its bronze figures deserves immediate attention: the representation of Pallas Athena (fig. 93). Reporting his father's own explanation of the meaning of his sculpture, Francesco Sansovino sets it in the context of the longevity and eternity of the Republic, which are due to its marvelous government, based on religion and justice, and to the "high wisdom [una somma sapientia] of its Senators." The foundation of Venice is its laws, which have preserved it for so long, and those who created those laws were sapientissimi, most wise, and since for the ancients Pallas stood for wisdom, she is figured here to represent the wisdom of the rulers of this noble city.[10]

Sansovino the architect gave clearer monumental definition to the Piazzetta with the Library (fig. 76), which faces the Ducal Palace (fig. 39). This was his most sumptuous building, celebrated for its proper combination of the classical orders and for the richness of its sculptural articulation and ornament.[11] Even as it stood as a model of Roman High Renaissance classicism, Sansovino's Library also stood as a further example of the wisdom of the rulers of the Republic.

The project itself goes back to the legacy of Cardinal Bessarion, the Patriarch of Constantinople who, following the fall of that city to the Turks in 1453, found in Venice the proper home for his vast library, which included close to a thousand volumes, over half in Greek. In his letter of donation in 1468 he explained the reasons for his choice:

> As I considered this problem and thought of many cities in Italy, your glorious and most splendid state at last presented itself to me as the only one on which I could settle with complete peace of mind. First, I did not see how I could choose anywhere safer than one where justice

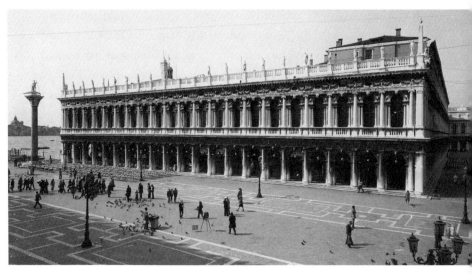

FIGURE 76: Libreria di San Marco (Photo: Alinari).

rules, the laws are upheld, wisdom and honesty are at the helm, and where virtue, restraint, morality, justice and good faith have their dwelling; where power has the most formidable resources at its disposal, but is exercised only in just measure; where minds are free to think as they wish, without fear of any hostile passion or violence; where the levers of power are in the hands of the wise; where the good are preferred to the wicked, and all forget their private advantage in the single-minded, honest service of the commonweal.

The most patriotic Venetian patrician could hardly have improved on this summary presentation of the myth of Venice. Bessarion saw in the Republic the realization of the ideal state, a modern embodiment of ancient political wisdom, founded on a constitution that seemed modeled on that formulated in the *Laws* of Plato. Indeed, the cardinal explicitly recognized the special relationship of Venice to the Greek world: "Though nations from almost all over the earth flock in vast numbers to your city, the Greeks are most numerous of all: as they sail in from their own regions they make their first landfall in Venice, and have such a tie with you that when they put into your city they feel they are entering another Byzantium." And Venice, which did indeed consider itself successor to Byzantium, had welcomed Bessarion himself with honors. "So I have given and

granted all my books, both in Latin and Greek, to the most holy shrine of the Blessed Mark in your glorious city."[12]

In pledging his precious collection to San Marco, Bessarion was clear in his purpose. He wanted to see his books "preserved in a place that is safe and accessible, for the general good of all readers, be they Greek or Latin." He wanted this repository of accumulated wisdom to serve as a public library, and the Venetian Senate agreed.

A century before Bessarion's gift Petrarch had concluded a similar deal with the Republic. Seeking the security and tranquility afforded by Venice, and in exchange for a modest palace, the celebrated humanist and poet offered to leave his library to the state. That the deal fell through did not deter later Venetian apologists from exploiting it. In 1581 Francesco Sansovino published the decree of 1362 by which the Maggior Consiglio accepted the offer of this most famous man in Christendom to name as his heir the Blessed Evangelist Mark. Like Bessarion's, Petrarch's legacy was to honor Mark, and it too was intended as a public library. Sansovino, in fact, associates the origin of the Libreria di San Marco with Petrarch's intention.[13]

Culture and learning, as both adornment and necessity to the state, had become part of the myth of Venice. "Greece was the seat of learning and powerful in arms; now the Venetians are the learned ones, now the lion is strongly armed," as Marin Sanudo, quoting an earlier source, declared in 1493.[14] Unfortunately, Bessarion's bequest suffered neglect for many decades, and it was not until the appointment of Pietro Bembo as librarian in 1530 that the initiative was taken finally to create a proper home for the library. With the construction of Sansovino's Libreria di San Marco, then, Venice boasted a magnificent public library to compare with those celebrated institutions of antiquity—most relevant, of course, that of Alexandria. This treasury of historical, philosophical, and theological knowledge, of intellectual and moral wisdom, stood as a glorious monument to the wisdom of the Republic itself. Through the architectural intelligence and imagination of Sansovino, the Piazzetta finally realized its potential as the triumphal gateway to the city: passing through the two colossal columns of St. Mark and St. Theodore, one was flanked on either side by the *domus Iustitiae* and the *domus Sapientiae* (fig. 39).[15]

On the piano nobile of the Library were the two main rooms, the grand reading room and a vestibule, at the top of a grand staircase, its vault richly

decorated *all'antica* in painting and stucco—matching the Scala d'Oro designed by Sansovino in the Ducal Palace. Above the marble portal to the reading room, which was contracted in 1553, the inscribed date is recorded *ab urbe condita MCXXXIII*, that is, calculated from the foundation of Venice in 421. Until it was converted into a museum for display of the Grimani collection of antiquities in 1591–96—another cultural bequest that came to manifest the *virtù* of the Republic—the vestibule served as an educational center; there lecturers employed by the state offered lessons in humanistic studies to young patricians. The education in Greek and Latin of noble youth at public expense had been a policy since the early fifteenth century—if not "from the foundation of the city," as proclaimed in 1511—for eloquence as well as wisdom was necessary for these future governors.[16] On Sansovino's Loggetta, the figure of Mercury (fig. 95) stood for "literature and eloquence," because wise thoughts command greater authority and are more effective when expressed eloquently.[17]

The original pedagogic function of the vestibule may clarify the interpretation of the octagonal painting by Titian that crowns the room (plate 12). The elaborate *quadratura* framework of the vault (fig. 77), a complex illusion of paired polychrome columns sustaining a set of nested cornices, was created by the brothers Cristoforo and Stefano Rosa. When the work was evaluated by Sansovino and Titian in April of 1560 "the figure that goes in the center" was not yet in place. Titian's canvas was probably installed not long after, but the earliest description we have of it dates from 1648, when Carlo Ridolfi wrote that it was believed to represent History personified.[18] The intended significance of Titian's cloud-enthroned woman was evidently no longer recognizable with any certainty. Since the early nineteenth century, however, she has generally been called Wisdom, and that identity resonates well with her setting, the Library as the house that Wisdom built: *Sapientia aedificavit sibi domum* (Prov. 9:1).[19]

As Wisdom, Titian's figure extends the Solomonic associations first embodied in the palace of justice across the Piazzetta. Although the painting is designed for a ceiling, conceived to be seen *dal sotto in sù*, the figure is not seen radically foreshortened—as are the more active protagonists of Titian's previous ceiling paintings, for the Scuola Grande di San Giovanni Evangelista and the nave of Santo Spirito in Isola.[20] Rather, foreshortening is here muted, calculated to maintain the integrity and continuity of the

FIGURE 77: Libreria di San Marco, vestibule ceiling (Photo: Böhm).

figure. Filling the octagonal field of the canvas, this figure subtly accommodates itself to the picture plane so that she seems barely to acknowledge the strained angle of vision. She balances a long scroll, its inscription tantalizingly illegible, and gazes at the object held up to her by a winged putto, not a book but a mirror — a self-reflection we may compare with the more cosmetic situation of the *Toilet of Venus* in the National Gallery of Art.[21] Set up in the heavens, she reclines almost languidly on a cloud that

derives its supporting substance from the structure of Titian's brushwork. Indeed, it is the prominence of the cloud that lends further credibility to the identity of this creature as Divine Wisdom.

"I came out of the mouth of the most High, the firstborn before all creatures: I made that in the heavens there should rise a light that never faileth, and as a cloud I covered all the earth: I dwelt in the highest places, and my throne is a pillar of cloud": Thus declares Divine Wisdom in the apocryphal Ecclesiasticus (24:5–7); so does she proclaim her eternity in Proverbs (8:23): *Ab aeterno ordinata sum*. With full pictorial conviction the cumulus throne of Titian's hovering figure realizes that image: *Ego in altissimi habitavi, et thronus meus in columna nubis*.

Divine Wisdom is described, venerated, and given voice in Proverbs and Ecclesiasticus, as well as in the apocryphal Book of Wisdom: "For she is the brightness of eternal light: and the unspotted mirror of God's majesty, and the image of his goodness" (7:24). These texts enjoyed an enormous theological resonance. Along with the Song of Songs, the most famous Solomonic text, they provided the basis for the development of the Marian liturgy and the doctrine of the Immaculate Conception. Like Proverbs, the Book of Wisdom is written in the voice of Solomon himself. It is addressed to the rulers of the earth and admonishes them to love and exercise justice and wisdom. The opening words announce its basic theme: "Love justice, you that are the judges of the earth." (*Diligite iustitiam, qui iudicatis terram*).

As Divine Wisdom, then, Titian's figure embodies those Solomonic themes extended from the Ducal Palace and given new inflection and resonance in Sansovino's library building. That the noble youth of Venice should be instructed under her eternal aegis was appropriate, "For in her is the spirit of understanding" (Wisdom 7:22). Practically and symbolically, Wisdom adds herself to the figuration of the Republic.

The celebrated serenity of this Republic ruled by a small patrician minority depended upon the extension of certain protections and privileges to the disenfranchised majority of its citizenry. The most visible means of such extension, as noted earlier, was the system of guilds and confraternities through which the nonpatrician found his place within the structure of the state. This was especially true of the *scuole grandi*, which, as Francesco Sansovino explains, "represent a certain type of civil government, in which

as if in a republic of their own, the citizens enjoy rank and honor according to their merits and qualities."[22] Their officers enjoyed a dignity that was compared to that of the Procuratori di San Marco, and their buildings imitated the Ducal Palace itself in splendor, their chapter halls the Sala del Maggior Consiglio. The *scuole* reflected in plebeian microcosm the larger order of the patrician state, and their wealth and splendor were in turn an adornment of that state as well as of religion.

Just as they participated in the public spectacle of official Venetian self-celebration, the *scuole* themselves contributed to the dissemination of Venetian iconography and ideology. We have traced that process in the most obvious case of the Scuola Grande di San Marco and its pictorial elaboration of the legends of St. Mark. We can follow the extension of the Solomonic themes we have been considering to the Scuola Grande di Santa Maria della Carità, specifically in the great canvas that Titian painted between 1534 and 1538 for the *sala dell'albergo* representing the Presentation of the Virgin in the Temple (plate 13).

The Scuola della Carità had originally commissioned the mural in 1504 of Pasqualino Veneto, a minor painter who died before executing the work; the brothers evidently kept the design he submitted, and they may well have asked Titian to respect it in some way when they commissioned him thirty years later. Indeed, Titian's *Presentation of the Virgin*, so insistently planar in structure and ceremonial in mood, has often struck critics as disturbingly traditional in composition, if not downright *retardataire*; an apparent revival of the processional tableaux of the generation of Gentile Bellini and Carpaccio, it has been deemed unworthy of a true High Renaissance master. Such respect for tradition would hardly be unusual in the conservative world of the Venetian *scuole*—recall, for example, the problematic reception in 1548 of Tintoretto's radical design for the Scuola di San Marco. The adherence to an archaic type of mural decoration by a painter who had already proved himself brilliantly innovative and inventive—who had revolutionized the altarpiece in Venice and expanded the techniques of painting in oil—should lead us to expect in such apparent reversion deliberate purpose and motivation.

Titian's *Presentation of the Virgin* has remained *in situ*, filling the entrance wall to the *albergo* (fig. 78), and that setting begins to define the possibilities of meaning in the painting. More obviously than the other *scuole grandi*,

the Scuola di Santa Maria della Carità was dedicated to its titular virtue. Its *mariegola,* or statutes, proudly affirm that principle: "Our fraternity originated from the greatest love and affection for our fellow man and is named after the glorious and honored name of the major theological virtue, charity, in which is the faith of God."[23] Charity, we recall, figured prominently on the Ducal Palace: she took the place of Justice among the virtues on the Porta della Carta, and she fills the roundel of the balcony on the Molo facade.[24] Charity activates the scene at the extreme left of Titian's composition, where *confratelli* of the Scuola della Carità distribute alms to an importunate mother holding her child, herself a mundane rendering of the allegorical personification of the virtue. Although beggars were a traditional presence at the entrance to the Temple, the act of charity in this milieu assumes a decidedly local relevance.

Central to the pictorial task of composing a Presentation of the Virgin is the challenge of its architectural stage, that is, recreating the ancient Temple itself. To the reconstruction of the Temple of Solomon Titian brought a formidable pictorial intelligence and a profound iconographic and architectural knowledge. Traditionally, the staircase to the Temple was a flight of fifteen steps, "one for each of the Gradual Psalms," as explained in the *Golden Legend*. At the age of three, Mary was brought by her parents "to the Lord's Temple with offerings. . . . The virgin child was set down at the lowest step and mounted to the top without help from anyone, as if she were already fully grown up."[25] Titian, however, designed a staircase of only thirteen steps, broken significantly to establish a ratio of 8:5; the Virgin thus stands at a point defining the golden section. In seeking to create a temple that would appropriately reflect the perfection of divinely inspired proportions according to the standards of the Renaissance, Titian naturally turned to the example of classical antiquity, specifically, to Vitruvius. Among the discoveries of human wisdom described in the preface to the ninth book *De architectura* is the Pythagorean triangle—whose discoverer, Vitruvius recounts, was convinced that the Muses had inspired him. The Roman author recommends that the proportions of this triangle be used as a guide in the construction of staircases, and Titian evidently followed this advice: each of the two flights of the staircase in the *Presentation* is based on that 3:4:5 ratio. The deliberate planimetric articulation of the drafted masonry, regardless of any possible relation to Serlio or to con-

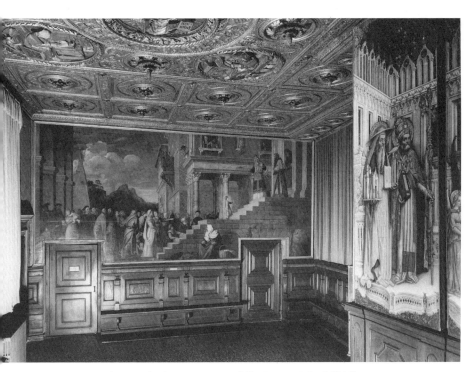

FIGURE 78: Scuola Grande di Santa Maria della Carità, Sala dell'Albergo
(now Gallerie dell'Accademia) (Photo: Soprintendenza ai Beni Artistici e
Storici di Venezia).

temporary architectural models, thus assumes a critical function in under-
scoring the commensurability and proportionality of this structure.[26]

Solomon's architectural project, we recall, included both the Temple of
the Lord and the palace of the king, the latter structure distinguished by a
*porticum columnarum*. Just such a porch of columns provides the immediate
backdrop for the Virgin in Titian's painting, marking her position with a
certain precision. More than a casual scenographic device, this porch of
columns represents a further constituent in the reconstruction of the Solo-
monic complex. Just beyond the colonnades of the portico, a rich diaper
pattern of pink and white masonry introduces a further dimension of ar-
chitectural allusion, one that resonates with obvious *venezianità*. Often ap-
preciated for the way in which it offers a monumental tectonic correlative
to the broken touches of Titian's brush, this polychrome wall unambigu-
ously evokes the Ducal Palace. If the Ducal Palace itself could be seen as a

Palace of Solomon redux, the full Solomonic setting of Titian's painting confirms the legitimacy of the equation. By this means the architecture of the *Presentation* extends from scriptural antiquity to the Venetian present.

In much the same way, the portraits of the *confratelli* expand the temporal dimensions of the dramatis personae, affirming the meaning of the past in the present.[27] And as they participate in the Presentation of the Virgin, the officers of the Scuola della Carità, assembled in the left half of Titian's composition, quite appropriately balance the patrician architecture of state, on the right. As we shall see, that contrast between the two sides of the painting determines a central dimension of its meaning.

Typically, Titian fitted his picture to its architectural setting. He was especially attentive to the sources of illumination. In the *albergo* of the Scuola della Carità there are, in effect, two, and Titian exploited both. Windows to the left of the entrance wall provide the source of natural light. From the center of the late fifteenth-century ceiling emanates a heavenly light (fig. 79). Elaborately carved, painted, and gilded, the ceiling features in its central roundel the figure of Christ Pantocrator, surrounded by the four Evangelists. Emitting golden rays, the deity displays an open book inscribed, *Ego sum lux mundi* ("I am the light of the world"). From the Gospel of St. John (8:12), these words initiate the major theme of Titian's picture: the diffusion of that divine light into the world.

In the painting below, the young Mary is surrounded by a full mandorla of golden light, a venerable sign of theophany. Even as she restates the gold and blue color notes of the ceiling, Mary shines as *theotókos*, she who bears the light that is Christ. Light as a metaphor for the Virgin belongs, of course, to an impressive liturgical and aesthetic tradition, a tradition founded on the same Solomonic texts we have been considering, the descriptions of Divine Wisdom: "For she is the brightness of eternal light: and the unspotted mirror of God's majesty, and the image of his goodness" (Wisdom 7:26). "For she is more beautiful than the sun, and above all the order of the stars: being compared with the light, she is found before it" (Wisdom 7:29).

The many virtues and attributes of Divine Wisdom were early transferred to the person of Mary, becoming a basic part of the liturgical celebration of the Virgin. In the fifteenth century that language found new visual expression at the hands of painters capable of exploiting the oil

FIGURE 79: Scuola Grande di Santa Maria della Carità, Sala dell'Albergo ceiling (now Gallerie dell'Accademia) (Photo: Böhm).

medium to realize the potential of such imagery—one thinks initially of Jan van Eyck.[28] And it is important to appreciate the crucial role of the painter in this development, for his active participation was the critical factor in giving tangible form to literary metaphor.

This imagery and these same Wisdom texts underlie Titian's *Presentation of the Virgin*, the essential meaning of which is epitomized in the contrasts of lights. The divinely radiant Virgin on the stairs does indeed rival and outshine the natural light entering through the windows of the room; she is the light beyond the light of nature, a radiance more brilliant than the sun. Such luministic imagery was indeed traditional in Byzantine representations of the Presentation of the Virgin. The particular conditions of the *albergo* of the Scuola della Carità, however, encouraged Titian to reconsider

its pictorial potential with new imaginative energy. The painter found in the textual sources a wealth of imagery awaiting, as it were, visual expression. The Wisdom texts, then, offer a key to reading this *Presentation of the Virgin*; they allow us to discover significance in many of the details that have generally been taken as merely picturesque. Instead, such details participate eloquently in the construction of meaning when viewed within the controlling context of a unified thematic structure.

The major contrast between the two sides of the composition, landscape and architecture, implies a certain dialectic inherent in the design itself, one that assigns specific values to these forms. Against the Temple and the Virgin ascending its stairs stand two great mountain peaks, surmounted by a billowing cumulus cloud. Marking the figures of Mary's aged parents, Anna and Joachim, in the procession below, these twin peaks have always been appreciated from a naturalistic bias, recognized as magnificently depicted recollections of the Dolomites around Titian's native Cadore. Their distinct formal prominence, however, clearly presumes a consonantly weighted significance, especially since they are rather precisely related to the Virgin. Like her, they are elevated above the crowd, their distant color inflecting the blue of her dress.

The juxtaposition is clearly comparative, and it returns us to the figure of Divine Wisdom: "The Lord possessed me in the beginning of his ways, before he made anything from the beginning. I was set up from eternity, and of old before the earth was made. . . . The mountains with their huge bulk had not as yet been established: before the hills I was brought forth" (Prov. 8:22–25). Like the sunlight, the mountains in the *Presentation* provide a natural standard against which to measure the eternal brilliance of the Virgin—the concept of *Maria aeterna*, central to the doctrine of the Immaculate Conception and celebrated in her liturgy: "From the beginning and before the ages was I created and never shall I cease to be" (Eccles. 24:14).[29]

The idea of the eternity of the Virgin as Divine Wisdom is further expressed in Titian's painting by the elongated pyramid at the left. Egyptologists of the Renaissance were familiar with the ancient association of the pyramid or obelisk with the sun, the form itself imitating the rays of the sun, which was the object of worship. As an architectural symbol of radiance the pyramid stands as witness to the incarnation of Divine Wisdom

in distant antiquity and hence to her eternity. That association was readily transferred to the Immaculate Conception of Mary, and the form seems to have acquired this particular symbolic function in images of the Presentation of the Virgin—by, for example, Peruzzi, Lorenzo Lotto, and, following Titian, Tintoretto.

Behind the pyramid and above the mountains rises the great cumulus cloud, its luminous shape dominating the left side of the canvas. Moving so majestically over the landscape, it too carries a meaning beyond its obvious naturalistic function. It too relates directly to the Virgin as Divine Wisdom: "I came out of the mouth of the most High, the firstborn before all creatures: I made that in the heavens there should rise a light that never faileth, and as a cloud I covered all the earth: I dwelt in the highest places, and my throne is a pillar of cloud" (Eccles. 24:5–7). In this nebulous form, divinity presides over Titian's landscape; together, pyramid and cloud become a monumental hieroglyph of the divine immanence, while on the opposite side of the picture the Virgin's radiance speaks of its ultimate incarnation for the salvation of mankind.

There are further dimensions of meaning in Titian's *Presentation of the Virgin*, especially the opposition between the Virgin Mary and the old egg-seller seated before the stairs to the Temple and, significantly, outside its space: they figure, respectively, the initiation of the new era of grace and the old era of the law, Ecclesia and Synagoga. The latter was one of the dramatis personae in the *sacra rappresentazione* of the Presentation of the Virgin, a sacred drama in which the crone Synagoga is expelled from the church in derision—a drama that was in fact introduced from Byzantium to the West via Venice. More immediately relevant to our theme, however, is the identification of the old woman as "A foolish woman and clamorous, and full of allurements, and knowing nothing at all," the *mulier stulta et clamosa* of Proverbs, whose loud ignorance is poignantly contrasted to Wisdom's promise of life and salvation (Prov. 9:13, 8:35).

This reading of Titian's *Presentation of the Virgin* may sound over-determined, and the number of elements contributing to its meaning may seem daunting—although there are still others I have not addressed. When I first offered this interpretation, over twenty-five years ago, I sought to emphasize the degree to which all the parts participate synthetically in the overall unity of the composition, a unity that is both conceptual and for-

mal. If the *Presentation of the Virgin* can no longer be considered simply a *retardataire* composition, it is nonetheless a major monument in what may be considered the extended life of an older Venetian pictorial tradition. At a time when modish central Italian scenographic perspective models were rendering the Venetian tableau composition aesthetically obsolete—and, again, the example of the young Tintoretto comes to mind—Titian demonstrated, and on a grand scale, the still vital potential of the native tradition. Indeed, the stylistic reference functions as part of the meaning of the picture; evoking as it does an unmistakable sense of history and tradition, it celebrates the continuity and stability of the Serenissima and, of course, its institutions such as the *scuole grandi*. By pictorially exploring and exploiting the textual sources of both Christian and Venetian iconography, Titian gave the most subtle yet resonant expression to the wisdom of Venice. As *Maria aeterna* enters the Temple, set against the distinctive masonry of the Venetian *domus Iustitiae*, a Venetian attuned to the resonance of such imagery might well have recalled the state liturgy celebrating the eternity of Venice herself: *qui dominium venetum ab eterno mirabilitur deposuit.*

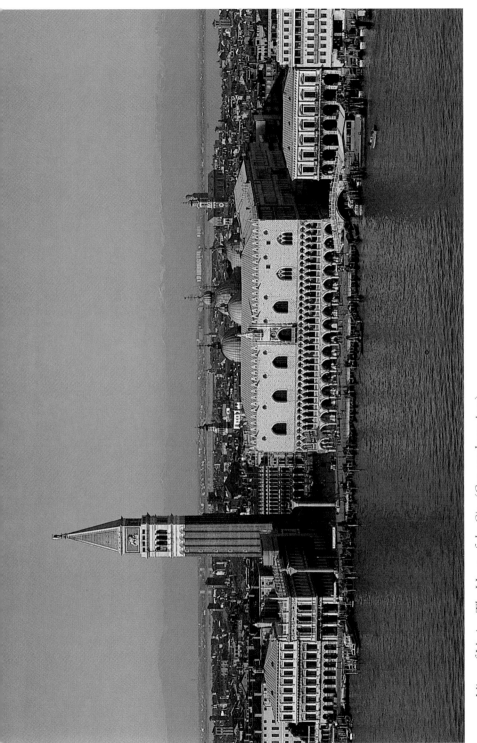

PLATE 1: View of Venice: The Heart of the City (Cameraphoto Arte).

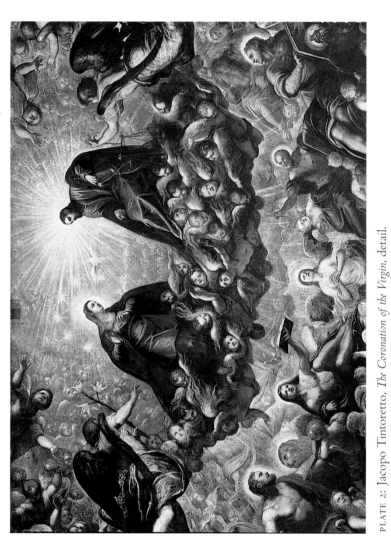

PLATE 2: Jacopo Tintoretto, *The Coronation of the Virgin*, detail.
Sala del Maggior Consiglio, Ducal Palace (Cameraphoto Arte).

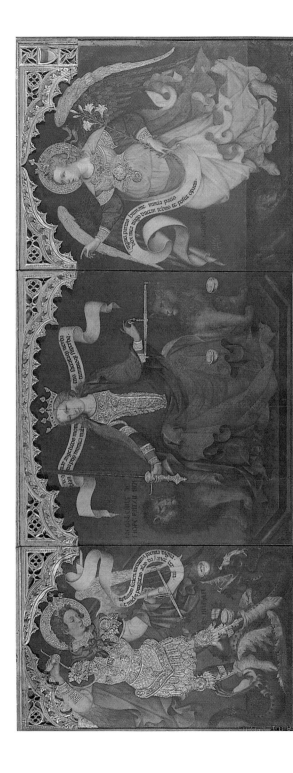

PLATE 3: Jacobello del Fiore, *Justice with the Archangels Michael and Gabriel*. Gallerie dell'Accademia, Venice (Cameraphoto Arte).

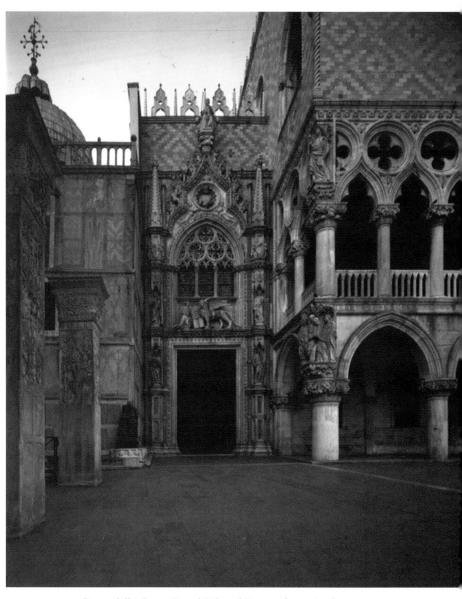

PLATE 4: Porta della Carta, Ducal Palace (Cameraphoto Arte).

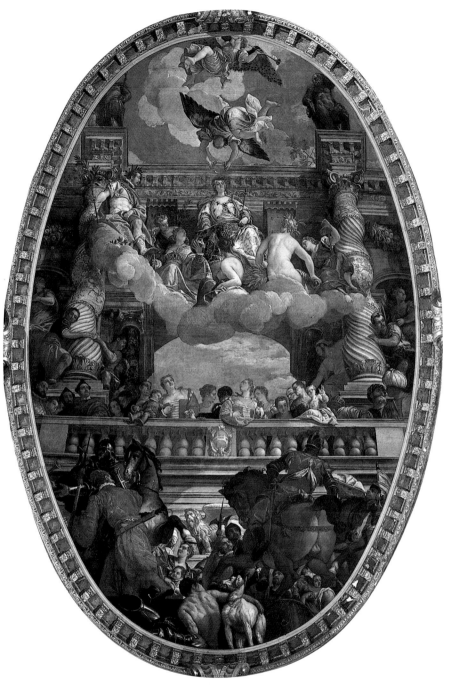

PLATE 5: Paolo Veronese, *The Apotheosis of Venice (Pax Veneta)*.
Sala del Maggior Consiglio, Ducal Palace (Cameraphoto Arte).

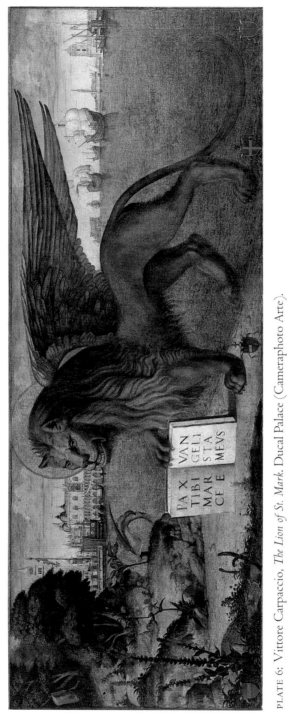

PLATE 6: Vittore Carpaccio, *The Lion of St. Mark*. Ducal Palace (Cameraphoto Arte).

PLATE 7: Gentile Bellini, *Procession in Piazza San Marco*. Gallerie dell'Accademia, Venice (Cameraphoto Arte).

PLATE 8: Gentile and Giovanni Bellini, St. *Mark Preaching in Alexandria*. Pinacoteca di Brera, Milan (Erich Lessing/Art Resource).

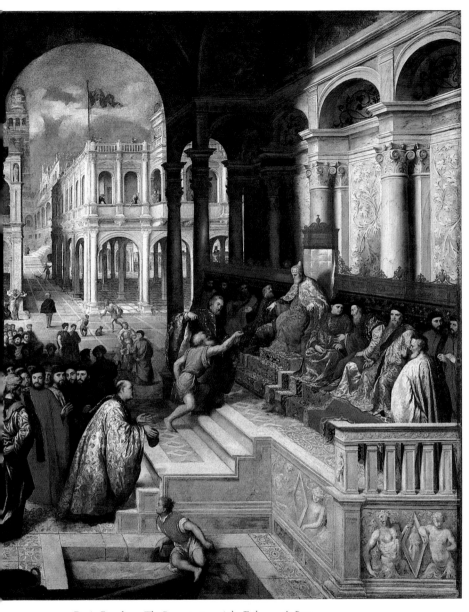

PLATE 9: Paris Bordon, *The Presentation of the Fisherman's Ring.*
Gallerie dell'Accademia, Venice (Cameraphoto Arte).

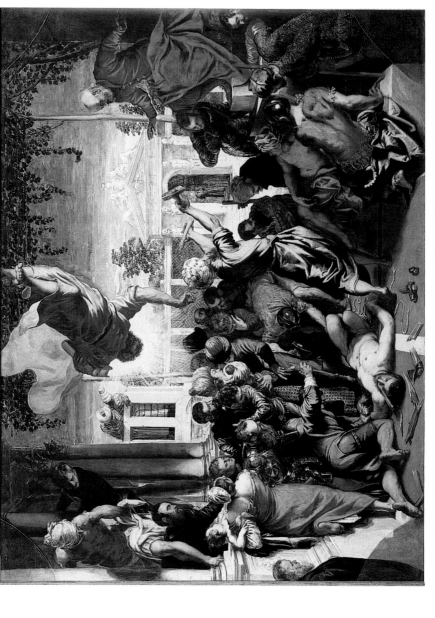

PLATE 10: Jacopo Tintoretto, *St. Mark Saving the Slave of Provence*. Gallerie dell'Accademia, Venice

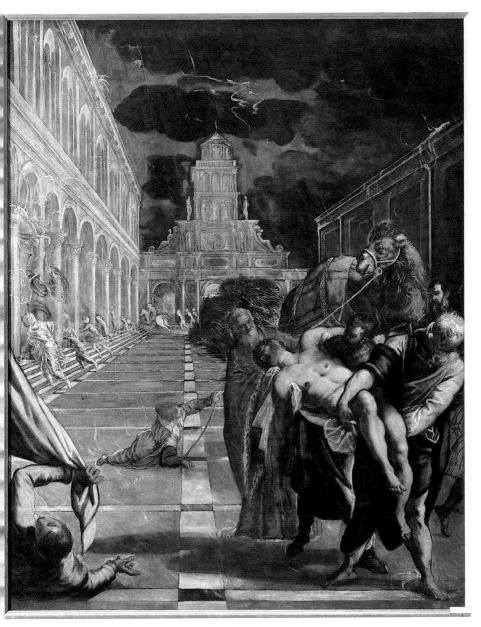

PLATE II: Jacopo Tintoretto, *The Rescue of the Body of St. Mark*.
Gallerie dell'Accademia, Venice (Cameraphoto Arte).

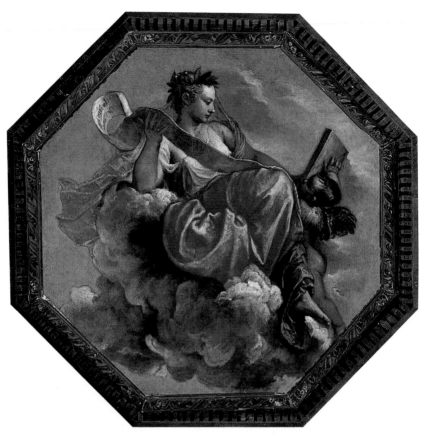

PLATE 12: Titian, *Wisdom*. Libreria di San Marco, vestibule ceiling (Cameraphoto Arte).

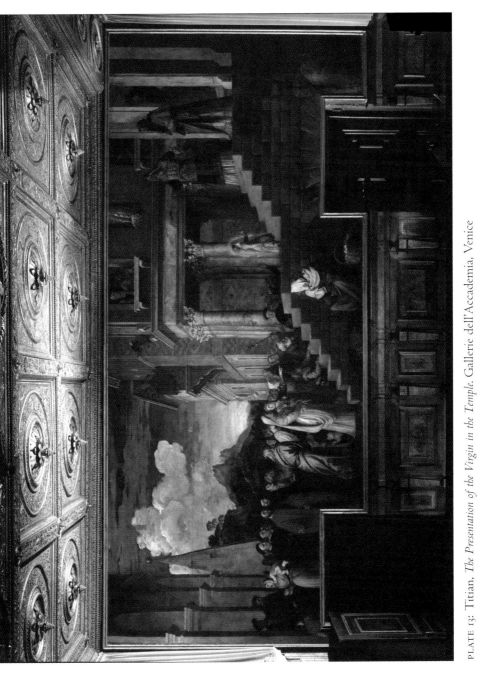

PLATE 13: Titian, *The Presentation of the Virgin in the Temple*. Gallerie dell'Accademia, Venice (ex-Sala dell'Albergo, Scuola Grande di Santa Maria della Carità) (Cameraphoto Arte).

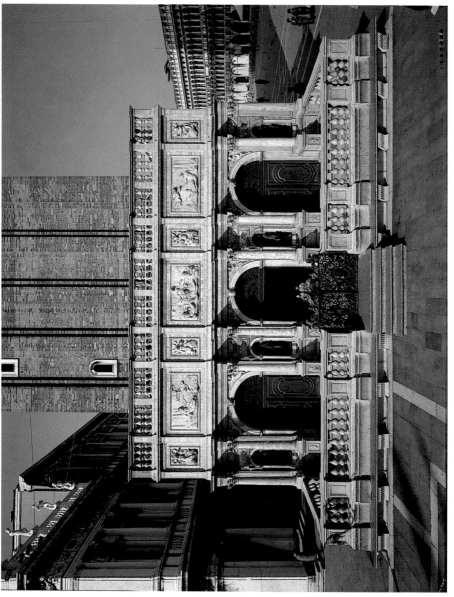

PLATE 14. Iacopo Sansovino, Loggetta di San Marco (Cameraphoto Arte)

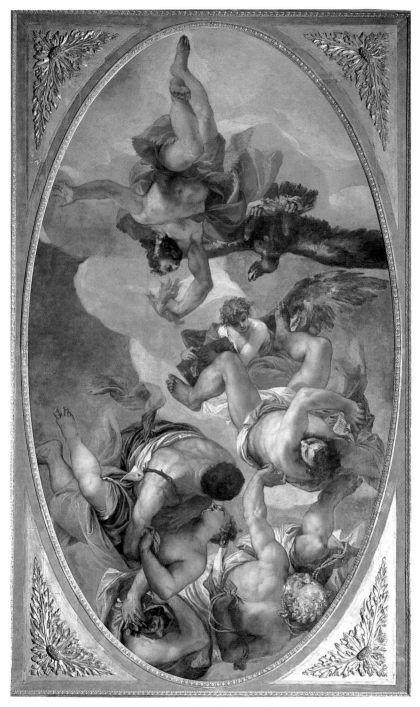

PLATE 15: Paolo Veronese, *Jupiter Expelling the Vices*. Musée du Louvre, Paris
(Erich Lessing/Art Resource).

PLATE 16: Giambattista Tiepolo, *Venice Receiving the Gifts of Neptune*. Ducal Palace (Cameraphoto Arte).

# THE APPROPRIATION OF OLYMPUS

With the constant celebration of the city's wondrous foundation upon the waters, rising miraculously from the sea, it was inevitable that Venetian mythography should appropriate that other sea-born goddess of antiquity, Venus herself. The implications of the parallel were most explicitly realized on the reverse of a medal of Sebastiano Renier (fig. 80). Inscribed MEMORIAE ORIGINI VENETIAE, it depicts a female nude riding above the waves, holding in her hand the standard of St. Mark: *Venetia anadyomene*. As a type, the medal, with its highly individual *impresa*, tends to be a rather personal form of expression. For this Venetian noble, however, the image on the reverse carries a more public responsibility. Although a nude personification of Venice may be rare, the *concetto* is immediately legible; Renier's numismatic invention undoubtedly spoke clearly and eloquently to the Venetian imagination.[1]

However apparently incompatible with the notion of Venetia Vergine, of Venice of the Annunciation, the notion of a beautiful woman representing Divine Love was itself central to the image of Mary as developed by Renaissance artists. Indeed, that fateful twenty-fifth day of March in the Year of Our Lord 421 also belonged to the ancient goddess of love: on that birthday of Venice, Venus was ascendant, as confirmed by the horoscope charted by the astrologers, and the planetary conjunction naturally augured well for the destiny of the newborn city.[2]

Like Venus, Venice was born of the sea, and what was at first metaphoric and suggestive, poetic even, became a standard topos later as Venice herself became a literary theme of her own.

FIGURE 80: Medal of Sebastiano Renier. Bibliothèque Nationale, Paris (Photo: Bibliothèque Nationale).

Again, the English prove avid readers of the Venetian myth. James Howell writes that Venice "is no other than a Convention of little islands peeping up above the waters," completing the image of "her salt tayle seepd and brind perpetually in the Sea." From that ostensibly objective description, his account takes characteristic flight:

> In so much that it may be well thought that the Goddesse Venus and the Cittie of Venice had one kind of procreation being both engendered by the Sea; It is also very likely Aphrodite that wanton Lady had her Original out of that white Spume which Neptune casts upon those little gentle Islands wheron Venice makes her bed.[3]

Howell was drawing upon a Venetian poetic tradition, somewhat folkloric and difficult to document precisely, which he probably knew through Giovanni Nicolò Doglione's *Venetia trionfante et sempre libera* (1613). The opening pages of this little book celebrate the mythological origins of the miraculous city and, in an accompanying poem, the etymological implications of her name. Playing upon the names of Venus and Venice, an anonymous poet wonders whether the goddess had given her name to the city or vice versa; in any event, he concludes that whoever failed to love Venice was incapable of loving Venus.[4]

Venice had figured herself first as Justice and as Virgin; to those aspects

was now added a Venereal dimension. This identification with the goddess of love was part of a larger programmatic appropriation of the Olympian deities that marks Venetian self-imaging in the Cinquecento, part of the increasingly deliberate application of classical visual language to the glorification of the Republic.[5]

At the very beginning of the century, two pagan deities watch over Venice in Jacopo de' Barbari's monumental graphic representation of the city published in 1500 (fig. 4). Above, the god of commerce pledges his protection of this "above all other emporia" (fig. 5). Below, astride a dolphin in the *bacino*, the god of the seas declares Venice his home and promises smooth sailing (fig. 6). Their words sanction the rhetoric of the marvelous city whose greatness derives as much from its international maritime commerce as from the laws of its constitution.[6]

Toward the end of the fifteenth century Venice was at the height of its power and prosperity, its empire having achieved maximum extension on the terra firma. Just that ambition and success led to the League of Cambrai, the alliance of the major powers of Europe against the Serenissima; following the disastrous defeat of Venetian forces at Agnadello on May 14, 1509, nearly the entire mainland dominion was lost and the very survival of the Republic seemed in doubt. Miraculously, Venice recovered. By the final signing of peace at Bologna in 1530, which followed years of maneuvering and realignments, she had regained most of the *stato da terra*, primarily through astute diplomacy.

Battling foreign invaders, Venice proclaimed herself the defender of Italian freedom—just as she claimed to be the most ardent champion of Christianity against the Turks. The realities of fact and policy may put into question the assertions of public rhetoric, but it is the rhetoric itself that inspires the imagery that is our concern. As her actual power waned, Venice presented herself as the champion of peace, even as she assumed an increasingly heroic posture, which found visual expression in the more monumental Roman classicism introduced above all by Jacopo Sansovino.[7]

The shift in attitude is well represented by another pair of pagan gods co-opted by Venetian propaganda, the colossal statues of Mars and Neptune with which Sansovino crowned the grand Quattrocento staircase of the Ducal Palace in 1566 (fig. 81). Referred to in the documents as *giganti*, these figures were commissioned in 1554, to be carved from blocks of mar-

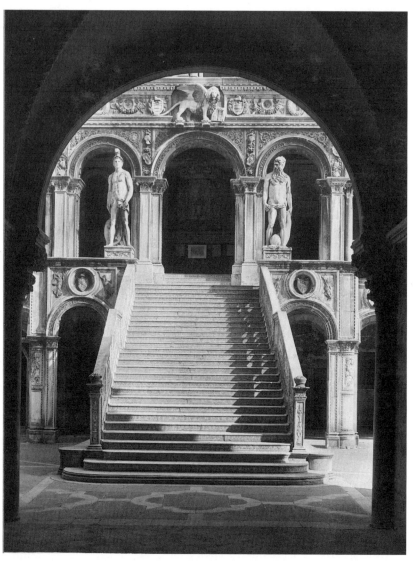

FIGURE 81: Scala dei Giganti, Ducal Palace (Photo: Alinari).

ble ten Venetian feet in length "to be installed for the adornment of this palace wherever seems most appropriate."[8] Their particular siting was undoubtedly determined by the artist himself, "for the honor of this City and of this Palace," and it gave a name to the staircase designed by Antonio Rizzo and built between 1485 and 1495. In his book on the most noble and singular city of Venice, Francesco Sansovino proves sensitive to the sceno-

graphic impact of this situation. Standing before the campanile, he explains, one sees through the aperture of the Arco Foscari, framed by the Porta della Carta, this "truly royal staircase of whitest marble worked in fine relief." To this already impressive staircase, his father's giants lent new "majesty and grandeur."[9]

Although the preserved documents make no reference to their subject or significance, their meaning was apparent to all even without the explanation of the sculptor's son: Mars and Neptune (figs. 82, 83) stand, respectively, for the "stato di terra & di mare." In this reassertion of Venetian empire, Mars, the god of war, lends an appearance of military might to a state that, following the debacle of Agnadello, had come increasingly to recognize the negotiating table as a more effective arena than the battlefield in the pursuit of policy.

Shortly after the publication of Jacopo de' Barbari's commercial Olympian protectors of the city, and half a century before Sansovino's marble giants, other pagan deities made their public—if somewhat more timid—appearance in Piazza San Marco itself, in the three bronze pedestals set up before the basilica (fig. 8). These serve as bases for the flagstaffs from which large crimson standards with the winged lion in gold were flown on solemn feast days. Two Venetian diarists, Girolamo Priuli and Marin Sanudo, record the dedication of the central pedestal (fig. 84)—"per honore dela piaza de San Marcho," as Priuli notes—on August 15, 1505, the Feast of the Assumption of the Virgin.[10] The work bears the signature of Alessandro Leopardi, the bronze caster who was responsible for the execution of Verrocchio's equestrian statue of Bartolommeo Colleoni, although their design has recently been ascribed to Antonio Lombardo.[11] Also inscribed are the names of the Procuratori responsible for the project and the name of Doge Leonardo Loredan, in whose fourth year of rule the work was done; finally, the central pedestal features three large medallions with portraits of Loredan—to which Priuli took strenuous objection: such public ruler portraits were inappropriate in a republic.

Francesco Sansovino makes a rather lame effort at interpreting these pedestals: they signify "freedom and liberty dependent on God alone and not on any prince." Then again, he adds, they may also represent the three realms of Venice, Cyprus, and Crete—an interpretation, as we shall see, read back from the program of the Loggetta.[12] Of the three bases, the two

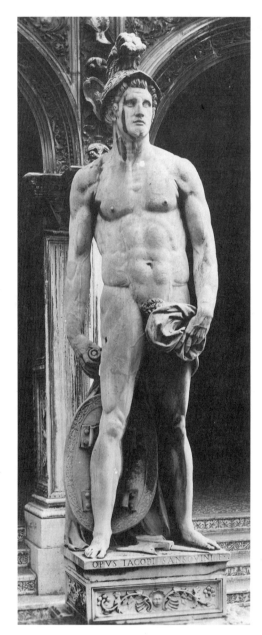

FIGURE 82:
Jacopo Sansovino,
*Mars*.
Scala dei Giganti,
Ducal Palace
(Photo: Böhm).

FIGURE 83:
Jacopo Sansovino,
*Neptune*.
Scala dei Giganti,
Ducal Palace
(Photo: Böhm).

FIGURE 84:
Alessandro
Leopardi
(design by
Antonio
Lombardo?),
Bronze Pedestal.
Piazza San Marco
(Photo: Böhm).

outer ones feature marine deities inspired by antique motifs and, more im-
mediately, by engravings of Mantegna. It is the central pedestal, however,
the first erected, that is of the greatest iconographic interest. Around its
cylindrical base runs an aquatic *trionfo*, a procession of vessels guided by
marine creatures and carrying virtues personified by ancient goddesses:
Minerva, helmeted and holding an olive branch, stands for Peace (fig. 85);
Ceres, with grain and cornucopia, for Abundance (fig. 86); finally, Justice
is represented by herself, that is, as the virgin Astraea (fig. 87)—the last of

FIGURE 85: Alessandro Leopardi (design by Antonio Lombardo?),
Bronze Pedestal, detail: *Minerva* (Photo: Böhm).

the immortals to abandon earth in the age of iron and the first to return in
a renewed golden age.[13] The figure owes her stature to Virgil's messianic
Fourth Eclogue (6–7):

> iam redit et Virgo, redeunt Saturnia regna;
> iam nova progenies caelo demittutur alto.
>
> (Now the Virgin returns, the reign of Saturn returns;
> now a new generation descends from heaven on high.)[14]

Astraea had already made her official appearance in Venice a decade ear-
lier, on the staircase of the Ducal Palace that was designed to serve as mon-
umental setting for the coronation of the doge—and was to become the
"Scala dei Giganti" (fig. 88). In a swirl of draperies, one of four heaven-
borne winged Victories bears a tablet inscribed ASTREA DVCE (fig. 89).[15]

The iconographic program for the bronze pedestals was probably de-
vised by the patrician humanist Daniele Renier, whom Sanudo reports was

FIGURE 86: Alessandro Leopardi (design by Antonio Lombardo?),
Bronze Pedestal, detail: *Ceres* (Photo: Böhm).

"deputato a li stendardi." Although no written instructions have been preserved, their continued legibility is confirmed by a later reading, by Pietro Contarini, published in 1541:

> In front of the door [of San Marco] there are three flags that blow in the gentle breeze. The lofty flagstaffs reach above the clouds. Their bases are made of Parian marble, their cases of bronze. The one in the middle shows three ships coming from the high seas. On the stern of the first ship one sees the golden Virgin of the Pole [Astraea], who, having been exiled by the wicked world, has fixed her abode in Venetian waters. In her right hand she has the honored sword, but in the left she holds the head of a convicted traitor. A pilot waves her golden vexillum; the prow bears the balanced scales. An elephant carries the ship on his shoulders into the beautiful city. A robust triton helps to tow it and goes along sounding a horn for pleasure. The other boat transports the Mother of the Granaries [Ceres], who in her bounteous hand holds ears

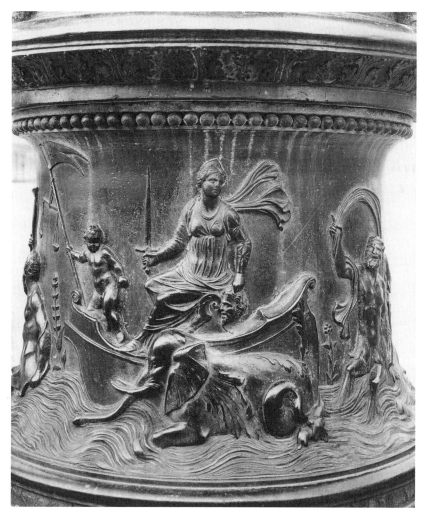

FIGURE 87: Alessandro Leopardi (design by Antonio Lombardo?),
Bronze Pedestal, detail: *Astraea* (Photo: Böhm).

of wheat above a dolphin's curved back. The heavy ship is borne along,
which Cymothoe [a Nereid], the pure wife, helps to tow, singing. Then
in the third boat comes happy Victory in a white dress. In her right
hand she holds up the palm branch; in the left, spoils of the enemy. Into
the heart of the Venetian city the honored vessel is drawn along through
the calm sea by snow-white horses. Portumnus, the god of ports, from
whose chin hangs a green beard, assists her. Above this there are three
[winged] lions emitting a golden radiance.[16]

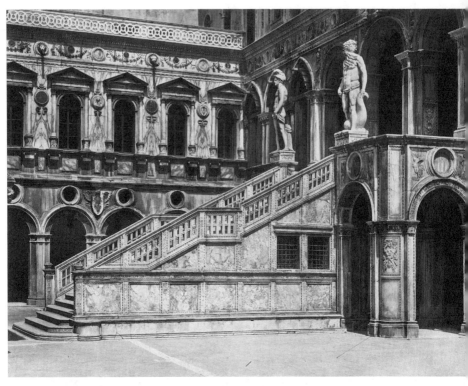

FIGURE 88: Scala dei Giganti, Ducal Palace (Photo: Alinari).

Contarini's ekphrasis reveals the iconographic literacy, and imagination, of an educated Venetian, his ability to read such imagery in a properly patriotic key and to respond to its rhetorical invitation. Astraea quite naturally finds her home in Venetian waters. That she herself, Justice personified, is indeed to be identified with Venice is made explicit by the standard held by the putto at the prow of her vessel, and from which depend the scales of justice: the pennant displays the winged lion of St. Mark.[17]

Forty years after the bronze pedestals were erected in front of San Marco the Olympians made their major descent *in piazza*, on Sansovino's Loggetta at the base of the campanile (plate 14). This small but elaborately articulated porch, which replaced an older simple structure with wood roof, was begun in 1537 and completed by 1546. Mediating between the Ducal Palace and the Libreria di San Marco, it is the pivotal work in Sansovino's urban transformation of the commercially crowded Piazza San Marco into a public space worthy of the Republic. Conceived along

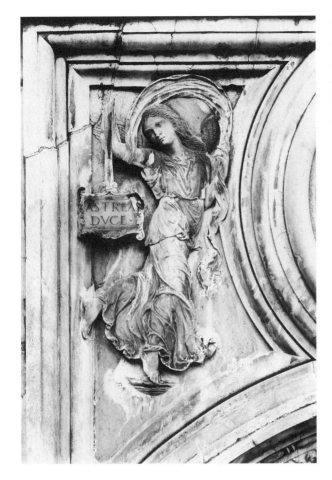

FIGURE 89:
Antonio Rizzo,
*Astraea.*
Scala dei Giganti,
Ducal Palace
(Photo: Böhm).

with the Library, the architecture of the Loggetta shares a triumphal classical vocabulary with its larger neighbor. Its polychromy, however, marked especially by the combination of red Verona and white Carrara marble, relates rather to the Ducal Palace opposite; in particular, it responds to the sculpturally rich Porta della Carta, which it faces directly. When he situated his two *giganti* at the top of the great staircase, Sansovino effectively realized the dramatic potential of this axial relationship—as his son recognized in introducing the Scala dei Giganti to a viewer standing at the foot of the campanile, that is, in front of the Loggetta (fig. 81).

The architectural program of the Loggetta is part of Sansovino's vision for Piazza San Marco, a vision both urbanistic and political. It is the sculptural program, however, that articulates the political vision in more certain

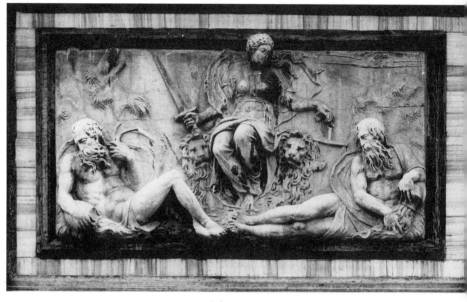

FIGURE 90: Jacopo Sansovino, *Venice/Justice*. Loggetta di San Marco
(Photo: Böhm).

detail. The artist verbalized that program himself, at least according to
Francesco, who elaborates on the significance of his father's sculptures in
several of his publications. In the sequence of editions of his cicerone dia-
logue on the *le cose notabili* of Venice, he offers the visiting *forestiero* a full lec-
ture on the meaning of his father's work, a lecture given final official form
in *Venetia città nobilissima* of 1581.

The three marble reliefs in the attic of the Loggetta make a basic state-
ment of the Venetian empire "in mar come in terra." In the center is a fig-
ure of Venice (fig. 90). If it seems rather to have the appearance of Justice,
the author explains, "that is because such is our City, which, wanting to
represent itself, does so as a most holy Justice." The river gods below her
represent the rivers of the terra firma. In the outer relief panels, to either
side of Venetia/Justitia, are figures of the maritime empire: Jupiter on
Crete (fig. 91) and Venus on Cyprus (fig. 92). Thus, says the Venetian to
the stranger, "you see represented [*collocato in figura*] on this little facade the
Empire of these Lords on sea and on land."[18] We recall how the author
transfers to the triad of bronze pedestals this same imperial significance:
the three realms of Venice, Crete, and Cyprus.

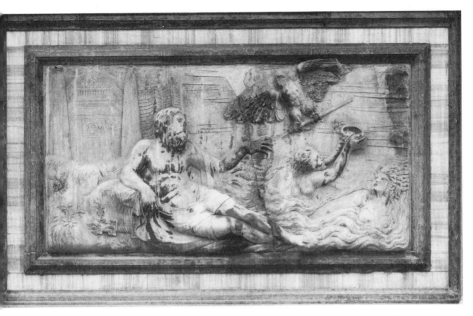

FIGURE 91: Jacopo Sansovino, *Jupiter*. Loggetta di San Marco (Photo: Böhm).

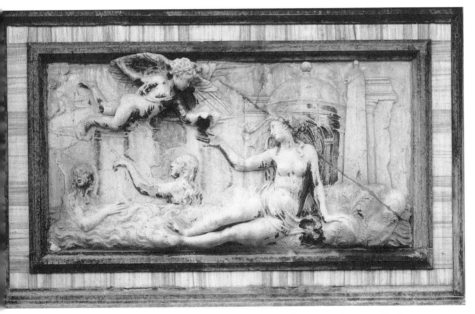

FIGURE 92: Jacopo Sansovino, *Venus*. Loggetta di San Marco (Photo: Böhm).

FIGURE 93:
Jacopo
Sansovino,
*Minerva*.
Loggetta di
San Marco
(Photo:
Böhm).

It is only in *Venetia città nobilissima* that Francesco ascribes to his father
the explication of the Loggetta sculptures, their "exquisite meaning."[19]
However the interpretation may have expanded in the course of the son's
publishing career, dilating upon its own initial tropes, there is little reason
to doubt that it was the sculptor himself who first articulated the basic
values represented. That articulation received its first printed form within
months of the completion of the Loggetta in 1546, in Francesco Sanso-
vino's treatise on the art of oratory, which was published later that same

FIGURE 94:
Jacopo
Sansovino,
*Apollo.*
Loggetta di
San Marco
(Photo:
Böhm).

year. Here, in the context of the art of memory, the "treasury of elo-
quence," the sculptures of the Loggetta are presented as memory images
("luoghi della memoria"). Each of the four bronze figures in niches oper-
ates according to a basic hermeneutic algebra: Minerva stands for wisdom
(fig. 93), Apollo for music (fig. 94), Mercury for eloquence (fig. 95), and
the figure of Peace for itself (fig. 96).[20]

Francesco Sansovino's expanding interpretation of these figures offers
further insight into the rhetorical momentum of interpretation, the gener-

FIGURE 95:
Jacopo
Sansovino,
*Mercury.*
Loggetta di
San Marco
(Photo:
Böhm).

ation of meaning through imaginative association. We recall that the interpretation of Minerva follows from a discourse on the longevity of the Republic, longevity due to the high wisdom of the Senate and of those who established the constitution of Venice on a foundation of religion and justice. Just as Pallas Athena figured wisdom for the ancients, she represented the wisdom of the state on the Loggetta. In the dialogue *Delle cose notabili*, which is understandably less formal than the more ambitious *Venetia città nobilissima et singolare*, the description of the statue is somewhat more

FIGURE 96:
Jacopo
Sansovino,
*Peace*.
Loggetta di
San Marco
(Photo:
Böhm).

circumstantial: she is "a Pallas armed, not so much beautiful as alive and ready for action, because the wisdom of these Lords is ready in the governance of this cherished city."[21]

Mercury is here as god of eloquence because decisions made wisely must be expressed eloquently if they are to be persuasive, and this Republic has always boasted men of eloquence and learning and held them in the highest esteem. Any reference to his commercial side is missing in this account of the god of the winged helmet; no longer the merchant-protector

of Jacopo de' Barbari's view of Venice, Sansovino's heroic Argus-slayer seems more like a triumphant David, looking heavenward to the source of his righteous strength.[22]

Apollo offers a particularly rich occasion for rhetorical dilation, the kind of semantic play and syllogistic enthusiasm capable of opening ever new interpretive prospects:

> Apollo signifies the sun [*il Sole*], and the sun is truly unique, one alone [*un solo*] and no more, and Apollo is therefore called the sun [*Sole*]. Thus this Republic is one alone [*una sola*] in the world, for its constitution of laws, for its union, and for its uncorrupted liberty, ruled with justice and wisdom. Beyond that, everyone knows how much this nation delights in music, and so Apollo stands for music. Since from the union of its Magistrates joined together with inexpressible temperament there issues extraordinary harmony, which perpetuates this marvelous government, Apollo was therefore depicted.

The final figure is and represents Peace, who with her lowered torch destroys the arms of war. This, as Sansovino explains, is the Peace "so beloved by this Republic, by which it has grown to such greatness and which has made it the metropolis of all Italy for its commerce by land and by sea." This is the peace "that the Lord gave to the Protector of Venice, St. Mark, saying to him, *Pax tibi Marce Evangelista meus.*" Deriving from religion, justice, and observance of the laws, that peace leads to concordant harmony.[23] Even as the figure of Peace sets the allegorical mode for interpreting the pagan gods, she returns this figural discourse back to its Venetian foundation, to the divine promise made to the patron saint of the Republic.

Nothing in the Sansovino account of the meaning of the Loggetta sculptures is particularly obscure or recherché. Indeed, it is made of commonplaces, standard qualities traditionally attributed to the pagan gods and rhetorical tropes of Venetian panegyric. Both father and son were familiar with that political language, Jacopo in his intimate relationship with the Procuratori di San Marco, Francesco through his own literary and editorial work—which included publishing a volume of ambassadorial orations delivered to the doge, a veritable treasury of encomiastic cliché.[24]

Increasingly, the pagan gods, generally as allegories of the virtues of the

state, became part of the spectacle of public life in Venice. Unconfined by statuary immobility, they were the personae of the *trionfi* and *momarie* of occasional celebration. Among the many such events recorded by Sanudo is one that took place in Piazza San Marco in 1532. The diarist describes a procession of mythological and allegorical figures mounted on various beasts: first came Pallas Athena, fully armed and with a book in one hand, mounted upon a serpent; she was followed by Justice with sword and scales riding on an elephant, and then came Concord, Victory, Peace, Abundance, Wisdom, and the vices over which they were triumphant, Discord, War, Violence, Penury, Ignorance. They mount a stage on which is depicted "the temple of Janus with trophies and arms of various kinds" and "the temple of Peace," which opens at the finale with all the characters dancing before it.[25]

Since Venice takes such delight in music, as Sansovino declared, it was only natural that these same figures should find full musical expression. Madrigals by Baldassare Donato published in 1550, for example, set texts by the Venetian patrician Domenico Venier that give further voice to the standard imagery. They sing of "Questa pura verginella / Gran regina in libertate," of "Gloriosa felice alma Vineggia / Di Giustizia, d'amore di pace albergo," and of the "Vergine già mill'anni intatte pure." Another celebrates the descent to Venice, the great enterprise inspired by Jupiter himself, of four goddesses whose gifts will render the city immortal; they are Victory, Peace, Wisdom, and Fame.[26] Such public expressions of iconographic topoi offer a larger context in which to understand Sansovino's Loggetta program, the themes and terms of which were enacted or broadcast on every festive occasion.

When the Olympians actually enter the Ducal Palace they remain *in cielo*, in the heavens; that is, they generally appear in ceiling paintings. Indeed, it is just in those years of increasingly ambitious self-representation, following the Peace of Bologna (1530) and during the dogate of Andrea Gritti (1523–38), that Venetian ceiling design begins to open its framework to accommodate more expansive fields of painting.[27] Olympian ambition begins in the rooms of the powerful Council of Ten, which had been recently built. The framework of the ceiling of the audience hall was completed by early 1553 and the canvas paintings installed within the next two years. Sansovino informs us that the author of the program was the patri-

cian humanist Daniele Barbaro; the artists were Paolo Veronese, Giovanni Battista Zelotti, and Giovanni Battista Ponchino.[28] In the central oval of the ceiling, a fulminating Jupiter cleanses heaven of crimes and vices (plate 15). Francesco Sansovino identifies them as Heresy, Rebellion, Sodomy, and Counterfeiting—all cases falling within the jurisdiction of the Council of Ten.[29] Giorgio Vasari, who visited Venice in 1566, recognized the painting as illustrating the role of the Council in expelling vice and punishing evil and took the larger meaning of the ceiling as a statement of "the greatness and peaceful and serene state of Venice."[30] It is not likely that a visually literate viewer such as Vasari needed a written program to read this imagery of Venetian celebration.

From the heavens of other canvases on the ceiling, other Olympians bring their gifts to Venice: Mercury accompanies Peace in a canvas by Ponchino, and in another, by Veronese, Juno showers wealth, dominion, and peace on Venice herself (fig. 97). In a painting by Zelotti Venice appears between the figures of Mars and Neptune (fig. 98)—representing, as we well know by now, Venetian dominion on land and sea. But we might as readily identify this female nude accompanied by a winged putto as Venus accompanied by Cupid; only the faithful lion at her side, which she caresses as a large pet dog, affirms her Venetian persona. The same mode of iconographic intercalation that permitted, indeed, encouraged, easy interpretive slippage in the Venetia/Iustitia/Maria complex here operates in a more purely mythological dimension. The conceit that inspired the reverse of Sebastiano Renier's medal here achieves pictorial expression on a monumental scale. On the ceiling of the Sala del Consiglio dei Dieci, the figure of a nude Venice is quite at home among the gods of Olympus. From the horoscope of March 25, 421, to the play on nominal similarity, the Venus-Venice equation has developed into a full trope in the political poetics of Venetian celebration. On the occasion of Doge Sebastiano Venier's election in 1577, an orator fell naturally into the rhetorical comparison of Venus and Venice as sisters: both were celestial, both mothers and nurses of most holy love, both born from the same womb of the sea, product of the same heavenly seed.[31]

The second half of the sixteenth century saw the further expansion of poetic imagination in the service of Venetian panegyric, the increasing appropriation of the Olympians and their myths. What might have been ac-

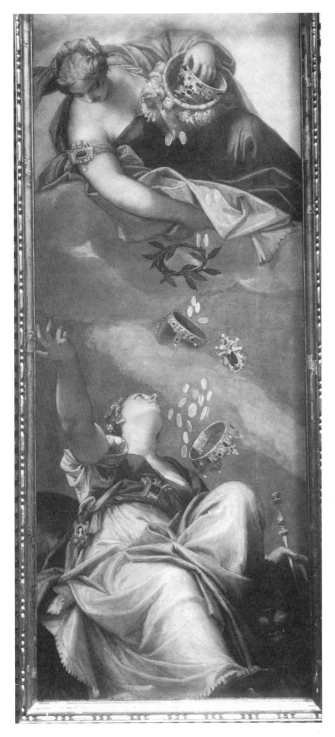

FIGURE 97:
Paolo Veronese,
*Juno Showering
her Gifts on
Venice*. Sala
dell'Udienza
del Consiglio
dei Dieci,
Ducal Palace
(Photo:
Fiorentini).

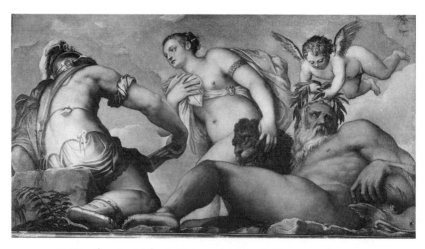

FIGURE 98: Giambattista Zelotti, *Venice with Mars and Neptune.*
Sala dell'Udienza del Consiglio dei Dieci, Ducal Palace (Photo: Böhm).

cepted as metaphoric and allegorical in Venier's madrigal texts—the role
of pagan Jupiter in the origin of Venice—becomes fully realized in a
fresco by Tintoretto, painted on the ceiling of the Sala delle Quattro Porte
in 1577 (fig. 99). The description by Francesco Sansovino, who was in fact
the inventor of the program, reflects the historical and cultural intercala-
tion of such figuration: "Venice is guided by Jove to these waters, for she
was created by the order of God, so that religion and Christian liberty
might be preserved there."[32] The two figures descend from the heavenly
court of the Olympians, a council of the gods that, in effect, sanctions the
succession of pagan Rome by Christian Venice.[33]

Some pictorial projects in the Ducal Palace seem to press harder at the
limits of legibility, such as the cycle of four canvases painted by Tintoretto
for the Salotto Dorato at the head of the Scala d'Oro (the paintings were
moved to the Sala dell'Anticollegio in the eighteenth century). The sub-
jects themselves, readily recognizable, are explicitly stated in a document
of November 10, 1578, recording the evaluation of the paintings by Paolo
Veronese and Palma il Giovane: on one wall were the "the three Graces"
(fig. 100) and "Vulcan and the Cyclops at the forge" (fig. 101); on the other
were "the marriage of Ariadne and Bacchus in the presence of Venus"
(fig. 102) and "Pallas who embraces Peace and Concord and expells Mars"
(fig. 103). Each of the paintings presents a group of figures joined in some

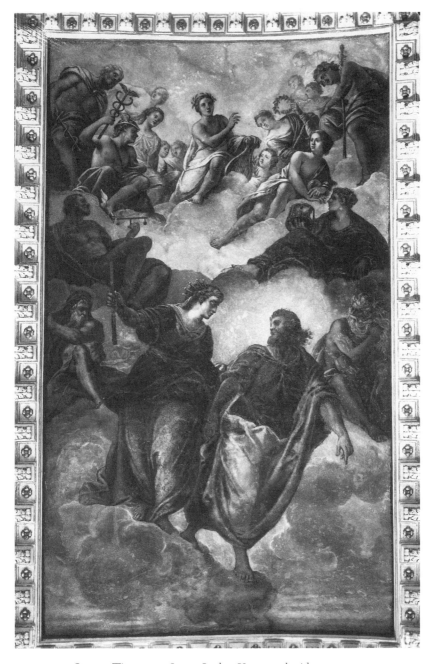

FIGURE 99: Jacopo Tintoretto, *Jupiter Leading Venice to the Adriatic*
Sala delle Quattro Porte, Ducal Palace (Photo: Böhm).

FIGURE 100: Jacopo Tintoretto, *The Three Graces and Mercury*. Sala dell'Anticollegio, Ducal Palace (Photo: Böhm).

common endeavor, and collectively, the document declares, they "signify union."[34]

When, seventy years later, Ridolfi offered a more detailed interpretive analysis, he may well have been drawing upon knowledge of the original program. In any case, his reading offers a further example of a specifically Venetian visual literacy. The subjects, he observes, are "appropriate to the administration of the Republic."[35]

Ridolfi begins with Vulcan and his Cyclops beating iron into "perfect form," which perfection refers to the "union of the Venetian Senators in the administration of the Republic." The arms of course allude to the military might of Venice, to the arms that "serve as ornament to the City" and "strike terror in her enemies."

Moving to the Graces accompanied by Mercury, Ridolfi notes that one

FIGURE 101: Jacopo Tintoretto, *The Forge of Vulcan*. Sala dell'Anticollegio, Ducal Palace (Photo: Böhm).

of them leans upon a die, "because the Graces correspond to the offices of the Republic," which change as they are distributed among the worthy patricians. The other two Graces hold myrtle and a rose, flowers sacred to Venus, the goddess of love, and symbols of perpetual love. Mercury accompanies them, "because graces [gifts] must be granted with reason, as the Senate confers honors on those worthy." (That is the theme of the ceiling fresco in the next room, the Anticollegio, where Veronese depicted *Venice Distributing Honors*.)[36]

Peace and Abundance celebrate as Mars is expelled by Minerva, who, of course, represents "the wisdom of the Republic in keeping war far from the state, from which is born the happiness of its subjects" and which in turn leads to love of the doge.

Finally, Ariadne, discovered by Bacchus on the strand, is crowned by

FIGURE 102: Jacopo Tintoretto, *Venus Officiating at the Marriage of Bacchus and Ariadne.*
Sala dell'Anticollegio, Ducal Palace (Photo: Böhm).

Venus with the constellatory corona, "declaring her free and welcoming
her to the number of the celestial images." This denotes "Venice born
along the sea shore, abounding in every earthly good, through heavenly
grace, but crowned with the crown of liberty by the divine hand, [Venice]
whose domain is inscribed in eternal characters in Heaven."

In Ridolfi's reading we encounter the troping momentum of Renais-
sance hermeneutics, acknowledging the range of association inherent in the
images of the pagan gods and accepting the invitation to exploit it. Almost
any mythological deity, attribute, or action is susceptible to inflection in a
Venetian mode. By now, the interpretive logic is familiar. The basic themes
of Venetian panegyric were fully and publicly established—in political or-
atory, in poetry and music, in sculpture and painting. Those themes achieve
visual expression of the greatest clarity in Veronese's painted decoration of
the ceiling of the Sala del Collegio, a room rebuilt quickly following a fire

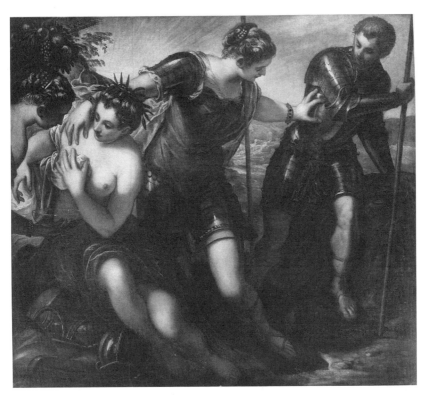

FIGURE 103: Jacopo Tintoretto, *Minerva Embracing Peace and Concord and Rejecting Mars.* Sala dell'Anticollegio, Ducal Palace (Photo: Böhm).

in 1574. Surrounded by personified virtues and historical exempla, the central canvases synthesize the several dimensions of Venetian iconographic development—religious, allegorical, mythological. Large inscriptions declare their meaning.

The central oval represents a triumph of Christian Faith (fig. 104): above a scene of ritual sacrifice a woman in white and gold rises heavenward toward the divine light; the chalice she holds aloft symbolizes the eucharistic sacrifice that supercedes the old law. Whether Faith (*Fides*) or Church (*Ecclesia*), she figures the religion that is the foundation of Venice and guarantor of its immortality, as the inscriptions proclaim: the "foundation of the Republic" (REIPVB [LICAE] FVNDAMENTVM) is "never neglected" (NVNQVAM DERELICTA).[37]

In the rectangular field above the tribunal an enthroned Venice receives homage from Justice and Peace (fig. 105), the "preservers of liberty"

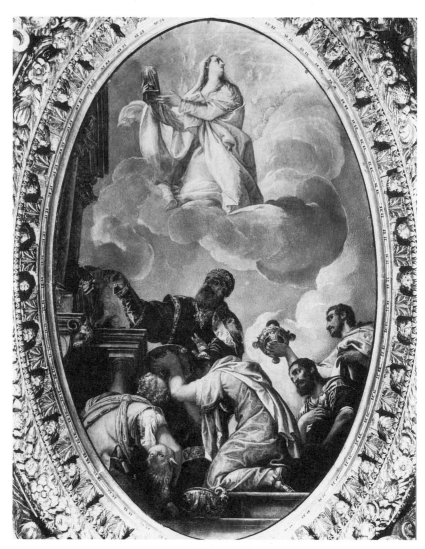

FIGURE 104: Paolo Veronese, *Religion and Faith*. Sala del Collegio, Ducal Palace
(Photo: Böhm).

(CVSTODES LIBERTATIS). At the other end of the ceiling Mars and Nep-
tune (fig. 106), by now the two standard figures of the state on land and on
sea, here stand together for the "strength of the empire" (ROBVR IMPERII).

Such mingling of the Christian and the pagan, mediated by allegorical
personification, enabled a pictorial language of subtle flexibility, a rhetoric
capable of operating by inference and association. We may recall the re-

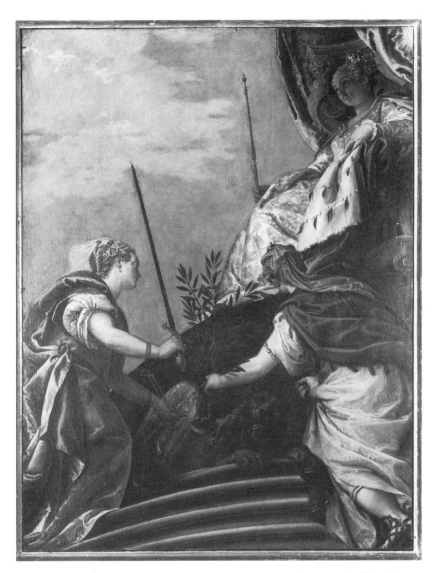

FIGURE 105: Paolo Veronese, *Venice Enthroned with Justice and Peace*. Sala del Collegio, Ducal Palace (Photo: Böhm).

sponse of the visiting Englishman Thomas Coryat to the paintings on the ceiling of the Sala del Maggior Consiglio, his ready reading of the Queen of the Adriatic as the Virgin Queen of Heaven. From the identification with the virtue of Justice, and hence with the virgin goddess Astraea, and with the Virgin Mary herself, via their shared celebration of March 25th,

FIGURE 106: Paolo Veronese, *Mars and Neptune*. Sala del Collegio, Ducal Palace (Photo: Böhm).

the divinity of Venetia extended finally to the cumulus court of the pagan Olympians. In the progress of the ceiling of the Sala del Maggior Consiglio, she ascends from her initial position on earth in Palma's painting (fig. 27), where she sits enthroned, triumphant like the goddess Roma, crowned by a winged Victory. In Tintoretto's central rectangle (fig. 28) she descends from the eternal heavens to bring laurels of honor and the olive branch of peace to the doge and Signoria; according to the program, Venice is accompanied by two pagan deities, Cybele and Thetis, presumably representing less dominion over than the bounty of earth and of sea.[38]

In every sense, Veronese's canvas, located over the tribunal, is the culmination of this progress (plate 5): from Venetia triumphantly militant to diplomatically imperial Venice to, finally, an Olympian Venetia adored by jubilant subjects fortunate to be living under her sign. Representing, according to the program, Venice "seated above towers and cities in imitation of Rome seated above the world," Veronese's painting is often called a triumph or apotheosis of Venice; it may be more accurately recognized as an image of *Pax Veneta*.[39] As Bardi's program and published *Dichiaratione* indicate, these figures are inspired by the model of ancient Roma, ruler of the world, especially as found on coins and medals. Veronese's Venetia, however, goes well beyond such antiquarian sources; she is, as Coryat's misprision confirms, a much more complex character. Crowned by Victory and celebrated by high flying Fame, she sits above the clouds of a surrounding court, enthroned and sceptered, a majestically regal figure in the heavens. We can hardly avoid recognizing a further constituent in the iconographic makeup of *Venetia figurata*: Juno, queen of the gods.

Beyond her generally regal aspect, Juno brings her association with wealth and power to the figure of Venetia. Mythographers expanded on the concept of Juno Moneta, to whom the Romans had dedicated a temple that became the mint—and thereby naming such factories of coinage. Citing Boccaccio, among many other sources, Vincenzo Cartari explains that Juno is imagined in splendor because she was believed to be the goddess of wealth; she is depicted holding a scepter because it was "in her power to award riches and realms"[40]—as indeed she does in Veronese's painting in the Sala del Consiglio dei Dieci. Immediately beneath her right hand, the figure with the caduceus holds up the crown as though it had been received from this queen. Bardi's program hardly mentions Juno as a

model, but by now we have learned how fluid such inferences and associations could be in the political imagination of Venice. Veronese's regal matron is as legitimately the Queen of Olympus as she is the Virgin Queen of Heaven.

Veronese's elevation of Venetia incorporates still further echoes of the resonant iconography we have been exploring. From the triumphal arch that serves as immediate backdrop to Venetia and her court of virtues there extend two monumental spiral columns. Veronese had earlier adapted these helical forms to ceiling painting in the *Triumph of Mordecai* in San Sebastiano.[41] Even as it exaggerates the effect of foreshortening, the spiral motion, accentuated by the fluting, effectively slows the spatial thrust of such columns viewed in perspective. But twisted columns of this type, alternating levels of fluting and decorative tendrils of vine, are not neutral architectural elements. They come with their own significant aura: they are modelled on the spiral columns that formed a screen before the sanctuary of the old basilica of St. Peter's, which in turn were thought to have come from the Temple of Solomon.[42]

Through such architectural motifs Veronese invoked the archaeology of the Temple as it was understood in the Renaissance, and through them invested his *Venetia figurata* with the resonance of Divine Wisdom. Again, we can hardly expect Bardi's program—or any program worked out by literati—to have prescribed such architectural meaning. Here we meet the intelligence of the painter himself, for only he would have been capable of imagining the setting and its full historical and iconographic implications.[43] Indeed, it is precisely in the creation of a painting like this one that we confront the dynamics of Venetian panegyric in action. The acquisitive, associative momentum, appropriating imagery for its valued significance, enables the painter to expand and deepen the resonance of his pictorial invention—all for the greater glory of Venice.

Toward the end of the Cinquecento, that glory may have been somewhat dimmed by historical realities, and it suffered more serious eclipse in the following century. As the empire continued to dwindle, Venice became increasingly a spectacle for the rest of Europe; during its extended carnival season, modern opera developed as an art but also, not incidentally, as a celebration of the city itself.[44] But in the remarkable pictorial efflorescence of the eighteenth century, that Silver Age of Venice, the Olympians made

a final appearance on behalf of the Serenissima. In the canvas painted by Giambattista Tiepolo for the Sala delle Quattro Porte of the Ducal Palace Neptune pours forth his treasures to the Queen of the Adriatic (plate 16). Commissioned to replace an earlier image fallen into disrepair, itself a *restauro* of a ruined fresco by Tintoretto, Tiepolo's portrait of Venetia crowned and sceptered is less a confident affirmation than a nostalgic recollection of the glory of Venice, an epilogue, a final pictorial echo of the myth.[45]

# NOTES

INTRODUCTION

1. Warburg, *The Renewal of Pagan Antiquity*, 348.

2. Recent histories of Venice in English include Lane, *Venice: A Maritime Republic*—the particular biases and shortcomings of which have been rather severely, and perhaps unfairly, criticized by Cochrane and Kirshner, "Deconstructing Lane's *Venice*." For a more sweeping narrative chronicle, the reader may try Norwich, *A History of Venice*.

3. The modern literature on the myth of Venice is large and ever growing, the most recent contribution being Crouzet-Pavan, *Venise triomphante*. The following important studies in English, each with further bibliography, discuss the political and historical dimensions of the myth: Bouwsma, *Venice and the Defense of Republican Liberty*; Gilmore, "Myth and Reality"; Muir, *Civic Ritual*, and Finlay, *Politics in Renaissance Venice*, 14–43 ("Reality and Myth in Renaissance Venice"). For a recent analysis of historiographic sources and modern scholarship, see Silvano, *La "Republica de' Viniziani"*, and the papers in Martin and Romano, eds., *Venice Reconsidered*, especially their introduction, "Reconsidering Venice," 1–35. For a grand synthetic consideration of the larger issues and their implications, Ernst Cassirer's *The Myth of the State* remains essential reading.

4. For a more concentrated anatomy of this figure, see Rosand, *"Venetia figurata,"* and Wolters, *Der Bilderschmuck*, 236–46, *Storia e politica*, 228–38 (for convenience of reference, I will cite both the original German edition of this important book and its Italian translation).

5. For that resonance, see Bouwsma, "Venice and the Political Education of Europe," and Gilbert, "The Venetian Constitution in Florentine Political Thought." On the constitution itself: Maranini, *La costituzione di Venezia*.

6. See Fink, "Venice and English Political Thought"; McPherson, *Shakespeare, Jonson, and the Myth of Venice*, with further bibliography, and Haitsma Mulier, *The Myth of Venice and Dutch Republican Thought*. For the still larger resonance of the Venetian model, see Pocock, *The Machiavellian Moment*.

7. In addition to influential books such as *The Stones of Venice* (1851–53) and *St. Mark's Rest* (1877–84), Ruskin was directly responsible for the publication of the indispensable anthology of documents of the history of the Ducal Palace: Giambattista Lorenzi's *Monumenti per servire alla storia del Palazzo Ducale*, which is dedicated "all'illustre Signore John Ruskin."

8. Compare, for example, Queller, *The Venetian Patriciate: Reality versus Myth*, and Finlay, *Politics in Renaissance Venice*; also Grubb, "When Myths Lose Power."

### I. MIRACULOUS BIRTH

1. On this pictorial dimension of the Venetian historical imagination, see especially Brown, *Venetian Narrative Painting*. On the representation of the events of 1177, see as well Wolters, *Der Bilderschmuck*, 164–81, *Storia e politica*, 162–78. For the ceremonial consequences of those events, see Muir, *Civic Ritual*, 103–19.

2. So that it might be understood by everyone, Francesco Sansovino offered an Italian translation of Petrarch's letter, thereby assuring its prominent role in Venetian panegyric: *Venetia*, 407–9. On Sansovino, see Grendler, "Francesco Sansovino," and Silvano, *La "Republica de' Veneziani"*, 121–38. On Petrarch in Venice, see Saxl, *A Heritage of Images*, 43–56, as well as several of the contributions to *Petrarca, Venezia e il Veneto*: Lazzarini, "'Dux ille Danduleus'"; Muraro, "Petrarca, Paolo Veneziano e la cultura artistica," and Perocco, "Il Palazzo Ducale."

3. *The Commonwealth and Government of Venice*, 2. Contarini completed *De magistratibus et republica Venetorum libri quinque* in the early 1530s; it was first published in Paris in 1543, and in Italian and French translation the following year. See Gilbert, "The Date of the Composition"; further on Contarini, see Pocock, *The Machiavellian Moment* 272–330 (ch. 9: "Giannotti and Contarini: Venice as Concept and as Myth"); Gleason, *Gasparo Contarini*, 110–28, and Silvano, *La "Republica de' Veneziani"*, 85–120. On the English translation, see McPherson, "Lewkenor's Venice."

4. Cited by Fink, "Venice and English Political Thought," 156. According to Horatio F. Brown, the saying first appeared in the early sixteenth century, printed in the *Dieci tavole*, ten broadsides of collected Venetian proverbs (*Studies in the History of Venice*, 2:161).

5. Howell, *S.P.Q.V.*, 55. Other earlier English sources include *The Garden of Pleasure*, "done first out of Italian into Englishe by James Sandford" in 1573 ("Venetia, chi non ti vede non ti pretia: Venice, he that doth not see thee, doth not esteeme

thee"), and John Florio's *Firste Fruites* (1578) or his *Second Fruits* (1591) ("*Venetia, chi non ti vede, non ti pretia, ma chi ti vede ben gli costa.* Venise, who seeth thee not, praiseth thee not, but who seeth thee, it costeth him well").

6. On the copyright privilege, see the still fundamental work of Horatio F. Brown, *The Venetian Printing Press*, 50–108, 236–40.

7. On the condition and restoration of the extant woodblocks and the impression in the Museo Correr, see the recent exhibition catalogue, Venice, Musei Civici Veneziani, *A volo d'uccello: Jacopo de' Barbari e le rappresentazioni di città*, 101–15.

8. The text of Kolb's privilege was thought noteworthy enough to be recorded by Marin Sanudo (*I diarii*, 3, col. 1006); it was later published by Emmanuele Antonio Cicogna, *Delle iscrizioni veneziane*, 4:647, and is reprinted in Rosand and Muraro, *Titian and the Venetian Woodcut*, 25, n. 17. An English translation is available in Chambers and Pullan, eds., *Venice: A Documentary History*, 373.

9. On the topographical achievement of this monumental image, see especially Juergen Schulz, "Jacopo de' Barbari's View of Venice"; also Mazzariol and Pignatti, *La Pianta prospettica di Venezia*, as well as the contributions to the recent exhibition catalogue *A volo d'uccello*.

10. Thus, for example, Sanudo: "questa città in l'isola de Rialto fo comenzata a edificar . . . del 421, adí 25 Marzo in zorno di Venere cercha l'hora di nona asendendo, come nella figura astrologica apar, gradi 25 del segno del Cancro" (*De origine*, 12–13). On the horoscope, see Jacks, *The Antiquarian and the Myth of Antiquity*, 319–20, with further references, and Brown, *Venice and Antiquity*, 176–78.

11. On Giustiniani's history of the origin of Venice, see Labalme, *Bernardo Giustiniani*, 247–304 (267 for the translated passage). For a review of the earlier, prehumanistic historiographic traditions, see Carile and Fedalto, *Le origini di Venezia*, 19–123; see also the papers collected in Pertusi, ed., *La storiografia veneziana*, and, especially for the imaginative aspect of creating a past, Brown, *Venice & Antiquity*, 11–29.

12. On the various claims to civic renaissance, see Puppi, *Verso Gerusalemme*, 62–76; Marx, *Venezia — altera Roma?*; Brown, *Venice & Antiquity*, 3–29.

13. Sansovino, *Venetia*, 509–10.

14. Moschini Marconi, *Gallerie dell'Accademia . . . : secolo XVI*, no. 73.

15. For the facade reliefs, see Demus, *The Church of San Marco*, 131–33; Demus et al., *Le sculture esterne di San Marco*, cat. nos. 87, 90, and for the aediculae figures: Wolters, *La scultura veneziana*, cat. no. 175.

16. The sculpture, by Agostino Rubini, is documented to 1590: Calabi and Paolo Morachiello, *Rialto*, 296. On the other side of the bridge are sculptures by Tiziano Aspetti representing the two patron saints of the city, Mark and Theodore.

17. In the words of Petrus Berchorius, *Dictionarium seu repertorium morale*, cited by Erwin Panofsky, *Meaning in the Visual Arts*, 262.

18. For further discussion of the resonance of the *Paradise* in the Sala del Maggior Consiglio, see Tolnay, "Il 'Paradiso' del Tintoretto"; Sinding-Larsen, *Christ in the Council Hall* 45–80, and Wolters, *Der Bilderschmuck*, 289–305, *Storia e politica*, 281–96.

19. Justice: EXEQUAR ANGELICO MONITUS SACRATAQUE VERBA / BLANDA PIIS INIMICA MALIS TUMIDISQUE SUPERBA. Michael: SUPLICIUM SCELERI VIRTUTUM PREMIA DIGNA / ET MICHI PURGATAS AN[IM]AS DA LANCE BENIGNA. Gabriel: VIRGINEI PARTUS HUMANE NUNCIA PACIS / VOX MEA VIRGO DUCEM REBUS TE POSCIT. See Moschini Marconi, *Gallerie dell'Accademia . . . secoli XIV e XV*, no. 26.

20. Bibliography on this theme will be found in Rosand, *Painting in Sixteenth-Century Venice*, 214, n. 135.

21. See Wolters, *La scultura veneziana*, 46–47 and cat. no. 49. Although the roundel has occasionally been dated as late as ca. 1420, Wolters argues for a much earlier date, before 1355, the year of the death of Filippo Calendario, to whom he attributes the work. Furthermore, he suggests that the relief served as the model for two similar reliefs, of Justice and Fortitude, on the facade of Palazzo Loredan on the Riva del Ferro, which can be dated to 1365 (ibid., cat. no. 98).

22. Further on the interpretation of this figure, see Wolters, *Der Bilderschmuck*, 236–37, *Storia e politica*, 228–29, as well as Manno, *Il poema del tempo*, 50–52.

23. The militant figure without scales but with sword and shield represents VENETIA MAGNA on the reverse of a medal of Doge Francesco Foscari (1423–57). See Rosand, "*Venetia figurata*," 180 and fig. 10, and Wolters, *Der Bilderschmuck*, 238, fig. 245, and *Storia e politica*, 230, fig. 244.

24. Cited by Sinding-Larsen, *Christ in the Council Hall*, 155, who offers a profound exploration of the Venetian appropriation of liturgical language and significance.

25. Ibid., 140.

26. Sansovino, *Venetia*, 323.

27. Harff, *The Pilgrimage*, 59.

28. *Coryats Crudities*, 158, 278–79, 290.

29. Howell, *S.P.Q.V.*, 1. The theme was soon repeated in James Harrington's *Oceana* (1656): "To come unto experience, *Venice*, notwithstanding that we have found some flaws in it, is the only Commonwealth, in the make whereof, no man can find a cause of dissolution; for which reason wee behold her (albeit she consist of men that are not without sin) at this day with one thousand years upon her back, for any internal cause, as young, as fresh, and free from decay, or any appearance of it, as shee was born, but whatever in nature, is not sensible of decay by the course of a thousand years, is capable of the whole age of nature; a Commonwealth rightly or-

dered, may for any internal causes be as immortal, or longlived as the World"
(185–86). For an early modern appreciation of Howell and his response to Venice,
see Livingston, "James Howell e la città vergine."

30. The significance of this painting was recognized by Sinding-Larsen, *Christ in
the Council Hall*, 55, 218. The relevance of the papal interdict to its dating was first ob-
served by Father Richard Lamoureux in a National Endowment for the Humani-
ties Summer Seminar in 1979.

31. On this resonance, see especially Bouwsma, *Venice and the Defense of Republican
Liberty*, and "Venice and the Political Education of Europe," as well as the references
cited above, Introduction, note 5.

32. *Coryats Crudities*, 199–200.

33. Bardi, *Dichiaratione di tutte le istorie*. At least four manuscript versions of Bardi's
program have been preserved: that in the Museo Civico Correr was published by
Wolters, "Der Programmentwurf," that in the Archivio di Stato of Venice in
Wolters, *Der Bilderschmuck*, 307–16, *Storia e politica*, 299–310.

### 2. THE PEACE OF SAINT MARK

1. Recent studies of the Venetian lion include Rudt de Collenberg, "Il leone
di San Marco," and a series by Alberto Rizzi: "I leoni di Zara," "'Urbem tibi di-
catam conserva'," "Il San Marco a San Marco," "Il leone di San Marco e la lega di
Cambrai."

2. See Gilbert, "Venice in the Crisis of the League of Cambrai."

3. Sanudo, *I diarii*, 8, col. 448. See Rizzi, "Il leone di San Marco," 301.

4. Mason Rinaldi, *Palma il Giovane*, cat. no. 535.

5. On the political significance of Carpaccio's lion, see Muraro, *Carpaccio*, CCX–
CCXII, as well as Wolters, *Der Bilderschmuck*, 231–35, *Storia e politica*, 223–27.

6. A convenient summary of the history of the saint, the church, and the state is
offered by Otto Demus, *The Church of San Marco*, 1–60; for a more circumstantial ex-
ploration of the theme and its political resonance, see Dale, "*Inventing* a Sacred
Past," and *Relics, Prayer, and Politics*. See also Pavanello, "S. Marco nella leggenda";
Tramontin in *Culto dei santi*, 43–73, and "Realtà e leggenda"; Niero, "Questioni
agiografiche," as well as the conference papers in Niero, ed., *San Marco*.

7. On the civic patronage of saints, see Peyer, *Stadt und Stadtpatron*, 8–24, for
Venice and Mark.

8. For recent scholarship on the altarpiece, see the sumptuously illustrated vol-
ume edited by Hahnloser and Polacco, *La Pala d'oro*.

9. See Muraro, "Il pilastro del miracolo," and Demus, "Bemerkungen"; also
Sinding-Larsen, *Christ in the Council Hall*, 197–203.

10. Voragine, *The Golden Legend*, 1:242–48.

11. See Boucher, "Jacopo Sansovino," and *The Sculpture of Jacopo Sansovino*, 1:55–72, 2, cat. nos. 21, 22.

12. Stringa, *Vita di S. Marco*, 88v. The basic hagiographic trilogy of *passio*, *translatio*, and *inventio* constituted the three books of Stringa's original publication, *Della vita, traslatione, et appartione di S. Marco Vangelista . . . libri tre* (1601). The second edition (1610) was revised by the addition of a fourth book devoted to the later miracles, which represent a patriotic elaboration of the collection in the *Golden Legend*; published after the papal interdict of 1606–7, the revised edition carries the more politicized title: *Protettor invittissimo della Serenis. Republica di Venetia*. For further on the hagiography of St. Mark, see note 6 above.

13. These reliefs had generally been viewed as parts of a single narrative, of the slave of Provence, until Erasmus Weddigen associated them with separate miracles recounted in the *Golden Legend*: see Weddigen, "Il secondo pergolo."

14. For this reading of Titian's altarpiece, see Rosand, *Titian*, 68, and *Painting in Sixteenth-Century Venice*, 35–38, 52, 192, with further bibliography.

15. Sansovino, *Venetia*, 98.

16. The mosaic inscription adds to that aura: AVE VIRGINEI FLOS INTEMERATE PUDORIS ("Hail, undefiled flower of virgin modesty"). This salutation to the Virgin recalls the angelic greeting of the Annunciation, a reference to that fateful date, March 25, on which God became man and, 421 years later, created the first Christian republic. See Goffen, *Giovanni Bellini*, 143–60.

17. Further on the Scuola dei Calegheri, see Gramigna and Perissa, *Scuole di arti*, cat. no. 42/A.

18. In the expanding literature on the *scuole grandi*, the most fundamental study remains Pullan, *Rich and Poor*, 33–193; see as well his "Natura e carattere delle scuole." On the early history of their decoration, see the dissertation of William B. Wurthman, "The *Scuole Grandi*." Further discussion and bibliography will be found in Rosand, *Painting in Sixteenth-Century Venice*, chaps. 3 and 5, and Brown, *Venetian Narrative Painting*.

19. The most precise visual document of the *andata in trionfo* is the eight-block woodcut published by Matteo Pagan about 1560 (Rosand and Muraro, *Titian and the Venetian Woodcut*, no. 89). On the ducal procession and related public ceremony, see Muir, *Civic Ritual*, 185–250, as well as his "Images of Power."

20. On Bellini's canvas, see Moschini Marconi, *Gallerie dell'Accademia . . . secoli XIV e XV*, no. 62, and Meyer zur Capellen, *Gentile Bellini*, 70–86, cat. no. A19. On its position in the pictorial cycle and its larger resonance, see Brown, *Venetian Narrative Painting*, 165–91, 282–86.

21. Document of August 2, 1523, cited in Sohm, *The Scuola Grande di San Marco*, 27, 283.

22. By 1523 the Signoria had granted the confraternity four thousand ducats toward reconstruction. Sohm, *The Scuola Grande di San Marco*, offers a thoroughly documented building history; see as well Paoletti, *La Scuola Grande di San Marco*, and Pignatti, ed., *Le scuole di Venezia*, 129–50.

23. The stylistic resonance of the new facade has been explored by Wendy Stedman Sheard, "The Birth of Monumental Classicizing Relief." For the older form of the Misericordia, see Howard, *The Architectural History*, 99, or Concina, *A History of Venetian Architecture*, 111.

24. Sansovino, *Venetia*, 286. See Wolters, *La scultura veneziana*, cat. no. 251. The attribution has been contested by some modern scholars: compare Schulz, *The Sculpture of Giovanni and Bartolomeo Bon*, 27–32, who ascribes the relief to Giorgio da Sebenico.

25. On the theme and the facade, see Sohm, *The Scuola Grande di San Marco*, 169–74; Wolters, *La scultura veneziana*, cat. no. 248. Schulz, *The Sculpture of Giovanni and Bartolomeo Bon*, 23–27, assigns the sculpture to Giovanni.

26. On the lions, see Sohm, *The Scuola Grande di San Marco*, 172–78.

27. Cited in Paoletti, *La Scuola Grande di San Marco*, 14.

28. On *restauri* as political and pictorial in the Venetian tradition, see Tietze-Conrat, "Decorative Paintings of the Venetian Renaissance."

29. On Gentile Bellini's vision of the Orient, see Meyer zur Capellen, *Gentile Bellini*, 87–102; Brown, *Venetian Narrative Painting*, 203–9, and Howard, *Venice and the East*, 72–75, 118.

30. On this recently restored pictorial cycle, see Nepi Sciré, *Gallerie dell'Accademia*; also Humfrey, "The Bellinesque Life of St. Mark Cycle," and Brown, *Venetian Narrative Painting*, 291–95.

31. Nepi Sciré, *Gallerie dell'Accademia*, no. 6.

32. For this contextual reading, see Rosand and Muraro, *Titian and the Venetian Woodcut*, no. 4; also Olivato, "'La Submersione di Pharaone'." This same subject, with the motto "Rebellion to Tyrants is Obedience to God," had been proposed by Benjamin Franklin, seconded by Thomas Jefferson, for the great seal of the new United States: see Patterson and Dougall, *The Eagle and the Shield*, 14–16.

33. Meyer zur Capellen, *Gentile Bellini*, doc. 6, cat. no. B 12.

34. Nepi Sciré, *Gallerie dell'Accademia*, no.7.

35. Paoletti, *La Scuola Grande di San Marco*, 171.

36. Ridolfi, *Le maraviglie*, 2:22.

37. For further discussion of Tintoretto's painting, see Rosand, *Painting in Sixteenth-*

*Century Venice*, 134–39; Krischel, *Jacopo Tintoretto's "Sklavenwunder"*, and *Jacopo Tintoretto, Das Sklavenwunder*.

38. Weddigen, "Il secondo pergolo di San Marco," 126, n. 25, in identifying the miracles as the subject of this canvas, categorically denies that it represents the discovery of the saint's body. Ridolfi had recognized it as the ninth-century recuperation of the body by Buono da Malamocco and Rustico da Torcello (*Le maraviglie*, 2:22) and that reading was repeated by Martinioni in his additions to Sansovino (*Venetia*, 287). The most recent discussions of the painting have continued to assume that subject: compare Tardito, *Il Ritrovamento del corpo di San Marco*, and Marinelli, *Il Ritrovamento del corpo di San Marco*.

39. Vasari, *Le vite*, 6:587. On the representational as well as expressive function of Tintoretto's brushwork, see Rosand, "Tintoretto e gli spiriti nel pennello."

40. Paoletti, *La Scuola Grande di San Marco*, 166–87, reviews the story of the Tintoretto canvases.

41. On Rangone, see Weddigen, "Thomas Philologus Ravennas." For the facade of San Giuliano, see Tafuri, *Jacopo Sansovino*, 145–60, and Howard, *Jacopo Sansovino*, 81–87; for the sculpted monument, see Boucher, *The Sculpture of Jacopo Sansovino*, 113–18, 338–39, and Martin, *Alessandro Vittoria*, 39–42.

42. On this "odor soavissimo," compare Stringa, *Vita di S. Marco*, 34, elaborating on the motif in the *Golden Legend*. The most significant visual document of the legend is to be found in the *translatio* mosaics of the Cappella di San Clemente in San Marco (Fig. 38), where Saracen guards are repelled by the Venetians' cargo, the transliterated Arabic KANZIR KANZIR declaring it to be swine or pig. See Demus, *The Mosaics of San Marco*, 1:66–67, pls. 63, 65, 66.

43. On Domenico's contribution, in addition to Paoletti, *La Scuola Grande di San Marco*, 184–89, see Tozzi Pedrazzi, "Le storie di Domenico Tintoretto," and Pignatti, ed. *Le scuole di Venezia*, 139–41, 145.

### 3. THE WISDOM OF SOLOMON

1. Sansovino, *Venetia*, 93.

2. On the Porta della Carta, see Wolters, *La scultura veneziana*, cat. no. 240, and Schulz, *The Sculpture of Giovanni and Bartolomeo Bon*, 31–49. For its larger context, see as well Wolters, "Scultura," 142–47.

3. Compare Francesco Sansovino's description of the earliest decorations in the Sala del Maggior Consiglio, in which the sharing of bread stands for patrician charity: *Venetia*, 326. The passage is quoted in Rosand, *Painting in Sixteenth-Century Venice*, 215, n. 137, and for other statements of the charity of state, 93–96, 243–44, n. 89.

4. Rossi, "Jacopo d'Albizzotto Guidi," 414. On the sculptural group of the *Judg-*

*ment of Solomon*: Sinding-Larsen, *Christ in the Council Hall*, 170–71; also Wolters, "Scultura," 136–41. Wolters, *La scultura veneziana*, cat. no. 245, assigns the sculpture to Bartolomeo Bon; Schulz, *The Sculpture of Giovanni and Bartolomeo Bon*, 8, retains an attribution to Nani di Bartolo.

5. From an oration of Agostino Michele upon the election of Pasquale Cicogna as doge (1585), quoted by Sinding-Larsen, *Christ in the Council Hall*, 141–42, n. 4.

6. Recall that Jacopo de' Barbari's representation of the south portal to San Marco includes a group of the Annunciation. For further discussion of the Solomonic corner of the Ducal Palace, see Manno, *Il poema del tempo*, 52–55.

7. On "the archangels and the law" on the Ducal Palace, see Sinding-Larsen, *Christ in the Council Hall*, 167–75, and Manno, *Il poema del tempo*, 41–50. On the sculptures themselves, see Wolters, *La scultura veneziana*, cat. no. 48, and "Scultura," 119–25, as well as Tigler, "Le facciate del Palazzo."

8. Bartolomeo Spatafora to Doge Francesco Venier (1554–56), quoted in Sinding-Larsen, *Christ in the Council Hall*, 142, n. 1.

9. Vasari, *Le vite*, 7:507. For Sansovino's transformation of Piazza San Marco, see Howard, *Jacopo Sansovino*, 8–37.

10. Sansovino, *Dialogo di tutte le cose notabili*, fol. 16; Sansovino's comments were first published in 1556 and slightly modified in 1581 (*Venetia*, 307–8). See below, Chapter 4, note 18.

11. For the architectural history and style of the Libreria, see Tafuri, *Jacopo Sansovino*, 63–71; Howard, *Jacopo Sansovino*, 17–28; Hirthe, "Die Libreria des Jacopo Sansovino."

12. Translation from Chambers and Pullan, eds., *Venice: A Documentary History*, 357–58. For the full Latin text, see Mohler, *Kardinal Bessarion*, 3:541–43. On Bessarion and the Library, see Zorzi, *La Libreria di San Marco*, 23–85.

13. Sansovino, *Venetia*, 309, and 76–77, for the decree of 4 September 1362. For a full account of the history of the Biblioteca Marciana, beginning with the intentions of Petrarch, see Zorzi, *La Libreria di San Marco*, 9–22.

14. Sanudo, *Laus urbis Venetae* (1493); translation from Chambers and Pullan, eds., *Venice: A Documentary History*, 16–17.

15. Tafuri, "'Renovatio urbis Venetiarum'," 33.

16. For the beginning of public education in Venice, see Labalme, *Bernardo Giustiniani*, 91–106.

17. Sansovino, *Dialogo di tutte le cose notabili*, fols. 16–16v, and *Venetia*, 307.

18. Ridolfi, *Le maraviglie*, 1: 202: "e nel soffitto del Statuario evvi una figurina di Donna, credesi fatta per l'historia, & un'Amorino, che gli tiene un breve." Boschini makes no attempt to identify the figure: "e nel vano di mezo, vi è una Donnina con un breve in mano, & un Puttino, opera rara di Titiano" (*Le minere*, 87).

19. For the fullest exposition of the Library and its decorations, see Ivanoff, "La Libreria Marciana," especially 65–69 on the vestibule and Titian's picture. For a survey of interpretations of the figure, see Schulz, *Venetian Painted Ceilings*, cat. no. 34; further on the painting itself: Wethey, *The Paintings of Titian*, 3, cat. no. 55, and the exhibition catalogue *Titian: Prince of Painters*, no. 54, both with further bibliography.

20. Schulz, *Venetian Painted Ceilings*, cat. nos. 20 and 26; *Titian, Prince of Painters*, nos. 38 and 42.

21. Wethey, *The Paintings of Titian*, 3, cat. no. 51; *Titian: Prince of Painters*, no. 51.

22. Sansovino, *Venetia*, 282, who essentially follows the account of Gasparo Contarini, *De magistratibus et republica Venetorum*, 111–13.

23. This reading of Titian's painting summarizes a thesis originally presented in Rosand, "Titian's *Presentation of the Virgin in the Temple*," and more fully elaborated in Rosand, *Painting in Sixteenth-Century Venice*, chap. 3, to which the reader is referred for further supporting argument, documentation, and bibliography.

24. Wolters, *La scultura veneziana*, cat. no. 143, fig. 493, and "Scultura," 134, fig. 79.

25. Voragine, *The Golden Legend*, 2:152.

26. It is worth noting that Antonio Rizzo's design for the staircase of the Ducal Palace cortile (not yet the Scala dei Giganti) is also based on the Pythagorean ratios. For references on the staircase, see below, Chapter 4, note 7.

27. The pictorial relationship between past and present and the engagement of the viewer as witness has been sensitively explored by Brown, *Venetian Narrative Painting*.

28. See especially Meiss, "Light as Form and Symbol," reprinted in *The Painter's Choice*, 3–18. In fifteenth-century Venice, the Beato Lorenzo Giustiniani found his true vocation at the age of twenty-one in the illumination of *Sapientia Dei*, who appeared to him as "a virgin more splendid than the sun" (Bernardo Giustiniani, *Vita Beati Laurentii*, cited by Labalme, *Bernardo Giustiniani*, 241).

29. Although not made dogma until the nineteenth century, the doctrine of Mary born free of Original Sin was sanctioned by the Franciscan Pope Sixtus IV in 1476 and again in 1480. In 1496 the brothers of the Scuola della Carità decided to celebrate the feast annually. See Rosand, *Painting in Sixteenth-Century Venice*, 80–85, and, for further on the doctrine in Venice, Goffen, *Piety and Patronage in Renaissance Venice*, 73–79, 138–54.

#### 4. THE APPROPRIATION OF OLYMPUS

1. On Renier's medal, see Armand, *Les médailleurs italiens*, 1:125, who ascribes the work to a Venetian medalist of 1523; Heiss, *Les médailleurs de la Renaissance*, 190, no. 21; Hill, *A Corpus of Italian Medals*, 1:129, no. 489, 2, pl. 91. The height of Renier's career

was evidently his election as "podestà e capitano" of Rovigo on April 3, 1527: see Sanudo, *I diarii*, 44, cols. 420, 422.

2. For example, Sanudo, *De origine*, 12–13: "questa città in l'isola de Rialto fo comenzata a edificar . . . del 421, adí 25 Marzo in zorno di Venere cercha l'hora di nona ascendendo, come nella figura astrologica apar, gradi 25 del segno del Cancro." Further on the identity of Venice and Venus, see Sinding-Larsen, *Christ in the Council Hall*, 144; Rosand, "*Venetia figurata*," 188–90, and below, note 29.

3. Howell, *S.P.Q.R.*, 32. For the continuing hold of the myth on the historical imagination, see Howard, "Venice as Dolphin."

4. Doglione, *Venetia trionfante* [6]:

INCERTI AVTHORIS
De Eadem Vrbe.

> Aut Venus à Venetis sibi fecit amabile nomen,
>   Aut Veneti Veneris nomen, & omen habent.
> Orta maris spuma fertur Venus, & Venetorum
>   Si videas vrbem, creditur orta mari.
> Iuppiter est illi genitor, sed Mars pater huic est;
>   Mulciberi coniunx illa, sed ista maris.
> Complet amat, hunc numquam debet amare Venus.

For earlier examples of imagining Venice as Venus, in courtly rather than Olympian guise, see Rosand, "*Venetia figurata*," 188–90.

5. The following expands upon a theme first adumbrated in Rosand, "Venezia e gli dei."

6. A few years before the publication of the woodcut, in a manuscript completed by 1493, Marin Sanudo concluded his verbal description of the city with just such conventional observations: *De origine*, 38–39. Translation in Chambers and Pullan, eds., *Venice: A Documentary History*, 20–21.

7. Manfredo Tafuri has explored with particular sensitivity the larger political and social implications behind architectural style: see his *Venice and the Renaissance*. On the architecture of Sansovino, see Tafuri, *Jacopo Sansovino*, and Howard, *Jacopo Sansovino*.

8. Boucher, *The Sculpture of Jacopo Sansovino*, cat. no. 35, docs. 226–39.

9. Sansovino, *Venetia*, 320. On the staircase itself and its significance, see Muraro, "La Scala senza Giganti"; also Schulz, *Antonio Rizzo*, 88–90, 98–106, 108–13, 145–52, and Schulz, *Antonio Rizzo: Scala dei Giganti*.

10. Priuli, *I diarii*, 2:386; Sanudo, *I diarii*, 6, cols. 214–15.

11. See Wolters, "Leopardi oder Lombardi?"; compare as well Jestaz, "Requiem pour Alessandro Leopardi."

12. Sansovino, *Venetia*, 293: ". . . i quali standardi significano franchigia, & libertà dipendente da Dio, & solo, & non da Principe alcuno. Si dice che rappresentano anco i tre Regni, di Venetia, di Cipri, & di Candia."

13. Such processions formed a major part of the public festivities of the Renaissance; *trionfi* and *momarie* brought personifications, allegories, and the pagan gods to life on stages and carriages as well as on barges. Many of these celebrations were recorded by Sanudo—e.g., a "fabula con cavalli mariani e carri trionfali, intervenendo Idio d'Amor, *Nymphae*, Inamorati" (*I diarii*, 23, col. 583). See Muraro, "La festa a Venezia," esp. 328–41.

14. On the appropriation of this figure by the European political imagination, see Yates, *Astraea*.

15. Her three sisters carry the ducal crown, the torch of war, and the olive branch of peace. On the staircase, in addition to the references cited above, note 7, see Wolters, "Scultura," 153–54; Brown, *Venice & Antiquity*, 166–69.

16. Translation (here modified) in Chambers and Pullan, eds., *Venice: A Documentary History*, 398. Contarini's *Argoa voluptas* was published in 1541, followed shortly thereafter by an Italian version, *Argo vulgar*. For the full Italian text of Contarini's description of the pedestals, see Wolters, "Leopardi oder Lombardi?" 65–66, n. 15.

17. Regarding the elephant that accompanies Astraea, a symbol of Strength, compare the image in an illuminated manuscript sent by the Paduan Jacopo Antonio Marcello to King René d'Anjou: an elephant bearing on its back a model of the Ducal Palace, a reference to the power of Venice. See Meiss, *Mantegna as Illuminator*, 8–12, but, on the attribution, compare Lightbown, *Mantegna*, 494–95.

An interesting variation on the theme is offered by the figure of Judith as/or Justice from the Fondaco dei Tedeschi. See Wind, *Giorgione's Tempesta*, 11–15, and Muraro, "The Political Interpretation of Giorgione's Frescoes," 178–84. On the Fondaco frescoes in the context of Giorgione's art, see Anderson, *Giorgione*, 267–86, 304–6; for the extant fragment itself, see also the entry by Valcanover in *Titian: Prince of Painters*, no. 1.

18. Sansovino, *Dialogo di tutte le cose notabili*, fols. 17–17v. This libretto first appeared in 1556, under the pseudonym Anselmo Guiscono, as *Tutte le cose notabili et belle che sono in Vinetia*, and then, under the author's proper name, in 1561 as *Delle cose notabili che sono in Venetia*; it went through several subsequent editions and was updated and published into the seventeenth century. For references on Sansovino, see above, Chapter 1, note 2.

19. Sansovino, *Venetia*, 307–8.

20. Sansovino, *L'arte oratoria*, fol. 52. For this text, as well as a sensible discussion of its evidentiary value, see Davis, "Jacopo Sansovino's 'Loggetta,'" 396–400.

21. Sansovino, *Dialogo di tutte le cose notabili*, fols. 16–17v.

22. The Florentine Jacopo Sansovino would have been quite familiar with Donatello's bronze *David*, and the comparison has frequently been made. See Boucher, *The Sculpture of Jacopo Sansovino*, 1:76–77, with previous bibliography.

23. On this theme, its rhetorical implications as well as practical manifestations, see Rosand, "Music in the Myth of Venice," 511–37.

24. *Delle Orationi recitate a principi di Venetia nella loro creatione da gli ambasciadori di diverse città.*

25. Sanudo, *I diarii*, 52, cols. 531–32. See Maria Teresa Muraro, "La festa a Venezia," 336.

26. See Rosand, "Music in the Myth of Venice," 527–30. On Domenico Venier and his academy, see Feldman, *City Culture and the Madrigal*, 83–119.

27. For this development see the introduction to Schulz, *Venetian Painted Ceilings*.

28. Ibid., cat. no. 35; Wolters, *Der Bilderschmuck*, 247–55, *Storia e politica*, 239–46. On Daniel Barbaro as iconographer, see Reist, "Renaissance Harmony," 137–53.

29. Sansovino, *Venetia*, 325. A slightly different list of crimes and vices is offered by Ridolfi, *Le maraviglie*, 1:310–11. Boschini, *Le minere*, 25, while not enumerating the miscreants, adds that the book held by the winged figure accompanying Jupiter represents the decrees of the Council.

30. Vasari, *Le vite*, 6:371, 595.

31. "[D]irei che Vinegia e Venere ambe celesti, ambe madri, e nudrici di santissimo amore fossero sorelle, nate da uno stesso ventre del mare, prodotte da uno stesso seme del cielo . . ." (*Oratione di M. Luigi Groto cieco ambasciator di Hadria nella creatione del Serenissimo Prencipe di Vinegia Sebastian Venier*), cited by Wolters, *Der Bilderschumck*, 251, n. 1, *Storia e politica*, 242, n. 2).

32. Sansovino, *Venetia*, 323.

33. In Antonio Maria Consalvi's *Il consiglio delli Dei per la fondatione, e grandezza dell'inclita città di Venezia e dell'eccellentissima sua Republica* (1614) Neptune calls the council to discuss the foundation of a city to eclipse Rome (cited by Wolters, *Der Bilderschumck*, 62, *Storia e politica*, 64). Further on Tintoretto's decoration of the Sala delle Quattro Porte, see Sinding-Larsen, *Christ in the Council Hall*, 242–44; also Pallucchini and Rossi, *Tintoretto*, cat. nos. 359–69.

34. Lorenzi, *Monumenti*, 449, doc. 880; the full text is reprinted in Pignatti and Pedrocco, *Veronese*, 2:560, doc. 53.

35. Ridolfi, *Le maraviglie*, 2:43–44. On the Salotto Dorato pictures, see Pallucchini

and Rossi, *Tintoretto*, 209–10, cat. nos. 373–76; Sinding-Larsen, *Christ in the Council Hall*, 238–40; Wolters, *Der Bilderschumck*, 245–46, *Storia e politica*, 236–37. Charles de Tolnay, "Tintoretto's Salotto Dorato Cycle," has suggested a more cosmological dimension to the cycle, as representing as well the four seasons and the four elements—a possible reading, one might agree, one potentially inherent in almost any quadripartite pictorial structure but not necessarily intended.

36. Pignatti and Pedrocco, *Veronese*, cat. no. 234.

37. Further on the Sala del Collegio, see Sinding-Larsen, *Christ in the Council Hall*, 254–60, and Wolters, *Der Bilderschmuck*, 256–64, *Storia e politica*, 247–55. See also Schulz, *Venetian Painted Ceilings*, cat. no. 41, and Pignatti and Pedrocco, *Veronese*, cat. nos. 214–30.

38. In the central canvas of the ceiling of the Sala del Senato (or dei Pregadi) Tintoretto's composition features Venice as ruler of the Olympians high above the orb of the world; from the oceans arise marine deities bringing the tribute of the sea. See Schulz, *Venetian Painted Ceilings*, cat. no. 43; Sinding-Larsen, *Christ in the Council Hall*, 247–48, and 263–68 (Appendix I: Annette Kuhn, "Venice, Queen of the Sea").

39. This is an important observation in Wolters' discussion of this imagery: *Der Bilderschmuck*, 275–87, *Storia e politica*, 267–79. See as well Sinding-Larsen, *Christ in the Council Hall*, 224–38.

40. Cartari, *Le imagini de i dei*, 145. Further on Juno Moneta: Wissowa, ed., *Paulys Real-Encyclopädie*, 10, col. 1118. On the implications of Juno Moneta in Rembrandt's *Juno*, a painting Venetian in so many ways, see Held, *Rembrandt Studies*, 112–17.

41. Schulz, *Venetian Painted Ceilings*, cat. no. 18.

42. See Ward Perkins, "The Shrine of Saint Peter." For further discussion and bibliography, see Shearman, *Raphael's Cartoons*, 56–57.

43. I have argued for Veronese's pictorial intelligence in *Painting in Sixteenth-Century Venice*, 107–33 (chap. 4: "Theater and Structure in the Art of Paolo Veronese"), with further bibliography. See as well Wolters, "Il pittore come storiografo?"

44. On this civic and aesthetic phenomenon, see Rosand, *Opera in Seventeenth-Century Venice*.

45. See William Barcham's entry on the painting in Christiansen, ed., *Giambattista Tiepolo 1696–1770*, no. 24. An even more distant echo of the pictorial resonance is heard in Pompeo Batoni's classicizing *Triumph of Venice*, commissioned by Marco Foscarini in 1737 upon his arrival in Rome as Venetian ambassador to the papal court. See the entry by Giorgio Fossaluzza in Bettagno, ed., *Venezia da stato a mito*, no. 32, and Fehl, "Pictorial Precedents."

# BIBLIOGRAPHY OF WORKS CITED

Anderson, Jaynie. *Giorgione: The Painter of "Poetic Brevity"*. Paris and New York: Flammarion, 1997.

Armand, Alfred. *Les médailleurs italiens des quinzième et seizième siècles*, 2d ed., 2 vols. Paris: E. Plon, 1883.

Bardi, Girolamo. *Dichiaratione di tutte le istorie che si contengono nei quadri posti nuovamente nelle Sale dello Scrutinio e del Gran Consiglio del Palagio Ducale della Serenissima Repubblica di Vinegia*. Venice: Felice Valgrisio, 1587.

Bettagno, Alessandro, ed. *Venezia da stato a mito*. Venice: Marsilio Editori, 1997.

Boschini, Marco. *Le minere della pittura*. Venice: Francesco Nicolini, 1664.

Boucher, Bruce. "Jacopo Sansovino and the Choir of St Mark's." *Burlington Magazine* 118 (1976): 552–66.

———. *The Sculpture of Jacopo Sansovino*. 2 vols. New Haven and London: Yale University Press, 1991.

Bouwsma, William J. *Venice and the Defense of Republican Liberty: Renaissance Values in the Age of the Counter Reformation*. Berkeley and Los Angeles: University of California Press, 1968.

———. "Venice and the Political Education of Europe." In *Renaissance Venice*, edited by J. R. Hale, 445–66. London: Faber and Faber, 1973.

Brown, Horatio F. *The Venetian Printing Press, 1469–1800* (1891). Rpt. Amsterdam: Gérarch Th. van Heusden, 1969.

———. *Studies in the History of Venice*. 2 vols. London: J. Murray, 1907.

Brown, Patricia Fortini. *Venetian Narrative Painting in the Age of Carpaccio*. New Haven and London: Yale University Press, 1988.

———. *Venice and Antiquity: The Venetian Sense of the Past*. New Haven and London: Yale University Press, 1996.

Calabi, Donatella, and Paolo Morachiello. *Rialto: Le fabbriche e il ponte, 1514–1591.* Turin: Giulio Einaudi, 1987.

Carile, Antonio, and Giorgio Fedalto. *Le origini di Venezia.* Bologna: Pàtron Editore, 1978.

Cartari, Vincenzo. *Le imagini de i dei de gli antichi* (1556). Lyon: Bartholomeo Honorati, 1581.

Cassirer, Ernst. *The Myth of the State.* New Haven: Yale University Press, 1946.

Chambers, David, and Brian Pullan, eds., with Jennifer Fletcher. *Venice: A Documentary History 1450–1630,* Oxford and Cambridge, Mass.: Blackwell, 1992.

Christiansen, Keith, ed. *Giambattista Tiepolo 1696–1770.* New York: Metropolitan Museum of Art, 1996.

Cicogna, Emmanuele Antonio. *Delle iscrizioni veneziane.* 6 vols. Venice: Giuseppe Orlandelli, 1824–53.

Cochrane, Eric, and Julius Kirshner. "Deconstructing Lane's *Venice.*" *Journal of Modern History* 47 (1975): 321–34.

Concina, Ennio. *A History of Venetian Architecture.* Translated by Judith Landry. Cambridge and New York: Cambridge University Press, 1998.

Contarini, Gasparo. *De magistratibus et republica Venetorum libri quinque.* Paris: Michaelis Vascosani, 1543.

———. *The Commonwealth and Government of Venice. Written by the Cardinall Gaspar Contareno and translated out of the Italian into English by Lewes Lewkenor.* London: I. Windet for E. Mattes, 1599.

Coryat, Thomas. *Coryats Crudities.* London: W.S., 1611.

Crouzet-Pavan, Elisabeth. *Venise triomphante: Les horizons d'un mythe.* Paris: Albin Michel, 1999.

Dale, Thomas E. A. "*Inventing* a Sacred Past: Pictorial Narratives of St. Mark the Evangelist in Aquileia and Venice, ca. 1000–1300." *Dumbarton Oaks Papers* 48 (1994): 53–104.

———. *Relics, Prayer, and Politics in Medieval Venetia: Romanesque Painting in the Crypt of Aquileia Cathedral.* Princeton: Princeton University Press, 1997.

Davis, Charles. "Jacopo Sansovino's 'Loggetta di San Marco' and Two Problems in Iconography." *Mitteilungen der Kunsthistorischen Institutes in Florenz* 29 (1985): 396–400.

Demus, Otto. *The Church of San Marco in Venice: History, Architecture, Sculpture.* Washington: Dumbarton Oaks Research Library and Collection, 1960.

———. "Bemerkungen zu M. Muraro's *Pilastro del miracolo.*" In *Interpretazioni*

*veneziane: Studi di storia dell'arte in onore di Michelangelo Muraro*, edited by David
Rosand, 23–28. Venice: Arsenale Editrice, 1984.

———. *The Mosaics of San Marco in Venice*. 2 vols in 4. Chicago and London:
University of Chicago Press, 1984.

———, et al. *Le sculture esterne di San Marco*. Milan: Electa, 1995.

Doglione, Giovanni Nicolò. *Venetia trionfante et sempre libera*. Venice: Muschio,
1613.

Fehl, Philipp. "Pictorial Precedents for the Representation of Doge Lionardo
Loredano in Batoni's *Triumph of Venice*." *North Carolina Museum of Art Bulletin* 11
(1973): 21–31.

Feldman, Martha. *City Culture and the Madrigal at Venice*. Berkeley, Los Angeles,
London: University of California Press, 1995.

Fink, Z. S. "Venice and English Political Thought in the Seventeenth Century."
*Modern Philology* 38 (1940–41): 155–72.

Finlay, Robert. *Politics in Renaissance Venice*. New Brunswick, N.J.: Rutgers
University Press, 1980.

Franzoi, Umberto, Terisio Pigatti, and Wolfgang Wolters. *Il Palazzo Ducale di
Venezia*. Treviso: Edizioni Canova, 1990.

Gilbert, Felix. "The Date of the Composition of Contarini's and Giannotti's
Books on Venice." *Studies in the Renaissance* 14 (1967): 172–84.

———. "The Venetian Constitution in Florentine Political Thought," in
*Florentine Studies: Politics and Society in Renaissance Florence*, edited by Nicolai
Rubinstein, 463–500. London: Faber and Faber, 1968.

———. "Venice in the Crisis of the League of Cambrai." In *Renaissance Venice*,
edited by J. R. Hale, 274–92. London: Faber and Faber, 1973.

Gilmore, Myron. "Myth and Reality in Venetian Political Theory." In *Renaissance
Venice*, edited by J. R. Hale, 431–44. London: Faber and Faber, 1973.

Gleason, Elisabeth G. *Gasparo Contarini: Venice, Rome, and Reform*. Berkeley, Los
Angeles, Oxford, 1993.

Goffen, Rona. *Piety and Patronage in Renaissance Venice: Bellini, Titian, and the
Franciscans*. New Haven and London: Yale University Press, 1986.

———. *Giovanni Bellini*. New Haven and London: Yale University Press, 1989.

Gramigna, Silvia, and Annalisa Perissa, *Scuole di arti, mestieri e devozione a Venezia*.
Venice: Arsenale Cooperativa Editrice, 1981.

Grendler, Paul F. "Francesco Sansovino and Italian Popular History." *Studies in the
Renaissance* 16 (1969): 139–80.

Grubb, James. "When Myths Lose Power: Four Decades of Venetian
Historiography." *Journal of Modern History* 58 (1986): 43–94.

Hahnloser, H. R., and Renato Polacco. *La Pala d'oro*. Venice: Canal & Stamperia Editrice, 1994.

Haitsma Mulier, Eco O. G. *The Myth of Venice and Dutch Republican Thought in the Seventeenth Century*. Assen: Van Gorcum, 1980.

Harff, Arnold von. *The Pilgrimage of Arnold von Harff, Knight . . . , 1496–1499*. Translated by Malcolm Letts. London: Hakluyt Society, 1946.

Harrington, James. *Oceana* (1656). Edited by S. B. Liljegren. Heidelberg: C. Winter, 1924.

Heiss, Aloïse. *Les médailleurs de la Renaissance: Venise et les Vénitiens du XVe-au-XVIe siècle*. Paris: Rothschild, 1887.

Held, Julius S. *Rembrandt Studies*. Princeton: Princeton University Press, 1991.

Hill, George F. *A Corpus of Italian Medals of the Renaissance before Cellini*. 2 vols. London: British Museum, 1930.

Hirthe, Thomas. "Die Libreria des Jacopo Sansovino: Studien zu Architektur und Ausstattung eines öffentlichen Gebäudes in Venedig." *Münchner Jahrbuch der bildenden Kunst* 37 (1986): 131–76.

Howard, Deborah. *Jacopo Sansovino: Architecture and Patronage in Renaissance Venice*. New Haven and London: Yale University Press, 1975.

———. *The Architectural History of Venice*. London: B. T. Batsford, 1980.

———. "Venice as Dolphin: Further Investigations into Jacopo de' Barbari's View." *Artibus et historiae* 35 (1997): 101–11.

———. *Venice and the East: The Impact of the Islamic World on Venetian Architecture, 1100–1500*. New Haven and London: Yale University Press, 2000.

Howell, James. *S.P.Q.V. A Survay of the Signorie of Venice, of Her Admired Policy, and Method of Government, &c*. London: Richard Lowndes, 1651.

Humfrey, Peter. "The Bellinesque Life of St. Mark Cycle for the Scuola Grande di San Marco in Venice and its Original Arrangement." *Zeitschrift für Kunstgeschichte* 48 (1985): 225–42.

Ivanoff, Nicola. "La Libreria Marciana: Arte e iconologia." *Saggi e memorie di storia dell'arte* 6 (1968): 33–78.

Jacks, Philip. *The Antiquarian and the Myth of Antiquity: The Origins of Rome in Renaissance Thought*. Cambridge and New York: Cambridge University Press, 1993.

Jestaz, Bertrand. "Requiem pour Alessandro Leopardi." *Revue de l'art* 55 (1982): 23–34.

Krischel, Roland. *Jacopo Tintorettos "Sklavenwunder"*. Munich: Scaneg Verlag, 1991.

———. *Jacopo Tintoretto, Das Sklavenwunder: Bildwelt und Weltbild*. Frankfurt am Main: Fischer Taschenbuch Verlag, 1994.

Labalme, Patricia H. *Bernardo Giustiniani: A Venetian of the Quattrocento.* Rome: Edizioni di Storia e Letteratura, 1969.

Lane, Frederic C. *Venice: A Maritime Republic.* Baltimore and London: The Johns Hopkins University Press, 1973.

Lazzarini, Lino. "'Dux ille Danduleus': Andrea Dandolo e la cultura veneziano a metà del Trecento." In *Petrarca, Venezia e il Veneto*, edited by Giorgio Padoan, 123–56. Florence: Leo S. Olschki, 1976.

Lightbown, Ronald. *Mantegna.* Berkeley and Los Angeles: University of California Press, 1986.

Livingston, Arthur. "James Howell e la città vergine." *Fanfulla della Domenica* (Rome), no. 20, 19 May 1912.

Lorenzi, Giambattista. *Monumenti per servire alla storia del Palazzo Ducale.* Venice: Visentini, 1868.

Manno, Antonio. *Il poema del tempo. I capitelli del Palazzo Ducale di Venezia: Storia e iconografia.* Venice: Canal & Stamperia Editrice, 1999.

Maranini, Giuseppe. *La costituzione di Venezia*, 2 vols. (1927–31). Florence: La Nuova Italia, 1974.

Marinelli, Sergio. *Il Ritrovamento del corpo di San Marco di Jacopo Tintoretto.* Milan: Tascabili degli Editori Associati, 1996.

Martin, John, and Dennis Romano, eds. *Venice Reconsidered: The History and Civilization of an Italian City-State, 1297–1797.* Baltimore and London: The Johns Hopkins University Press, 2000.

Martin, Thomas. *Alessandro Vittoria and the Portrait Bust in Renaissance Venice: Remodelling Antiquity.* Oxford: Clarendon Press, 1998.

Marx, Barbara. *Venezia—altera Roma? Ipotesi sull'umanesimo italiano.* Venice: Centro Tedesco di Studi Veneziani (Quaderno 10), 1978.

Mason Rinaldi, Stefania. *Palma il Giovane: L'opera completa.* Milan: Electa, 1984.

Mazzariol, Giuseppe, and Terisio Pignatti. *La pianta prospettica di Venezia del 1500 disegnata da Jacopo de' Barbari.* Venice: Cassa di Risparmio di Venezia, 1963.

McPherson, David. "Lewkenor's Venice and Its Sources." *Renaissance Quarterly* 41 (1988): 459–66.

———. *Shakespeare, Jonson, and the Myth of Venice.* Newark, London, Toronto: Associated University Presses, 1990.

Meiss, Millard. "Light as Form and Symbol in Some Fifteenth-Century Paintings." *Art Bulletin* 17 (1945): 175–81.

———. *Mantegna as Illuminator.* New York: Columbia University Press, 1957.

———. *The Painter's Choice: Problems in the Interpretation of Renaissance Art.* New York and London: Harper & Row, 1976.

Meyer zur Capellen, Jürg. *Gentile Bellini*. Stuttgart: Franz Steiner Verlag, 1985.

Mohler, Ludwig. *Kardinal Bessarion als Theologe, Humanist und Staatsmann*. 3 vols. Paderborn: 1942.

Moschini Marconi, Sandra. *Gallerie dell'Accademia di Venezia: Opere d'arte dei secoli XIV e XV*. Rome: Istituto Poligrafico dello Stato, 1955.

———. *Gallerie dell'Accademia di Venezia: Opere d'arte del secolo XVI*. Rome: Istituto Poligrafico dello Stato, 1962.

Muir, Edward. "Images of Power: Art and Pageantry in Renaissance Venice," *American Historical Review* 84 (1979): 16–52.

———. *Civic Ritual in Renaissance Venice*. Princeton: Princeton University Press, 1981.

Muraro, Maria Teresa. "La festa a Venezia e le sue manifestazioni rappresentative: Le Compagnie della Calza e le *momarie*." In *Storia della cultura veneta*, vol. 3/iii, 315–41. Vicenza: Neri Pozza Editore, 1981.

Muraro, Michelangelo. "La Scala senza Giganti." In *De Artibus Opuscula XL: Essays in Honor of Erwin Panofsky*, edited by Millard Meiss, 350–70. New York: New York University Press, 1961.

———. *Carpaccio*. Florence: Edizione d'Arte il Fiorino, 1966.

———. "Il pilastro del miracolo e il secondo programma dei mosaici Marciani." *Arte Veneta* 29 (1975): 60–65.

———. "The Political Interpretation of Giorgione's Frescoes on the Fondaco dei Tedeschi." *Gazette des beaux-arts* 86 (1975): 178–84.

———. "Petrarca, Paolo Veneziano e la cultura artistica alla corte del doge Andrea Dandolo." In *Petrarca, Venezia e il Veneto*, edited by Giorgio Padoan, 157–68. Florence: Leo S. Olschki, 1976.

Nepi Sciré, Giovanna. *Gallerie dell'Accademia di Venezia: I teleri della Sala dell'Albergo nella Scuola di San Marco*. Venice: Soprintendenza ai Beni Artistici e Storici, 1994.

Niero, Antonio. "Questioni agiografiche su San Marco." *Studi veneziani* 12 (1970): 3–27.

———, ed. *San Marco: Aspetti storici e agiografici* (Atti del Convegno internazionale di studi). Venice: Marsilio Editori, 1996.

Norwich, John Julius. *A History of Venice*. Harmondsworth, New York, Victoria: Penguin Books, 1983.

Olivato, Loredana. "'La Submersione di Pharaone'." In *Tiziano e Venezia* (Convegno internazionale di studi, Venezia, 1976), 529–37. Vicenza: Neri Pozza Editore, 1980.

Padoan, Giorgio, ed. *Petrarca, Venezia e il Veneto*. Florence: Leo S. Olschki, 1976.

Pallucchini, Rodolfo, and Paola Rossi. *Tintoretto: Le opere sacre e profane*. 2 vols. Milan: Electa, 1982.

Panofsky, Erwin. *Meaning in the Visual Arts: Papers in and on Art History*. Garden City: Doubleday Anchor Books, 1957.

Paoletti, Pietro. *La Scuola Grande di San Marco*. Venice: Comune di Venezia, 1929.

Patterson, Richard S., and Richardson Dougall. *The Eagle and the Shield: A History of the Great Seal of the United States*. Washington: Bureau of Public Affairs, Department of State, 1976.

Pavanello, Giuseppe. "S. Marco nella leggenda e nella storia." *Rivista della città di Venezia* 7 (1928): 293–324.

Perocco, Guido. "Il Palazzo Ducale, Andrea Dandolo e il Petrarca." In *Petrarca, Venezia e il Veneto*, edited by Giorgio Padoan, 169–77. Florence: Leo S. Olschki, 1976.

Pertusi, Agostino, ed. *La storiografia veneziana fino al secolo XVI: Aspetti e problemi*. Florence: Leo S. Olschki, 1970.

Peyer, Hans Conrad. *Stadt und Statdpatron im mittelalterlichen Italien*. Zurich: Europa Verlag, 1955.

Pignatti, Terisio, ed. *Le scuole di Venezia*. Milan: Electa, 1981.

———, and Filippo Pedrocco. *Veronese*. 2 vols. Milan: Electa, 1995.

Pocock, J. G. A. *The Machiavellian Moment: Florentine Political Thought and the Atlantic Republican Tradition*. Princeton: Princeton University Press, 1975.

Priuli, Girolamo. *I diarii di Girolamo Priuli [AA. 1499–1512]*. Edited by Roberto Cessi. 2 vols. Bologna: Nicola Zanichelli, 1930.

Pullan, Brian. *Rich and Poor in Renaissance Venice: The Social Institutions of a Catholic State, to 1620*. Oxford: Basil Blackwell, 1971.

———. "Natura e carattere delle scuole." In *Le scuole di Venezia*, edited by Terisio Pignatti, 9–26. Milan: Electa, 1981.

Puppi, Lionello. *Verso Gerusalemme: Immagini e temi di urbanistica e di architettura simboliche*. Rome: Casa del Libro, 1982.

———. *Nel mito di Venezia. Autocoscienza urbana e costruzione delle immagini: Saggi di lettura*. Venice: il Cardo, 1994.

Queller, Donald E. *The Venetian Patriciate: Reality Versus Myth*. Urbana and Chicago: University of Illinois Press, 1986.

Reist, Inge Jackson. "Renaissance Harmony: The Villa Barbaro at Maser." Ph.D. dissertation, Columbia University, 1985.

Ridolfi, Carlo. *Le maraviglie dell'arte* (1648). Edited by Detlev von Hadeln. 2 vols. Berlin: G. Grote, 1914–24.

Rizzi, Alberto. "I leoni di Zara," *Ateneo Veneto* 26 (1988): 7–36.

———. "'Urbem tibi dicatam conserva' (I leoni marciani lapidei di Treviso e della Marca)," *Ateneo Veneto* 27 (1989): 25–55.

———. "Il San Marco a San Marco. L'emblema lapideo della Repubblica Veneta nel suo cuore politico," *Ateneo Veneto* 28 (1990): 7–46.

———. "Il leone di San Marco e la lega di Cambrai," *Ateneo Veneto* 34 (1996): 297–314.

Rosand, David. "Titian's *Presentation of the Virgin in the Temple* and the Scuola della Carità." *Art Bulletin* 58 (1976): 55–84.

———. *Titian.* New York: Harry N. Abrams, 1978.

———. *Painting in Sixteenth-Century Venice: Titian, Veronese, Tintoretto* (1982), revised edition. Cambridge and New York: Cambridge University Press, 1997.

———. "*Venetia figurata*: The Iconography of a Myth." In *Interpretazioni veneziane: Studi di storia dell'arte in onore di Michelangelo Muraro*, edited by David Rosand, 177–96. Venice: Arsenale Editrice, 1984.

———. "Venezia e gli dei." In *"Renovatio urbis": Venezia nell'età di Andrea Gritti (1523–1538)*, edited by Manfredo Tafuri, 201–15. Rome: Officina Edizioni, 1984.

———. "Tintoretto e gli spiriti nel pennello." In *Jacopo Tintoretto nel quarto centenario della morte*, edited by Paola Rossi and Lionello Puppi, 133–37. Padua: Il Poligrafo, 1996.

———, and Michelangelo Muraro. *Titian and the Venetian Woodcut.* Washington: International Exhibitions Foundation, 1976.

Rosand, Ellen. "Music in the Myth of Venice." *Renaissance Quarterly* 30 (1977): 511–37.

———. *Opera in Seventeenth-Century Venice: The Creation of a Genre.* Berkeley, Los Angeles, Oxford: University of California Press, 1991.

Rose, Charles Jerome. "The Evolution of the Image of Venice (1500–1630)." Ph.D. diss., Columbia University, 1971.

Rossi, Vittorio. "Jacopo d'Albizzotto Guidi e il suo inedito poema su Venezia." *Nuovo Archivio Veneto* 5 (1893): 397–451.

Rudt de Collenberg, W. H. "Il leone di San Marco. Aspetti storici e formali dell'emblema statale della Serenissima," *Ateneo Veneto* 27 (1989): 57–84.

Sansovino, Francesco. *L'arte oratoria secondo i modi della lingua volgare.* Venice: I. Sansovino, 1546.

———. *Delle cose notabili che sono in Venetia.* Venice: Comin da Torino, 1561.

———. *Delle orationi recitate a principi di Venetia nella loro creatione da gli ambasciadori di diverse città . . . raccolte per Francesco Sansovino.* Venice: F. Sansovino, 1562.

———. *Dialogo di tutte le cose notabili che sono in Venetia.* Venice: Dominico de' Franceschi, 1568.

————. *Venetia città nobilissima et singolare* (1581). Edited by Giustiniano Martinioni. Venice: Steffano Curti, 1663.

Sanudo, Marin. *I diarii di Marino Sanuto (MCCCCXCVI–MDXXXIII)*. Edited by Rinaldo Fulin et al. 58 vols. Venice: F. Visentini, 1879–1903.

————. *De origine, situ et magistratibus urbis Venetae, ovvero La città di Venetia [1493–1530]*. Edited by Angela Caracciola Aricò. Milan: Cisalpino-La Goliardica, 1980.

Saxl, Fritz. *A Heritage of Images: A Selection of Lectures*. Edited by Hugh Honour and John Flemming. Middlesex and Baltimore: Penguin Books, 1970.

Schulz, Anne Markham. *The Sculpture of Giovanni and Bartolomeo Bon and their Workshop*. Philadelphia: American Philosophical Society, 1978.

————. *Antonio Rizzo: Sculptor and Architect*. Princeton: Princeton University Press, 1983.

————. *Antonio Rizzo: Scala dei Giganti*. Venice: Arsenale Editrice, 1985.

Schulz, Juergen. *Venetian Painted Ceilings of the Renaissance*. Berkeley and Los Angeles: University of California Press, 1968.

————. "Jacop de' Barbari's View of Venice: Map Making, City Views, and Moralized Geography before the Year 1500." *Art Bulletin* 60 (1978): 425–74.

Sheard, Wendy Stedman. "The Birth of Monumental Classicizing Relief in Venice on the Facade of the Scuola di San Marco." In *Interpretazioni veneziane: Studi di storia dell'arte in onore di Michelangelo Muraro*, edited by David Rosand, 149–74. Venice: Arsenale Editrice, 1984.

Shearman, John. *Raphael's Cartoons in the Royal Collection and the Tapestries for the Sistine Chapel*. London: Phaidon, 1972.

Silvano, Giovanni. *La "Republica de' Viniziani": Ricerche sul repubblicanesimo veneziano in età moderna*. Florence: Leo S. Olschki, 1993.

Sinding-Larsen, Staale. *Christ in the Council Hall: Studies in the Religious Iconography of the Venetian Republic* (Institutum Romanum Norvegiae, *Acta ad archaeologiam et artium historiam pertinentia* 5). Rome: "L'Erma" di Bretschneider, 1974.

Sohm, Philip L. *The Scuola Grande di San Marco, 1437–1550: The Architecture of a Venetian Lay Confraternity*. New York and London: Garland Publishing, 1982.

Stringa, Giovanni. *Della vita, traslatione, et apparitione di S. Marco Vangelista . . . libri tre*. Venice: Francesco Rampazetto, 1601.

————. *Vita di S. Marco Evangelista, Protettor invittissimo della Sereniss. Republica di Venetia. . . .* Venice: Francesco Rampazettto, 1610.

Tafuri, Manfredo. *Jacopo Sansovino e l'architettura del '500 a Venezia*. Padua: Marsilio Editori, 1972.

———. "'Renovatio urbis Venetiarum': Il problema storiografico." In *"Renovatio urbis": Venezia nell'età di Andrea Gritti (1523–1538)*, edited by Manfredo Tafuri, 9–55. Rome: Officina Edizioni, 1984.

———. *Venice and the Renaissance*. Translated by Jessica Levine. Cambridge, Mass., and London: MIT Press, 1989.

Tardito, Rosalba. *Il Ritrovamento del corpo di San Marco del Tintoretto: Vicende e restauri*. Florence: Cantini Editore, 1990.

Tietze-Conrat, E. "Decorative Paintings of the Venetian Renaissance Reconstructed from Drawings." *Art Quarterly* 3 (1940): 15–39.

Tigler, Guido. "Le facciate del Palazzo, l'ispirazione dell'artista: La cultura figurativa di 'Filippo Calendario'." In Antonio Manno, *Il poema del tempo. I capitelli del Palazzo Ducale di Venezia: Storia e iconografia*, 17–33. Venice: Canal & Stamperia Editrice, 1999.

*Titian: Prince of Painters*. Venice: Marsilio Editori, 1990.

Tolnay, Charles de. "Tintoretto's Salotto Dorato Cycle in the Doge's Palace." In *Scritti di storia dell'arte in onore di Mario Salmi*, vol. 2, 117–31. Rome: De Luca, 1963.

———. "Il 'Paradiso' del Tintoretto: Note sull'interpretazione della tela in Palazzo Ducale," *Arte Veneta* 24 (1970): 103–10.

Tozzi Pedrazzi, Rosanna. "Le storie di Domenico Tintoretto per la Scuola di S. Marco." *Arte veneta* 18 (1964): 73–88.

Tramontin, Silvio. "Realtà e leggenda nei racconti marciani veneti." *Studi veneziani* 12 (1970): 35–58.

———, et al. *Culto dei santi a Venezia*. Venice: Edizioni Studium Cattolico Veneziano, 1965.

Vasari, Giorgio. *Le vite de' più eccellenti pittori, scultori ed architettori* (1568). Edited by Gaetano Milanesi. 9 vols. Florence: G. C. Sansoni, 1878–85.

Venice, Musei Civici Veneziani. *A volo d'uccello: Jacopo de' Barbari e le rappresentazioni di città nell'Europa del Rinascimento*. Venice: Arsenale Editrice, 1999.

Voragine, Jacobus de. *The Golden Legend: Readings on the Saints*. Translated by William Granger Ryan, 2 vols. Princeton: Princeton University Press, 1993.

Warburg, Aby. *The Renewal of Pagan Antiquity: Contributions to the Cultural History of the European Renaissance* (1932). Translated by David Britt. Los Angeles: Getty Research Institute for the History of Art and the Humanities, 1999.

Ward Perkins, J. B. "The Shrine of St. Peter and its Twelve Spiral Columns." *Journal of Roman Studies* 42 (1952): 21–33.

Weddigen, Erasmus. "Thomas Philologus Ravennas: Gelehrter, Wohltäter und Mäzen." *Saggi e memorie di storia dell'arte* 9 (1974): 7–76.

———. "Il secondo pergolo di San Marco e la Loggetta del Sansovino: Preliminari al *Miracolo dello schiavo* di Jacopo Tintoretto." *Venezia Cinquecento* 1.1 (1991): 101–29.

Wethey, Harold E. *The Paintings of Titian.* 3 vols. London: Phaidon, 1969–75.

Wind, Edgar. *Giorgione's* Tempesta, *with Comments on Giorgione's Poetic Allegories.* Oxford: Clarendon Press, 1969.

Wissowa, Georg, ed. *Paulys Real-Encyclopädie der classischen Altertumswissenschaft,* vol. X. Stuttgart: J. B. Meltzer, 1917.

Wolters, Wolfgang. "Der Programmentwurf zur Dekoration des Dogenpalastes nach dem Brand vom 20. Dezember 1577." *Mitteilungen des Kunsthistorischen Institutes in Florenz* 12 (1966): 271–318.

———. *La scultura veneziana gotica (1300–1460).* Venice: Alfieri, 1976.

———. *Der Bilderschmuck des Dogenpalastes: Untersuchungen zur Selbstdarstellung der Republik Venedig im 16. Jahrhundert.* Wiesbaden: Franz Steiner Verlag, 1983; Italian translation: *Storia e politica nei dipinti di Palazzo Ducale: Aspetti dell'autocelebrazione della Repubblica di Venezia nel Cinquecento.* Venice: Arsenale Editrice, 1987.

———. "Scultura." In Umberto Franzoi, Terisio Pignatti, and Wolfgang Wolters, *Il Palazzo Ducale di Venezia,* 117–224. Treviso: Edizioni Canova, 1990.

———. "Il pittore come storiografo? A proposito delle pitture di Palazzo Ducale a Venezia." In *Crisi e rinnovamenti nell'autunno del Rinascimento a Venezia,* ed. Vittore Branca and Carlo Ossola, 205–19. Florence: Leo S. Olschki, 1991.

———. "Leopardi oder Lombardi? Zur Autorschaft der Modelle für die Sockel der Fahnenmasten auf der Piazza S. Marco in Venedig." In *Correspondances: Festschrift für Margret Stuffmann zum 24. November 1996,* edited by Hildegard Bauereisen and Martin Sonnabend, 51–67. Mainz: Verlag Hermann Schmidt, 1996.

Wurthman, William B. "The *Scuole Grandi* and Venetian Art, 1260–c.1500." Ph.D. dissertation, University of Chicago, 1975.

Yates, Frances A. *Astraea: The Imperial Theme in the Sixteenth Century.* London and Boston: Routledge & Kegan Paul, 1975.

Zorzi, Marino. *La Libreria di San Marco: Libri, lettori, società nella Venezia dei dogi,* Milan: Arnoldo Mondadori, 1987.

# INDEX

Doglione, Giovanni Nicolò, 118, 163 (n. 4)

*Domus Sapientiae*, 105, 106

Donatello: *David*, 165 (n. 22)

Donato, Baldassare, 137

Ducal Palace, 6, 12, 26–41 passim, 54, 96–102, 110, 111, 119, 127, 129, 137, 140, 164 (n. 17); *Adam and Eve*, 100; *ad jus reddendum*, 100; Arco Foscari, 121; Avogaria, 39; balconies of, 32–33, 110; Camera degli Imprestidi, 16; as *Domus Iustitiae*, 105, 116; *Drunkenness of Noah*, 102; fire of 1574 in, 49, 144–45; fire of 1577 in, 6, 18, 19; *Judgment of Solomon*, 97–100; Magistrato del Proprio, 20; pictorial cycles in, 6; Porta della Carta, 31, 97, 121, 129; Sala del Collegio, 44, 144–46; Sala del Consiglio dei Dieci, 138, 149; Sala dell'Anticollegio, 140, 143; Sala delle Quattro Porte, 140, 151; Sala del Maggior Consiglio, 6, 18, 19, 39, 41–46, 96, 100, 102, 109, 147, 149–50, 160 (n. 2); Sala del Senato, 49, 166 (n. 38); Salotto Dorato, 140–44; Scala dei Giganti, 119–21, 125, 129, 162 (n. 26); Scala d'Oro, 106, 140; *Venecia*, 26–32, 97

Dutch (people), 4

Ecclesia, personification of, 39, 115, 145

Ecclesiasticus, 108, 114, 115

Education, 106

Egypt, 58, 88

Elephant, 126, 137, 164 (n. 17)

Eloquence, 133

English (people), 4, 38

Eucharist, 39

Europe, personification of, 49

Evangelists, 112

Eve, 100

Evil, 20

Excommunication, 2, 39, 55

Ezekial, 47

Faith, 39, 145

Falier, Vitale (doge), 58

Fame, personification of, 44, 137, 149

Fides, 39, 145

Fisherman, legend of, 80, 81

Florence, 13

Florio, John, 155 (n. 5)

Fondaco dei Tedeschi, 164 (n. 17)

*Forestieri*, 41

Fortitude, 97; personification of, 156 (n. 21)

Fortunatus, Saint, 54

Foscari, Francesco (doge), 97; medal of, 156 (n. 23)

Foscarini, Marco, 166 (n. 45)

Franklin, Benjamin, 159 (n. 32)

Gabriel, Archangel, 12, 13, 16, 18, 19, 20–25, 33–36, 100

Genoa, 1

George, Saint, 80

Giustiniani, Beato Lorenzo, 162 (n. 28)

Giustiniani, Bernardo, 12–13

God, 7, 16, 36, 140; grace of, 19; love of, 117; wisdom of, 13, 100, 106, 108, 112, 114, 115, 150; word of, 13, 25

Gods, Olympian, 12, 44, 117–51 passim, 166 (n. 38)

Government, 3

Grace, divine, 19

Oratory: ambassadorial, 36, 136; political, 144
Original Sin, 13, 100

Pagan, Matteo: *Andata in trionfo*, 158 (n. 19)
Pala d'Oro, 58
Palazzo Loredan, 156 (n. 21)
Palazzo Vecchio, 6
Pallas Athena. *See* Minerva
Palma il Giovane, Jacopo, 41, 140; *Allegory of the League of Cambrai*, 49; *The Triumph of Venice*, 41–44, 149
Palma il Vecchio, Jacopo, 80
Panegyric, 36, 136, 138, 144
Paradise, 18–19; architectural, 19; celestial, 18; rivers of, 50
Patriciate, 2, 3
Paul, Saint, 97
*Pax Veneta*, 149
Peace, 49; personification of, 44, 49, 133, 136, 137, 138, 140, 145; temple of, 137
Peace of Bologna, 119, 137
Peace of St. Mark, 49, 51, 95, 100, 136
Pedestals, bronze, 121–28
Penury, personification of, 137
Personfication, 3, 20–26
Peruzzi, Baldassare, 115
Peter, Saint, 54, 55
Petrarch, Francesco, 7, 18, 105, 154 (n. 2)
Piazza San Marco, 16, 70, 87–88, 102–3, 127, 129, 137. *See also* Pedestals, bronze
Piazzetta, 16, 33, 55, 96, 100, 103, 105
Plague, 66
Plato, 104
Poetry, 144

Ponchino, Giovanni Battista, 138
Ponte, Nicolò da (doge), 44
Ponte della Paglia, 102
Porch of columns, 32, 99, 111, 112
Porta della Carta, 31, 97, 121, 129
Portraits, 77, 85
Portumnus, 127
*Praedestinatio*, 51, 53, 58, 77, 92–93
Presentation of the Virgin, 109–16; Byzantine representations of, 113; *Sacra rappresentazione* of, 115
Pride, personified, 30
Printing, 10, 36
Priuli, Girolamo, 121
Processions, 69, 164 (n. 13)
Procuratie Nuove, 88
Procuratori di San Marco, 102, 109, 121, 136
Propaganda, 4, 37, 38, 39
Protestants, 39
Proverbs, Book of, 106, 108, 114; foolish woman in, 115
Prudence, 97
Psalms, 96, 110
Publishing, 10, 36
Pyramid, 114

Queen of Heaven, 19, 46, 147
Queen of the Adriatic, 2, 46, 100, 147, 151

Rangone, Tommaso, 84, 85, 86–88
Raphael, Archangel, 102
Ravenna, 53
Rebellion, personification of, 138
Red Sea, drowning of pharoah's army in, 80–81
Religion, 134, 140, 145